Mirroring Evil

Nazi Imagery/Recent Art

EDITED BY NORMAN L. KLEEBLATT

Mirroring EVIL

THE JEWISH MUSEUM

NEW YORK

Under the auspices of the Jewish Theological Seminary of America

AND

RUTGERS UNIVERSITY PRESS

NEW BRUNSWICK, NEW JERSEY, AND LONDON

This book has been published in conjunction with the exhibition *Mirroring Evil: Nazi Imagery/Recent Art* at The Jewish Museum, New York, March 17–June 30, 2002.

Mirroring Evil: Nazi Imagery/Recent Art has been supported, in part, by grants from The Blanche and Irving Laurie Foundation, The Andy Warhol Foundation for the Visual Arts, The Dorsky Foundation, the Ellen Flamm Philanthropic Fund, Agnes Gund and Daniel Shapiro, and other generous donors.

Exhibition Curator: Norman L. Kleeblatt
Assistant Exhibition Curator: Joanna Lindenbaum
Manuscript Editor: Mary Beth Brewer
Writer and Producer of Contextual Video and Chief Consultant
 for Interpretative and Contextual Program: Maurice Berger
Designed and typeset by Jenny Dossin
Cover design by Trudi Gershenov
Manufactured in China

LIBRARY OF CONGRESS CATALOGUING-IN-PUBLICATION DATA
Mirroring evil : Nazi imagery/recent art/edited by Norman L. Kleeblatt.
 p. cm.
Catalog of an exhibition opening at the Jewish Museum in New York in Mar., 2002.
Includes bibliographical references.
ISBN 0-8135-2959-X (cloth : alk. paper)
ISBN 0-8135-2960-3 (pbk. : alk. paper)
1. National socialism in art—Moral and ethical aspects—Exhibitions. 2. Art, Modern—20th century—Exhibitions.
I. Kleeblatt, Norman L. II. Jewish Museum (New York, N.Y.)
N6868.5.N37 M57 2001
704.9'49943086—dc21 00-068345

CONTENTS

DISTANCED MIRRORS
Reflections on the Works of Art

DIRECTOR'S PREFACE

Mirroring Evil: Nazi Imagery/Recent Art focuses on thirteen contemporary, internationally recognized artists who use imagery from the Nazi era to explore the nature of evil. Their works are a radical departure from previous art about the Holocaust, which has centered on tragic images of victims. Instead, these artists dare to invite the viewer into the world of the perpetrators. The viewer, therefore, faces an unsettling moral dilemma: How is one to react to these menacing and indicting images, drawn from a history that can never be forgotten?

The artists are often two generations removed from the Nazi era and are descended from families of both victims and perpetrators. Obsessed with a history that they seem impelled to overcome, they ask us to examine what these images of Nazism might mean in our lives today. These artworks draw us into the past, leading us to question how we understand the appalling forces that produced the Holocaust. These works also keep us alert to the present, with its techniques of persuasion that are so easily taken for granted, its symbols of oppression that are too readily ignored.

Mirroring Evil is the most recent of many exhibitions at The Jewish Museum that have addressed the period of the Holocaust. In 1994 The Jewish Museum mounted an exhibition on the memorialization of the Holocaust and the complexities surrounding the commissioning, creation, use, and meaning of memorials. It focused on the preservation of memory and the intent and effect of physical memorials created as sites of mourning and contemplation. The works included in that exhibition referred to classical, poignant, and reverential buildings and sculptures and to events. That exhibition also showed contemporary art that challenged the very idea of the Holocaust monument. In *Mirroring Evil,* the artists dismiss classicism, edifices, and memorial rituals. They replace them with a disquieting, demanding, and jolting approach, which asks us over and over again to look deeply into human behavior.

The museum collects and exhibits art that provides visitors with many approaches that inspire thought about the period of the Holocaust. For example, in 2000 The Jewish Museum mounted the exhibition, *Charlotte Salomon: Life? Or Theatre?* Like the works in a 1985 Jewish Museum retrospective of another young artist who perished in the Holocaust—Felix Nussbaum—Salomon's paintings and drawings present the intimate chronicle of a life during the Nazi period. The cumulative effect of these works draws the viewer into the experience of living through the Nazi era.

Norman L. Kleeblatt, Susan and Elihu Rose Curator of Fine Arts, conceived of this project. As in the past, he has brought together works by a diverse group of artists to create a groundbreaking exhibition and a wonderfully informative publication. The catalogue essays provide an extensive and invaluable frame of reference for the works in the exhibition. Among other topics, this book provides a background on transgressive art, a critical analysis of the individual works in the show, and an exploration of the context of the museum as the presenter of work that may be considered taboo, in addition to a discussion of the psychological devices of Nazi oppression.

This exhibition was made with the support of devoted Jewish Museum staff, the contributions of generous donors, collectors, and museums, the advice of insightful consultants, and the loans of art by the remarkable artists whose work is the subject of this project. In addition to Norman Kleeblatt, I thank Maurice Berger, Rabbi Irwin Kula, Luisa Kreisberg, Stuart Klawans, and Reesa Greenberg for their thoughtful and sensitive work as consultants; Sidra DeKoven Ezrahi for her advocacy and thoughtful contextualization of the exhibition; and James E.

Young, Ernst van Alphen, Lisa Saltzman, and Ellen Handler Spitz for their insightful essays. I am additionally grateful to those institutions that have worked in cooperation with The Jewish Museum to create and host educational and public programming. In particular, I would like to thank Peter Nelson and Facing History and Ourselves; Sondra Farganis and The Vera List Center for Art and Politics of The New School; The National Jewish Center for Learning and Leadership; Grace Caporino and The University Seminar in Innovation in Education at Columbia University; and Betsy Bradley and The New York Public Library. I also thank Daniel Kershaw and Allan Wexler who together created the exhibition design; Joanna Lindenbaum, assistant curator for the exhibition; Carole Zawatsky, director of education; Aviva Weintraub, director of media and public programs; Anne Scher, director of communications; and Ruth Beesch, deputy director for program.

The exhibition funders have demonstrated much appreciated support for taking on a show that is filled with difficult, challenging art. Our thanks go to The Blanche and Irving Laurie Foundation, The Andy Warhol Foundation for the Visual Arts, The Dorsky Foundation, the Ellen Flamm Philanthropic Fund, Agnes Gund and Daniel Shapiro, and to many other donors to whom we are most grateful. I am additionally grateful to the lenders and artists whose work has been included in this exhibition. Both are courageous in recognizing that provocative and troubling images often yield important consideration and understanding.

Finally my appreciation to the museum's Board of Trustees, whose commitment to a complete understanding of the Jewish experience in the world makes this a museum that reaches far in its use of art for inspiration and education.

JOAN ROSENBAUM
Helen Goldsmith Menschel Director,
The Jewish Museum

ACKNOWLEDGMENTS

NORMAN L. KLEEBLATT

Over the past twenty years, The Jewish Museum has presented numerous exhibitions and acquired many works of art relating to the Holocaust, the catastrophic, signal event in both twentieth-century history in general and Jewish history in particular. In fact, the museum has become a virtual clearinghouse for art based on the subject. During the last several years, I began to notice a new generation of artists who look at these events in a radically different—indeed disturbing—way. They turned from what has become a standard focus on the often anonymous victims and instead stared directly at the perpetrators. More important, they created works in which viewers would encounter the perpetrators face to face in scenarios in which ethical and moral issues cannot be easily resolved. One of the first of such works to come our way was Zbigniew Libera's *LEGO Concentration Camp Set,* a slide of which appeared on my desk in 1997. It seemed a disturbing, yet significant, work of art. I decided to share it with the museum's fine arts acquisition committee and presented it as a possible purchase for the collection. I assumed it would be turned down, but that the process would help me better understand both its problematic nature and my attraction to it. I took the piece to the committee, chaired by trustee Barbara S. Horowitz. Not surprisingly, it provoked a lively, divisive discussion. Surprisingly, the committee decided to buy it. The work had provoked controversy before it was sent to us, and the national press promptly reported on the work's reception history and the museum's decision to acquire it.

As other unsettling works representing the Nazi era came to my attention, I took a selection to the staff exhibition committee. There was great interest among the group, and its members encouraged me to continue to think about a way to exhibit the works. Particularly useful were the comments of Fred Wasserman, associate curator, Heidi Zuckerman Jacobson, former assistant curator, and Carole

Zawatsky, director of education at the museum. I continued to question the logic and the ethical questions raised by these works.

Professors Barbara Mann and Leora Batnitzky invited me to participate in a conference at Princeton University titled "Icon, Image and Text in Modern Jewish Culture" in March 1999. When asked what I might speak about, I knew that it was the moment to focus on this group of complicated and disturbing works. Before that presentation, my meeting with James Young and my telephone conversations with Catherine Soussloff were enormously helpful, and I thank Catherine for reading and commenting on a draft of my paper. Indeed, the Princeton forum provided me with the first academic reactions to these pieces, and I am indebted to the organizers for offering me that opportunity. In the interim, I have presented additional papers on aspects of this subject: at the February 2000 meeting of the College Art Association in a panel chaired by Matthew Baigell and Marty Kalb; at the conference "Representing the Holocaust" at Lehigh University in May 2000, organized by Laurence Silberstein; and at "Images, Identities, and Intersections," a conference in November 2000 organized by Nicholas Mirzoeff and Karen Levitov at the State University of New York in Stony Brook. The discussions that ensued were very helpful to the formulation of my ideas for both the exhibition and the book, and I thank the organizers for the opportunities they afforded me and the participants for their thoughtful reactions. My conversations with Griselda Pollack, Reesa Greenberg, and Catherine Soussloff at the Princeton conference; with Irit Rogoff, Ellen Handler Spitz, and Carol Zemel following the CAA panel; and with Tami Katz-Freiman and Ariella Azoulay following the Lehigh conference were particularly useful, productive, and greatly appreciated.

At the museum, we formed a scholars' committee to talk about the issues and to think about both the catalogue and the exhibition. James Young, Reesa Greenberg, Ellen Handler Spitz, Lisa Saltzman, Ernst van Alphen, Sidra DeKoven Ezrahi, and Maurice Berger attended. They offered thoughtful insights and confirmed that this material, though complicated and thorny, exposed many issues about the war period and the Holocaust that are often skirted in standard cultural discussions. Leslie Mitchner, associate director and editor-in-chief at Rutgers University Press, was enthusiastic about both the exhibition and the potential book that was emerging. She and her colleagues at the press quickly signed on to publish the book. Leslie had published one previous volume of mine, and I greatly appreciate her continuing interest in and support of my projects. It was a pleasure to work with Leslie and with Tricia Politi, senior production coordinator at Rutgers Press. Mary Beth Brewer became involved late in the game, but without her intelligence and finely honed editorial skills the book would not exist. She offered no end of advice and masterminded the fitting together of the various components of the volume. Both Joanna Lindenbaum and I appreciated her collegiality and good humor. Together Brewer, Mitchner, and Politi have fashioned a wonderful book sensitive to both the artists' challenging works and to this complicated subject. Jennifer Dossin, the designer of the book, and Trudi Gershenov, the designer of the cover, have created a clear and attractive publication.

The contributions to the volume by Lisa Saltzman, Sidra DeKoven Ezrahi, Ellen Handler Spitz, Ernst van Alphen, Reesa Greenberg, and James E. Young are rich and thoughtful and offer great insight into the art presented. Not only do they address issues raised by the works shown, but also reflect on newer turns in the way the history of the war and the Holocaust has been absorbed and presented. I thank them all for their intelligence and interest and for managing to live with our tight deadlines. My gratitude goes to John Alan Farmer for having read and commented on a version of my texts for the book. I would also like

to thank Sidra DeKoven Ezrahi for taking part in subsequent meetings with the museum's staff and Reesa Greenberg, who served as a consultant for the exhibition interpretation. Maurice Berger advised us on many facets of the exhibition, and with his usual sensitivity and flair created contextual spaces that well matched interpretive needs.

Other scholars and curators were enormously helpful in discussing both the project and the artists I have chosen to show. Although they are too numerous to mention, I must single out colleagues and friends at various museums internationally who have been especially helpful and supportive: Lisa Corrin, chief curator at the Serpentine Gallery in London; Francesco Bonami, senior curator at the Museum of Contemporary Art in Chicago; Peter Friese at the Neues Museum Weserburg Bremen in Germany; Jill Snyder, executive director at the Cleveland Center for Contemporary Art in Ohio; Friederike Wappler at the Kunstverein Ruhr in Essen, Germany; Suzanne Landau and Yigal Zalmona at the Israel Museum in Jerusalem; Marcelo Araujo, director at the Museu Lasar Segall in São Paulo; Thomas Sokolowski, director at The Andy Warhol Museum in Pittsburgh; Murray Horne, director at The Wood Street Galleries in Pittsburgh; Helmuth Braun, curator at The Jewish Museum Berlin; Dahlia Levin, director of the Herzliya Museum of Israeli Art in Israel; Laurence Sigal, director of Musée d'art et d'histoire du Judaïsme in Paris; Didier Schulmann, curator at the Centre Georges Pompidou in Paris; Valerie Smith, curator at the Queens Museum of Art in New York; Paul Wombell, director, and Jeremy Millar, former curator, at the Photographers' Gallery in London. On different levels and at different times, each reviewed the exhibition's issues—artistic and ideological—with me and offered names of other artists I might consider.

It was a great pleasure to work with the particularly talented and generous group of artists, who discussed their work and the exhibition construct with me. Each believed in the direction I was taking,

and all helped with details too numerous to mention. To Mischa Kuball, Christine Borland, Elke Krystufek, Rudolf Herz, Roee Rosen, Boaz Arad, Alain Séchas, Zbigniew Libera, Mat Collishaw, Tom Sachs, Alan Schechner, Maciej Toporowicz, and Piotr Uklański go a great debt of gratitude for their honesty, courage, professionalism, and, often, their concern and friendship. Their dealers and representatives have also played important roles in providing information and intellectual, practical, and moral support: many thanks to Mary Boone; Elena Bortolotti at Galerie Thaddeus Ropac in Paris; Georg Kargl and Karina Simbuerger at Georg Kargl Gallery in Vienna; Leah Fried at Lombard-Fried Fine Arts in New York; Tanya Bonakdar and Ethan Sklar at Bonakdar Jancou in New York; Cecile Panzieri at Sean Kelly Gallery in New York; Rein Wolfs at the Migros Museum in Zurich; Paulina Kolczynska; Dorothee Fischer at the Konrad Fischer Gallery in Düsseldorf; Jennifer Flay in Paris, and Emmanuel Perrotin and Peggy Leboeuf at Galerie Emmanuel Perrotin in Paris; and Gavin Brown and Kirsty Bell at Gavin Brown's Enterprise in New York. As this book goes to press, I have been working with Daniel Kershaw and Allan Wexler on the exhibition design. These two talented minds have offered great stimulation and helped with ideas that will provide an intelligent, thoughtful, and appropriate installation and interpretive context for these complicated and provocative works.

Deepest thanks go to the colleagues in my department who have listened, offered constructive criticism and support, both practical and intellectual. Susan Chevlowe, associate curator; Mason Klein and Karen Levitov, assistant curators; Irene Z. Schenck, research associate; Michelle Lapine, former curatorial assistant; Johanna Goldfeld and Valerie von Volz, exhibition assistants; and former exhibition assistant Rachel Natalson, in various ways, were key to the success of the exhibition. I wish to thank Marie Rupert, another former exhibition assistant, who devoted unstinting energy and made time to

work on this project despite her many other obligations in the department. Special gratitude is due Rebecca Robbins, former project assistant, who organized the first scholars' meeting and helped in the initial planning and research for the exhibition and the book. Additionally, I am grateful to intern Celia Fanselow, who came to New York from Frankfurt, Germany, to assist with the show at a particularly critical point in the catalogue production.

I am wholeheartedly indebted to Joanna Lindenbaum for her intelligence and devotion to the project. Although she arrived quite late in the progression of the exhibition, the art I was presenting and the ideas it raised coincided perfectly with her own interests and research. She has been a wonderful colleague, who has supported the project in intellectual and practical ways too numerous to list. I benefited greatly from our continuing honest and sensitive conversations on the subject, and I am delighted that she has contributed three highly intelligent pieces about the artists Boaz Arad, Mat Collishaw, and Alan Schechner for the catalogue.

The efforts and enthusiasm of many other Jewish Museum colleagues have been invaluable in the execution of the exhibition and catalogue. The expertise of Carole Zawatsky, director of education, has been instrumental to the interpretive process of this exhibit. I am continually grateful to Anne Scher, director of communications, and her staff, who have adeptly planned the publicity strategies for such a complicated exhibition. I am also grateful to Grace Rapkin, director of marketing, and Jill Katz, marketing manager, who have patiently and thoughtfully helped to develop a website for this exhibition. As usual, many thanks to Aviva Weintraub, director of media and public programs, who has developed an excellent schedule of public events in conjunction with the show; and to Andrew Ingall, coordinator of broadcast archive, whose practical knowledge of film and related media has been useful. Special gratitude goes to our registrarial department, who intelligently and creatively coordinated all of the details of shipping and museum installation for this show. I am always indebted to Al Lazarte, director of operations, for his insightful suggestions and skillful coordination of the design of the exhibition, and to Allesandro Cavadini, audio visual coordinator, who creatively prepared the different media components in the exhibition. Finally, many thanks to Marc Dorfman, former deputy director for external affairs, for his sensitivity and concern, and to Lynn Thommen, current deputy director for external affairs. Many thanks to Elana Yerushalmi, director of program funding, and Gabriel DeGuzman, coordinator for program funding, who both wrote the highly intelligent proposals and helped procure the financial support for this exhibition.

I would also like to thank all of the junior staff members who attended focus groups: Leslie Friedman, Seth Fogelman, Katharina Garrelt, Jody Heher, Jill Katz, Sage Litsky, Laura Mass, Lionel Nanton, Marie Rupert, Elanit Snow, and Siri Steinberg. Their reactions and suggestions were important to the directions we were considering for the interpretive elements of the exhibition.

Certain consultants have proved invaluable to our efforts. Here special thanks go to Ann Appelbaum, counsel to the Jewish Theological Seminary; Jeremy Nussbaum at Kay Collyer & Boose; Rabbi Irwin Kula, president of CLAL—the Center for Learning and Leadership; and Luisa Kreisberg and Stuart Klawans of the Kreisberg Group. Each in his or her own area of expertise has provided highly specific information and advice that has been crucial to various aspects of planning.

Numerous artists, art historians, and friends have listened carefully to me in speaking about the project. They have offered insights and criticisms, assistance and encouragement. I thank Shimon Attie, Deborah Kass, David Levinthal, Rona Pondick, Dinos and Jake Chapman, Tslilit ben Nevat, Jacqueline Frydman-Klugman, Mark Godfrey, Ken Aptekar,

Eunice Lipton, Carol Zemel, Kenneth Silver, Shelley Hornstein, David Joselit, Stuart Hughes, Catherine Rice, and Patrick Palmer. Peter J. Prescott has listened to the evolution of the exhibition and book, read numerous texts, offered sound advice, and continuing support. As with his role in earlier projects, I am very grateful.

I am indebted to the support, intelligence and not least the friendship of Ruth Beesch, deputy director of program, who continued to champion this project and has assisted me in my thinking about the art displayed and issues raised by the works. Joan Rosenbaum, director of The Jewish Museum, is a strong believer in the importance of contemporary art in helping to raise public awareness about com-

plex social, historical, and political issues. She has provided enormous support for the project in general and for me personally. At the same time, she has encouraged sensitivity and caution for this challenging material. Our conversations together and with groups both inside and outside the museum have provided substantive insights into the issues confronted by the artists and scholars involved in the project. In view of the difficulties that some viewers will, no doubt, have with this art, she has nevertheless spearheaded an effort toward a sensitive display and interpretation of the work.

FOREWORD:

LOOKING INTO THE MIRRORS

OF EVIL

JAMES E. YOUNG

A notorious Nazi once said that when he heard the word "culture" he reached for his revolver. Now, it seems, every time we hear the word "Nazi" we reach for our culture. Thus might we protect ourselves from the terror of the Nazi Reich, even as we provide a window into it. It is almost as if the only guarantee against the return of this dreaded past lies in its constant aesthetic sublimation—in the art, literature, music, and even monuments by which the Nazi era is vicariously recalled by a generation of artists born after, but indelibly shaped by, the Holocaust.

Until recently, however, this has also been an art that concentrated unrelievedly on the victims of Nazi crimes—as a way to commemorate them, name them, extol them, and bring them back from the dead. By contrast, almost no art has dared depict the killers themselves. It is as if the ancient injunctions against writing the name of Amalek or hearing the sound of Haman's name have been automatically extended to blotting out their images as well. Of course, such blotting out was never merely about forgetting the tormentors of the Jews. It was, in fact, a way to remember them. By constantly condemning these tormentors to oblivion, we ritually repeat an unending Jewish curse that makes us remember the enemies of the Jews by enacting the attempt to forget them. A new generation of artists sees things a little differently, and the results are as unnerving as they are taboo breaking.

"You can't shock us, Damien," are the words artist Elke Krystufek has pasted over one of her collages. (The reference is to the English artist Damien Hirst, whose vivisected animals floating in glass vats of formaldehyde caused an enormous sensation in the early 1990s in London.) "That's because you haven't based an entire exhibition on pictures of Nazis." Is this to say that the point here is to shock? Or, that in a culture inured to the images of vivisected animals, only images of Nazis can still shock? Or is Krystufek after something else altogether? I think it's something else. Rather than repeat the degrad-

ing images of murdered and emaciated Jewish victims, thereby perpetuating the very images the Nazis themselves left behind, artists like Krystufek now turn their accusing gaze upon the killers themselves. For these artists, the only thing more shocking than the images of suffering victims is the depravity of the human beings who caused such suffering.

To the traditional art that creates an empathetic nexus between viewers and concentration camp victims, these artists would add an art that brings us face to face with the killers themselves. Rather than allow the easy escape from responsibility implied by the traditional identification with the victims, these artists challenge us now to confront the faces of evil—which, if truth be told, look more like us than do the wretched human remains the Nazis left behind. In the process, we are compelled to ask: Which leads to deeper knowledge of these events, to deeper understanding of the human condition? Images of suffering, or of the evildoers who caused such suffering? Which is worse? The cultural commodification of victims or the commercial fascination with killers? These artists let such questions dangle dangerously over our heads.

Victimized peoples have long appropriated their oppressors' insidious descriptions of themselves as a way to neutralize their terrible charge. But what does it mean to appropriate images of the Nazi killers into the contemporary artistic response to the terror they wrought? Is this a way to normalize such images, making us comfortable with them, bringing them back into the cultural conversation, denying to them the powerful charge that even the killers themselves hoped to spread? Or is it merely to redirect the viewers' attention away from the terror toward its causes?

These are the easy questions articulated so disturbingly by this exhibition of Nazi imagery in recent art. Tougher, more unsettling, and even more offensive questions are also raised and addressed by both the works in this exhibition and by the essays in this catalogue. To what extent, for example, are we even allowed to consider the potential erotic component in the relationship between Nazi murderers and their Jewish victims? What does it mean to "play" Nazis by building your own model concentration camp out of LEGOs? Is this different from "playing" Nazis in the movies? Were Nazis beautiful? And if not, then to what aesthetic and commercial ends have they been depicted over the years in the movie-star images of Dirk Bogarde, Clint Eastwood, Frank Sinatra, Max von Sydow, and Ralph Fiennes? What does it mean for Calvin Klein to sell contemporary perfumes and colognes in the Brekerian images of the Aryan ideal? And, if this is possible, is it also possible to imagine oneself as an artist drinking a Diet Coke amid emaciated survivors at Buchenwald? Just where are the limits of taste and irony here? And what should they be? Must a depraved crime always lead to such depraved artistic responses? Can such art mirror evil and remain free of evil's stench? Or must the banality of evil, once depicted, lead to the banalization of such images and become a banal art?

If these questions are problematically formalized in this exhibition, they are also profoundly elaborated in the unflinching catalogue essays. All of the writers are acutely aware that exhibiting and writing about works such as these may be regarded by some to be as transgressive and disturbing as the art itself. In this vein, both the curator Norman Kleeblatt and literary historian Sidra DeKoven Ezrahi have probed deeply into what Ezrahi presciently calls the "barbaric space" that tests the boundaries of a "safe" encounter with the past. Cultural critic Reesa Greenberg reminds us that "playing it safe" is no longer a viable option for museums, curators, critics, or viewers when the questions at hand are, necessarily, so dangerous. For, as art historian Lisa Saltzman shows in her reconsideration of the avant-garde, since "All the verities are [now] thrown into question," such transgressions require an art that makes excruciating demands on both critics and viewers. It

is almost as if the more strenuously we resist such art, the more deeply we find ourselves implicated in its transgressions.

In a parallel vein, child psychiatrist and art historian Ellen Handler Spitz explores the perilous border between inviolate childhood and absolutely violated children, that inner terror of children devastated by a cruelty whose name they cannot pronounce. What can children do with such trauma? Ernst van Alphen persuasively argues that to some extent the child has come to stand "for the next generations, who need to learn a trauma they have not directly lived," who instead of talking about such terror, or looking at it, will necessarily "playact" it as a way to know and work through it.

For a generation of artists and critics born after the Holocaust, the experience of Nazi genocide is necessarily vicarious and hypermediated. They haven't experienced the Holocaust itself but only the event of its being passed down to them. As faithful to their experiences as their parents and grandparents were to theirs in the camps, the artists of this media-saturated generation make their subjects the blessed distance between themselves and the camps, as well as the ubiquitous images of Nazis and the crimes they committed found in commercial mass media. These are their proper subjects, not the events themselves.

Of course, we have every right to ask whether such obsession with these media-generated images of the past is aesthetically appropriate. Or whether by including such images in their work, the artists somehow affirm and extend them, even as they intend mainly to critique them and our connection to them. Yet this ambiguity between affirmation and criticism seems to be part of the artists' aim here. As offensive as such work may seem on the surface, the artists might ask, is it the Nazi imagery itself that offends, or the artists' aesthetic manipulations of such imagery? Does such art become a victim of the imagery it depicts? Or does it actually tap into and

thereby exploit the repugnant power of Nazi imagery as a way merely to shock and move its viewers? Or is it both, and if so, can these artists have it both ways?

Years ago, the German artist Gerhard Richter openly broached the question as to whether the popular dissemination of Holocaust images amounted to a new, respectable kind of pornography. In his installation *ATLAS*, Richter juxtaposed photographs of naked, tangled corpses next to sexually explicit images of naked and tangled bodies copulating.[1] His aim was not to eroticize the death camp scenes so much as it was to force viewers to ask uncomfortable questions of themselves: Where is the line between the historically inquiring and the erotically preoccupied gaze?

Where is the line between historical exhibition and sensationalist exhibitionism? In fact, here we might even step back to ask whether any exhibition, even the most rigorously framed, can ever merely show such sensationalist imagery without descending into sensationalism. Can the artists, curators, or even we, as viewers, objectively critique such sensationalist images without participating in the sensation itself? In the end, viewers of the exhibition and readers of this catalogue will have to decide for themselves—and even here the answers may depend on just how self-aware each of us is when it comes to understanding our own motives for gazing on such art, or our own need to look evil in the face even as we are repelled by what we see.

In reference to Germany's Holocaust memorial problem, I once wrote that after the Holocaust, there could be no more "final solutions" to the dilemmas its memory posed for contemporary artists; there can be only more questions.[2] For these artists, the issue was never whether or not to show such images, but rather, what to ask of them: To what extent do we always reobjectify a victim by reproducing images of the victim as victim? To what extent do we participate in the degradation of vic-

tims by reproducing and then viewing such images? To what extent do these images ironize and thereby repudiate such representations? And to what extent do these images feed on the same prurient energy they purportedly expose? To what extent does any depiction of evil somehow valorize or beautify it, even when the intent is to reveal its depravity?

For artists at home in their respective media, questions about the appropriateness of their forms seem irrelevant. These artists remain as true to their forms and chosen media as they do to their necessarily vicarious "memory" of events. But for those less at home in the languages of contemporary art, the possibility that form—especially the strange and new—might overwhelm, or even become the content of such work, will lead some to suspect the artists' motives. Historian Omer Bartov, for example, has expressed his sense of "unease" with what he describes as the "cool aesthetic pleasure" that derives from the more "highly stylized" of contemporary Holocaust representations.[3] Part of what troubles Bartov is that such work seems more preoccupied with being stimulating and interesting in and of itself than it is with exploring events and the artist's relationship to them afterward. Also implied here is an understandable leeriness of the ways such art may draw on the very power of Nazi imagery it seeks to expose, the ways such art and its own forms are energized by the Nazi imagery it purports only to explore.

Even more disturbing may be the question Saul Friedlander raised several years ago in his own profound meditations on "fascinating fascism," in which the historian wonders whether a brazen new generation of artists bent on examining their own obsession with Nazism adds to our understanding of the Third Reich or only recapitulates a fatal attraction to it. Friedlander writes:

Nazism has disappeared, but the obsession it represents for the contemporary imagination—as well as the birth of a new discourse that ceaselessly elaborates and reinterprets it—necessarily confronts us with this ultimate question: Is such attention fixed on the past only a gratuitous reverie, the attraction of spectacle, exorcism, or the result of a need to understand; or is it, again and still, an expression of profound fears and, on the part of some, mute yearnings as well?[4]

As the artists in this exhibition suggest, these questions remain open—not because every aesthetic interrogation of Nazi imagery also contains some yearning for "fascinating fascism," but because neither artist nor historian can positively settle such issues. In fact, by leaving such questions unanswered, these artists confront us with our own role in the depiction of evildoers and their deeds and the ways we cover our eyes and peek through our fingers at the same time.

NOTES

1. For a reproduction of this installation, see Gerhard Richter, *ATLAS* (New York and London: Marian Goodman and Anthony d'Offay, 1997), 16–23.

2. See James E. Young, *At Memory's Edge: After-Images of the Holocaust: Contemporary Art and Architecture* (New Haven and London: Yale University Press, 2000), for a study of these issues as they arise in more public art and architecture.

3. Omer Bartov, *Murder in Our Midst: The Holocaust, Industrial Killing, and Representation* (Oxford and New York: Oxford University Press, 1996), 116.

4. Saul Friedlander, *Reflections of Nazism: An Essay on Kitsch and Death* (New York: Harper & Row, 1984), 19.

Mirroring Evil

The Nazi Occupation of the White Cube

Transgressive Images/Moral Ambiguity/Contemporary Art

NORMAN L. KLEEBLATT

We want to get near to the toxin [of Nazism] in order
to get as far away as possible.

Barbara Ehrenreich[1]

Tell me, my dear Anna, what would you do if Adolf
Hitler walked into the room?

George Steiner
The Portage to San Cristóbal of A. H.[2]

hange the Joke and Slip the Yoke," a 1998 conference at Harvard,

focused on the use of racist stereotypes by contem-

porary African-American artists. At the conference,

this generation of African-American artists who

emerged in the 1980s and deliberately play with

black stereotypes were pitted against an earlier

generation that advocates the use of affirmative

imagery. Reports and reviews of this two-day meeting made it clear that the meaning and function of racist imagery in art was still a contentious subject. Also at issue was the considerable white patronage of this ambiguous work. Moral considerations were particularly acute, given the current position of multiculturalism and the fragile state of affirmative action. Writing in *Artforum*, Ronald Jones related the debate to the divergent interpretations of Anselm Kiefer's art, which plays with images from German nationalist mythology and Nazi ideology. Comparing the two situations, Jones pointed out that to equate Kiefer's work with a "celebration of Nazi mastery" would be simplistic and absurd.[3]

Such racist representations intentionally carry multivalent meanings. The controversy they have spawned follows the debates about explicit sexual imagery that fueled the culture wars in the United States during the late 1980s and early 1990s.[4] Without a doubt, the artistic representation of Nazis and the symbols associated with them has caused a similar debate on the international stage.

Like the contested subject matter that the Harvard conference explored, the entry of Nazi representations into the supposedly pristine aesthetic sanctum of the "white cube" was as taboo as the artists' confrontational aesthetic strategies. The hotly debated work of Kara Walker and others marked a 180-degree turn from the art centered on personal identity and multiculturalism that thrived in the United States during much of the 1980s and 1990s. Work depicting Nazi villains, art, and architecture stands in sharp contrast to politically motivated identity art. Clear moral imperatives have been exchanged for purposely conflicting messages that hold the viewer captive to situations in which any sense of moral certitude seems impossible.

Work about the Nazi and Holocaust era is part of a larger body of contemporary art that reflects today's historical amnesia and how current events have rewritten what we had assumed to be historical gospel. Francesco Bonami explored these issues in his 1998 exhibition *Unfinished History* at the Walker Art Center. In the catalogue, he astutely commented, "History is not working any longer . . . nothing really matters when Leningrad changes its name, erasing the mesmerizing power of an entire revolution, or when teenagers have no clue as to how Pol Pot changed the world. History washes away hubris and pain, sorrow and power."[5] Distance from historical events and divergent attitudes among different generations are clearly central to the changing and contentious definitions of experience and memory. These have become the subjects so many contemporary artists engage.

A BRIEF BACKGROUND

Such works from the past decade continue a dialectic that began in the early 1970s. Nearly thirty years after World War II ended, ambiguous Nazi imagery began to emerge with greater frequency, especially in fiction and film. In the early 1980s this phenomenon intensified, especially in Germany, where artists used ironic or satiric strategies to produce works with hermetic, often intentionally deceptive meanings. Anselm Kiefer's *Occupations* (1975; fig. 1) stands out for its unwillingness to resolve its implied meanings or the political position of its maker.

In this series of photographed "performances," Kiefer posed on top of various German monuments or in assorted German Romantic landscape settings performing Hitler's *Sieg heil* salute. Dwarfed in scale and distanced from the foreground, Kiefer's image in these photographs left many viewers suspicious of his intentions. The critic Gotz Adriani, for example, described the Kiefer of *Occupations* as a "ridiculously lonely, Chaplinesque figure" and his pose as "sarcastically pointing up the false pathos of the occupiers before an empty backdrop . . . shadowboxing with the past."[6]

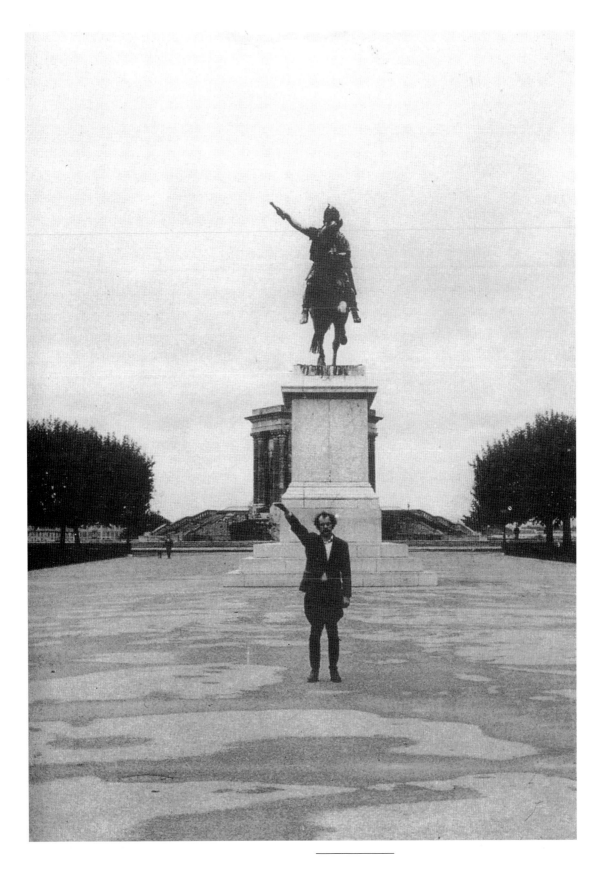

Fig. 1. Anselm Kiefer, *Occupations,* published in
Interfunktionen, Cologne, 1975, photo 9. Courtesy
of Marian Goodman Gallery, New York.

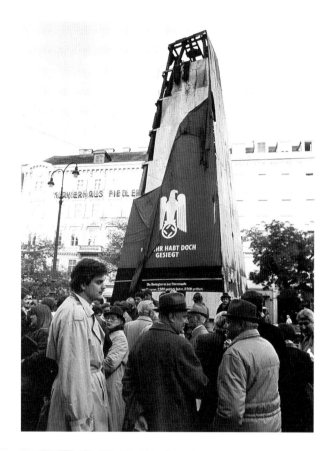

From a more self-consciously problematized position, Andreas Huyssen suggests that Kiefer was satirizing these gestures of occupation. While Huyssen rhetorically questions whether satire and irony are appropriate for dealing with this history, he demonstrates that the best of Kiefer's work derives its power precisely from the "unbearable tensions between the terror of German history and the intense longing to get beyond it."[7] Nevertheless, the ambiguity of Kiefer's art, be it his early photo works or his later monumental paintings centering on German myth and tragedy, reflects a complicated historical situation that is often glossed over by art that focuses on the victims of the Nazi era and proposes redemptive messages about the Holocaust. Questions regarding the moral integrity of Kiefer's work raise issues about collective German guilt, the historic myths that still resonate in contemporary life, and the seduction and repulsion experienced in confronting Nazi aesthetics and subject matter. Two inextricably linked questions emerge: Do we trust Kiefer, and can we trust our own responses to his work? These questions launch a trajectory of conflicting reactions applicable to the works of the artists in this volume. Kiefer's art, and work like it, tests viewers. If we choose to engage with this work, we must grapple with our own assumptions about the Nazi era and its visual legacy.

Kiefer was not the first artist whose work probed the taboo confines of Nazi or Holocaust subject matter, nor was he the only one to use transgressive modes of presentation. Until about 1990 the phenomenon remained largely German or Austrian. In works such as *Zwei Österreicher oder Geschichte bedingt Interpretation* (Two Austrians or History Determines Interpretation) (1976), the Munich-based, Austrian-born Flatz had himself photographed in poses composed and lit identically to Heinrich Hoffmann's official shots of Hitler.[8] Like Kiefer's *Occupations*, these works proved to be disturbing images for Germans. Other works, such as Hans Haacke's *Und*

ihr habt doch gesiegt (And You Were Victorious after All) (1988; fig. 2) and Jörg Immendorf's Café Deutschland series (late 1970s; fig. 3) have flirted dangerously with images from Nazi history in general or of Hitler in particular.

The discourse at the intersection of such subject matter and the Neo-Expressionist style that began to emerge internationally in the early 1980s was tense. So tense, in fact, that some works, such as Georg Baselitz's *Model for a Sculpture* (1980; fig. 4), a centerpiece for the German Pavillion at the 1980 Venice Biennal, may have been misread as an image of Hitler.[9] In light of this evolving critique, it is not all that coincidental that Moshe Gershuni's project for the 1980 Israeli Pavillion dealt with fascist/Nazi themes.[10]

Like artists in Germany and Austria, some artists in the United States have deployed similarly taboo images. Robert Morris's much debated poster of 1974 of a chain-bedecked, naked male torso sporting a Nazi helmet provoked more than aesthetic curiosity *(see page 60)*. The collision of its allusions to taboo politics, sadomasochism, and male chauvinism pushed buttons inside and outside the art world. Morris's poster became one of the cornerstones for Susan Sontag's inquiry into this ideologically complicated subject. In her essay "Fascinating Fascism," first published in 1974, Sontag expressed grave moral concern about the meanings inherent in, and audiences served by, a spate of fascist aesthetics and Nazi imagery in contemporary photography and film.[11] As with Kiefer, such representations, particularly because of their intentional political and moral ambiguity, proved troubling. Sontag and other critics condemned them, knowing full well that the possibility of constraining freedom of expression actually mirrored fascist politics. Six years later, as German Neo-Expressionism arrived on U.S. shores, certain art historians, especially those associated with the journal *October*, no longer focused on Sontag's concern about the meanings and intentions of such taboo

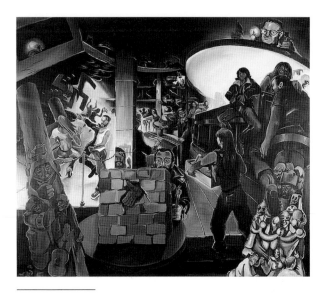

Fig. 3. Jörg Immendorf, *Café Deutschland I,* 1978. Oil on canvas, 111" x 130". Courtesy of Galerie Michael Werner, Cologne and New York.

Fig. 4. Georg Baselitz, *Model for a Sculpture,* 1980. Courtesy of Galerie Michael Werner, Cologne and New York.

Fig. 5. Christian Boltanski, two pages from the artist's book *Sans Souci,* 1991. Sixteen pages, 56 black-and-white illustrations. Courtesy of the artist and Marian Goodman Gallery, New York.

images but rather on the political implications of the expressionist style of the painting and sculpture itself.[12]

The work of Christian Boltanski and Art Spiegelman has also been interpreted as potentially exploitative. Both have become internationally renowned for their work relating to the Nazi era and the Holocaust. A half-Jew who spent the war in hiding, Boltanski has created a host of works that transform photographs of ordinary citizens into allusions to Holocaust victims. His work, like Kiefer's, has been questioned because of the multiple readings it encourages. *Sans Souci* (1991; fig. 5) is one of his more difficult works. Here he rephotographed the family album of a Nazi officer, showing the perpetrators in their seemingly harmless domestic bliss.[13] Traditionally, borders between the moral and the immoral have been carefully guarded, offering sure footing for representations of the Nazi era. Boltanski's depiction of the positive aspects of a villain's family life complicates the secure divide between good and evil that Western culture so comfortably assumes.

Spiegelman, the child of Holocaust survivors,

challenges boundaries both aesthetically and ideologically. First, he dares to tell his own father's "survivor's tale" in the seemingly banal, pop-cultural form of a comic book, using different animals to represent this true story as Orwellian allegory. But even more disturbing is the way he portrays his father. As victims, survivors are usually shown as morally unblemished. Yet Spiegelman has chosen to portray his own father as unsympathetic, cold, misogynist, and—even more paradoxically—racist (fig. 6).[14]

Boris Lurie's large-scale collages *Saturation Paintings (Buchenwald)* (1959–64; fig. 7) and *Railroad Collage* (1963) are earlier, less well-known examples of transgressive art about the Holocaust era that place the viewer at the highly uncomfortable intersection between desire and terror. Lurie appropriates the harrowing, iconic photographs taken by Margaret Bourke-White and others in the weeks following the liberation of the camps. He juxtaposes her images of the piles of victims' bodies and the emaciated survivors clinging to barbed-wire fences with prurient nude pinups. Simply put, as we look at these opposing scenes of defilement, Lurie forces us to confront our own voyeurism. The artist equates our looking at representations of victims with viewing pornography. Given Lurie's personal history, it is more difficult to condemn his artistic production than that of Kiefer, Flatz, or Morris. It is perhaps because he raises irreconcilable issues at extraordinarily high stakes that his works, unlike Kiefer's, have seldom been shown or discussed. Lurie, a radical left-wing artist who was part of the highly politicized No!art group, expresses this unpopular, even shocking view not only as a Jew, but also as a Buchenwald survivor. Therefore, he cannot be charged easily with two of the common accusations often leveled at art that deploys taboo Nazi or Holocaust imagery: dispassion with the subject or distance from the events.[15] In Lurie's case, the visual representations are so horrific that it is easier to ignore them than to engage in the many terrifying issues they bring forth. After

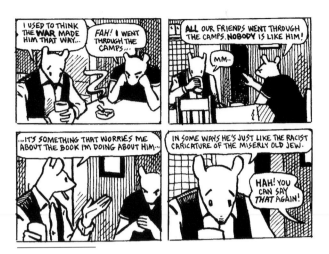

Fig. 6. From *Maus I: A Survivor's Tale,* by Art Spiegelman, page 131. Copyright ©1973, 1980, 1981, 1982, 1983, 1984, 1985, 1986 by Art Spiegelman. Reprinted by permission of Pantheon Books, a division of Random House, Inc.

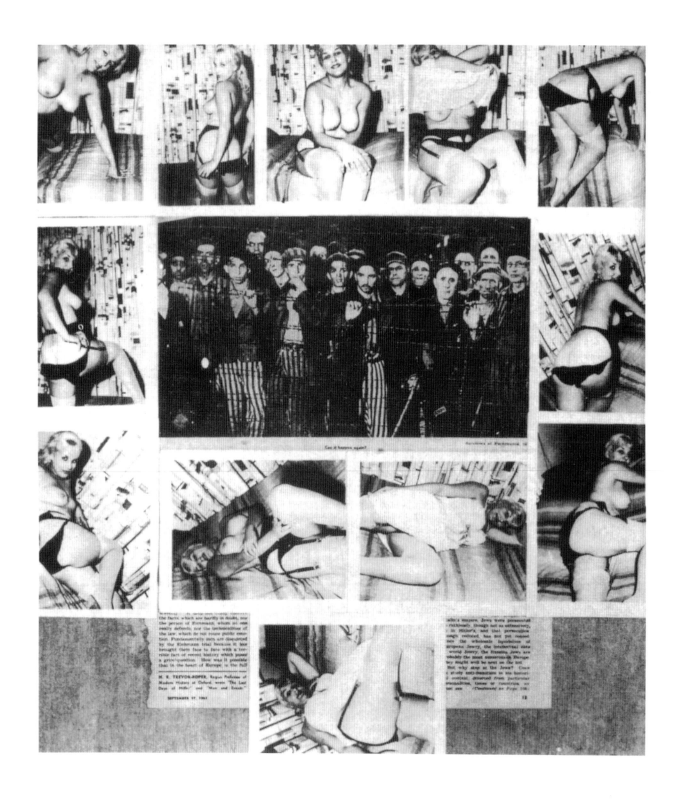

Fig. 7. Boris Lurie, *Saturation Paintings (Buchenwald)*,
1959–64. Collage with photographs and newspaper clip-
pings, 37½" x 37½". Courtesy of the artist and No!art.

nearly forty years, his collages sustain the power to shock. One would think their aesthetic and ideological edge might have mellowed after the extensive controversies that surrounded the sexually charged images by Robert Mapplethorpe and Andreas Serrano and the more recent ones related to the exhibition of Chris Ofili's *The Holy Virgin Mary (see page 89)*.

Lurie's collages crossed boundaries. But who sets these boundaries, and who dares to traverse them? Not least, who has the right to? Whatever the answer, most ideological boundaries—especially those regarding representation—have a way of dissolving with time. What has seemed shocking, transgressive, or inappropriate in one decade becomes normalized by repeated exposure and by distance, not so much from the events represented, but from the societal attitudes that prevailed at the time of their creation. Transgressive art questions assumed proprieties and often attempts to change society's standards and behaviors. Breaking one set of assumptions permits a new set of questions to be broached. But Lurie's simultaneous crossing of forbidden boundaries—ones that have to do with sexuality, voyeurism, and the Holocaust—creates an entanglement that few historians or curators have chosen to engage. Through nonengagement, however, we remain at an impasse, and serious issues proposed by this survivor are left unresolved.

David Levinthal's highly composed photographs of Nazi military spectacle and violence to Jews and women have fewer explicitly sexual connotations than Lurie's collages. Yet the sensuality of his images has been called into question for their intentionally ambiguous meaning. In this case, the usual concerns about exploitation of the live subject are evidently not at issue. However, the possible misuse of his implied subjects has been posited by both critics and other artists. As a student at Yale, Levinthal, already a collector of antique toys, played with images of Hitler. In the series Hitler Moves East (*see page 67*), he sets up battle scenes that are at once aggressive and playful. Like a number of artists discussed in this volume, Levinthal shows how toys and children's games are anything but harmless and how society reflects its values in the playthings made for juveniles.

While in Austria, Levinthal was stunned to find toys from the Nazi era, especially miniature figures of Nazi soldiers and the paraphernalia of their pageantry and violence. He uses these materials to make miniature stage sets, adding other elements to enlarge the repertoire of his narratives. Levinthal photographs them in voluptuous colors. Self-consciously exploiting the sexuality of Nazi aesthetics, he accomplishes for photography what filmmakers like Pier Paolo Pasolini in *Salo—The 120 Days of Sodom* (1975) and Liliana Cavani in *The Night Porter* (1974) have done in film. But something about the photograph as innate luxury commodity seems to provoke more discomfort than experiencing the similar, more fleeting imagery of a film. It is precisely for plumbing the oft-discussed sexuality of Nazi aesthetics that Levinthal's photographs, like numerous films, have often been attacked. Levinthal captures us in the moral quandary that philosopher and social critic Georges Bataille has called the dual impulses that sway humans: violence and desire. Following Bataille's logic, Levinthal's photographs of Nazi pageantry and racist violence drive us away by their inherent terror, yet they pull us in by an awed fascination. Bataille observes that "taboo and transgression reflect these two contradictory urges. Taboo would forbid the transgression but fascination compels it."[16]

Maurizio Cattelan's proposal in 1993 for a performance piece seems to be the work that tested what Saul Friedlander has called the "limits of representation." For the exhibition *Sonsbeek 93*, Cattelan proposed advertising a "fake" rally of skinheads in the Dutch city of Arnhem. His highly intellectual and conceptual intention raised many issues at the nexus between the real and the counterfeit and between

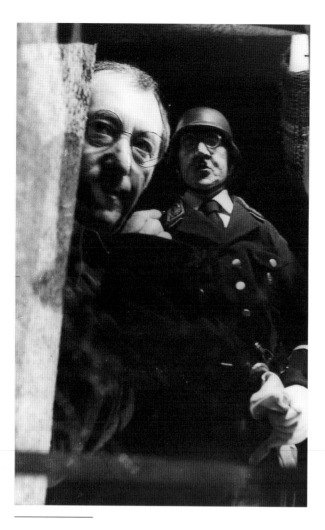

Fig. 8. From the film *Hitler, A Film from Germany*, 1977, directed by Hans-Jürgen Syberberg. Courtesy of Syberberg Filmproduktion, Munich.

art and morality. It also extended one of the most pressing issues for modern and contemporary art: the connection between art and life. In proposing his "rally," Cattelan wanted the public to realize how this very negative social element remains, nevertheless, a serious product of modern society's failings. He was attempting to examine the primitive emotion of fear, but somehow expected that such advertisements might not actually result in a rally. He observes how the "skin[head] introjects [*sic*] his existential negativity" and feeds his "emptiness with the nightmares of recent history." The highly controversial and indeed suspicious nature of Cattelan's proposal poses pivotal questions for art and for society. Through what the artist feels to be an ultimate betrayal of his fellow beings, he (like Barbara Ehrenreich) asks us to use such "representations" to "search to understand, understand to grow up to be more civilized."[17] And Cattelan demonstrates that art can expand understanding intuitively, but cautions us that it cannot provide answers.

Realizing the potential danger this proposal may have posed for the population of Arnhem, curator Valerie Smith boldly opposed the plan. In the communication between artist and curator lies the notion, perhaps even her hope, that Cattelan's project was meant to be left as a concept. However, its conceptual daring, and the potentially tragic results it may have wrought, force us to confront not just what the limits of representation might be, but also what the limits may be today for increasingly adventuresome artworks.[18] The issue was the social responsibility of artists, but also the dangerous confusion between the real and the represented.

All of the artists mentioned have all dared to flaunt controversy. Some, like Lurie, have suffered critically and commercially for their positions. Others, like Kiefer, have succeeded in part because of the ambiguous narrative disruption of their work. James E. Young has effectively considered some of the ideological problems presented by recent work

about the Holocaust. He shows how many issues are raised by those who make the works and by those who dare to look at or write about them. These works are often criticized as evasive and self-indulgent.[19] However, condemnations of representations are often posed across the same generational divide that rocked the African-American community discussed at the start of this essay. In these cases, distance from World War II and the Holocaust seems to increase the artist's experiment with transgressive representations or strategies. However, the distance does not necessarily make viewers more tolerant of its challenges.

Although he does not write about visual art per se, Saul Friedlander has dealt with problematic Nazi imagery more extensively and for longer than many. In the early 1980s, he coined the term "new aesthetic discourse on Nazism" to investigate fiction and film using Nazi images and the ambiguous strategies that surround them. For example, Friedlander trains his lens on George Steiner's novel *The Portage to San Cristóbal of A. H.* (1981) and examines Hans-Jürgen Syberberg's highly nuanced, brilliant, and provocative *Hitler, A Film from Germany* (1977; fig. 8). Friedlander lays out the moral and aesthetic problems such imagery poses. On one hand, he is concerned that transgressive images and ironic stances may simply revoke all meaning. On the other, he understands that the postmodern probing of the limits of representation may ultimately extend a fuller grasp of the dilemmas intrinsic in this onerous subject. He realizes that "Nazism represents an obsession for the contemporary imagination" and ponders whether attention given to its imagery functions as "a gratuitous review, the attraction of the spectacle, exorcism, or the result of a need to understand." And he worries whether the seduction of Nazi imagery operates as "an expression of profound fears . . . and mute yearnings as well."[20]

THIS PROJECT, THESE ARTISTS

This volume and the exhibition it accompanies concentrate on the work of thirteen artists who use Nazi imagery—the ultimate signifier of evil—to mirror moral and ethical issues that resonate in contemporary society. Each artist puts the viewer in the uncomfortable terrain between good and evil, seduction and repulsion. If we dare engage in their discomfiting art, we are forced to confront the very process of moral and ethical decision making. Using a variety of media and aesthetic strategies, they catalyze a process of self-doubt that, in many cases, is just short of chilling. They surround viewers with the unmentionable, bring them close to synecdoches for evil, then leave them to ponder the inexorable complexity of ethics.

Such self-conscious and morally ambiguous work appropriating Nazi imagery has become an unmistakably international presence in the art of the last decade. In fact, the first two issues of the popular German monthly *Spiegel Reporter* for the year 2000 included major articles about artists whose work images and imagines Nazis. The January 2000 issue highlighted Tom Sachs, a Jewish artist living in New York, whose recent work has tested the limits of representation in the face of what he considers a sacralization of the Holocaust.[21] In February, the focus was on Piotr Uklański's exhibition and book titled, all too simply, *The Nazis*.[22] Uklański is a Polish-born, Christian-raised artist who divides his time between New York and Warsaw.

As this goes to press, the installation of Jake and Dinos Chapman's newest work, titled *Hell*, is proving controversial in the British press (fig. 9). Their monumental swastika-shaped model appears to be a concentration camp gone haywire. Hard to imagine, they have reversed perpetrators and victims in confusing and confounding ways. One part of this *Gesamtkunstwerk* shows Nazi bodies as they tumble into a mass grave usually associated with Jewish victims. No

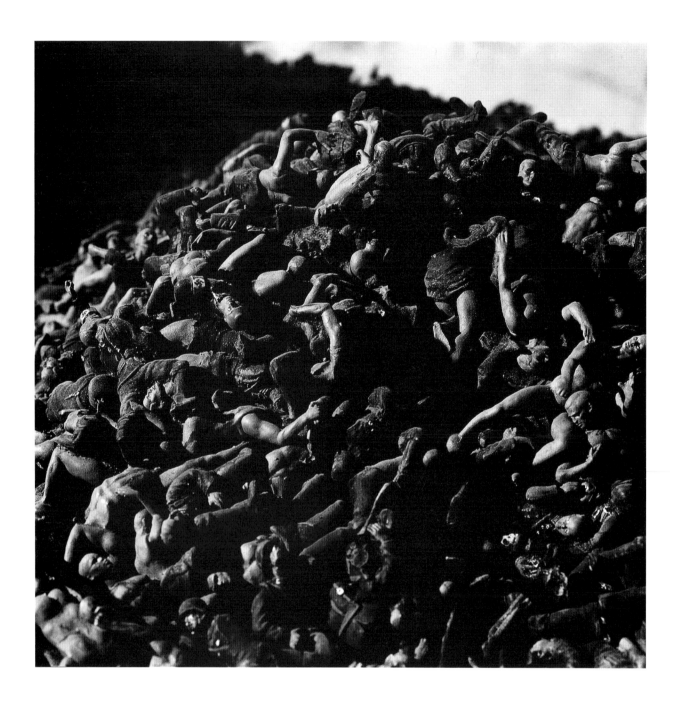

Fig. 9. Dinos and Jake Chapman, *Hell* (installation shot
from the Royal Academy exhibition *Apocalypse*), 2000.
Courtesy of the artists and The Saatchi Gallery, London.
Photograph by Norbert Schoener.

wonder the inclusion of this work in the Royal Academy's show *Apocalypse* has been criticized for attempting to shatter Holocaust taboos.

With its lens on the depiction of perpetrators and its appearance in the aesthetic "white cube" of the art gallery, such photo-based appropriation differs considerably from the reverential art that Andreas Huyssen has called "an often facile Holocaust victimology."[23] "Holocaust art" has become increasingly prevalent during the past two decades and tends to be shown in exhibitions and programs that teach straightforward moral lessons, attempting to heal the wounds of the remaining survivors and to keep memory of the tragedy alive. References to and interpretations of its victim-oriented imagery remain mostly historical. The artists included in this exhibition, and others working in a similar vein, approach the subject in a radically different way. Their divergent concentrations on victim and perpetrator and their differing positions on moral rectitude and moral ambiguity illustrate Holocaust historian Sidra DeKoven Ezrahi's "fundamental distinction between a static and a dynamic appropriation of history and its moral and social legacies."[24]

The artists in this exhibition are offspring of both victims and perpetrators and come from a variety of national, ethnic, and religious backgrounds. All have shown their work internationally during the 1990s. They practice in Austria, France, Germany, Israel, Poland, the United Kingdom, and the United States and have exhibited these works in Düsseldorf, Paris, Amsterdam, Berlin, Munich, Essen, London, Jerusalem, Tel Aviv, Lisbon, and New York. A substantial number of these presentations were surrounded by controversy. As a group, these provocative works use Nazi-era images to probe issues at the center of prevailing cultural and aesthetic discourses, among them desire, commodification, and spectatorship. Virtually all of them capitalize on the way art and, by extension, visual culture at large confuses the represented and the

real. As their focus shifts from victim to perpetrator, they follow the complex issues about memory recently outlined by Thomas Lacquer. As a cultural historian, Lacquer asks us "to concentrate on the task of representing temporal contingencies rather than spatial absolutes, on the history of political and moral failures, for example, that produced the Holocaust rather than the memory of its horrors."[25] The artists in the exhibition place us precisely in the former position, asking us to look at cause rather than effect. Aside from their use of images of Nazis and Nazi-era aesthetics, the unifying premise for the works is how they force us onto morally ambiguous terrain. Such theoretical positions and aesthetic strategies cogently reflect Geoffrey Hartman's assertion that it is incongruous for contemporary society to reverently teach about past atrocities while observing present ones tolerantly, at a distance.[26]

NOTES

1. Barbara Ehrenreich, in *Male Fantasies,* vol. 1 (Minneapolis: University of Minnesota Press, 1987–89), x.

2. George Steiner, *The Portage to San Cristóbal of A. H.* (Chicago: University of Chicago Press, 1979).

3. Ronald Jones, "Crimson Herring," *Artforum* 36, no. 10 (Summer 1998): 17–18. See also Lorraine O'Grady, "Poison Ivy," *Artforum* 37, no. 2 (October 1998): 8. The full title of the conference was "Change the Joke and Slip the Yoke: A Series of Conversations on the Use of Black Stereotypes in Contemporary Visual Practice."

4. For an insightful analysis of the power of art to fuel controversy, see Wendy Steiner, *The Scandal of Pleasure: Art in the Age of Fundamentalism* (Chicago: University of Chicago Press, 1995).

5. Francesco Bonami, *Unfinished History* (Minneapolis: Walker Art Center, 1998), 15–16.

6. Gotz Adriani, "Every Present Has Its Past," in *The Books of Anselm Kiefer* (New York: Braziller, 1991), 10–20.

7. Andreas Huyssen, *Twilight Memories: Marking Time in a Culture of Amnesia* (New York and London: Routledge, 1995), 215, 228.

8. Cornelia Gockel, *Zeige deine Wunde: Faschismusrezeption in der deutschen Gegenwartskunst* (Munich: Verlag Silke Schreiber, 1998), 80.

9. Georg Bussman, "Hackenkreuze in deutschen Wald: Faschistisches als Thema der Neuen Malerei," in *Inszenierung der Macht: Ästhetisch Fazination im Faschismus* (Berlin: Neue Gesellschaft für Bildende Kunst, Nishen, 1987). See also Lisa Saltzman's discussion of this misreading in her *Anselm Kiefer and Art after Auschwitz* (Cambridge and New York: Cambridge University Press, 1999), 109.

10. See Roee Rosen, "The Visibility and Invisibility of Trauma: On Traces of the Holocaust in the Work of Moshe Gershuni and Israeli Art," *Jerusalem Review* 2 (1998): 98–118.

11. Susan Sontag, "Fascinating Fascism," in *Under the Sign of Saturn* (New York: Farrar, Straus & Giroux, 1980), 73–105.

12. Benjamin Buchloh, "Figures of Authority, Ciphers of Regression: Notes on the Return of Representation in European Painting," *October* 16 (Spring 1981): 39–68.

13. For a discussion of Christian Boltanski's *Sans Souci* (1991), see Ernst van Alphen, *Caught by History: Holocaust Effects in Contemporary Art, Literature, and Theory* (Stanford, Calif.: Stanford University Press, 1997).

14. James E. Young, "Art Spiegelman's *Maus* and the After-Images of History," in *At Memory's Edge: After-Images of the Holocaust in Contemporary Art and Architecture* (New Haven: Yale University Press, 2000), 12–41.

15. Georg Bussman, "JEW-ART," in *NO!art: Pin-ups, Excrement, Protest, Jew-Art* (Berlin: Neue Gesellschaft für Bildende Kunst, 1995), 61–65. I thank Susan Chevlowe for sharing her copy of this article, translated by Kurt Germundson. I also greatly benefited from her own presentation, "Boris Lurie: Self-Representation in the Wake of the Holocaust" at the "NO!art" conference at the University of Iowa, Iowa City, in February 1999.

16. Georges Bataille, *Eroticism,* trans. Mary Dalwood (London: J. Calder, 1962), 58.

17. Jan Brand, Catelijne de Muynck, and Valerie Smith, eds., *Sonsbeek* 93 (Ghent: Snoeck-Ducaju & Zoon, 1993), 34–35.

18. Ibid.

19. James E. Young, "Germany's Holocaust Memorial Problem—And Mine," in *At Memory's Edge,* 184–223.

20. Saul Friedlander, *Reflections of Nazism: An Essay on Kitsch and Death,* trans. Thomas Weyr (Bloomington and Indianapolis: Indiana University Press, 1984), 19; see also 11–22. See also Friedlander, *Memory, History, and the Extermination of the Jews in Europe* (Bloomington and Indianapolis: Indiana University Press, 1993), 49–52, as well as Friedlander, ed., *Probing the Limits of Representation: Nazism and the "Final Solution"* (Cambridge: Harvard University Press, 1992), 1–21.

21. Jonathan Rosen, "The Trivialization of Tragedy," *Culturefront* (Winter 1997): 80–85. See also Thomas Hüetlin, "Angst und Schreken und Chanel," *Spiegel Reporter* 1 (January 2000): 117–25.

22. Piotr Uklański, *The Nazis,* exh. cat., The Photographers' Gallery, London, 1998 (Zurich: Scalo/Edition Patrick Frey, 1999).

23. Andreas Huyssen, "Monument and Memory in a Postmodern Age," in James E. Young, ed., *The Art of Memory: Holocaust Memorials in History,* exh. cat., The Jewish Museum, New York, 1994 (New York: Prestel, 1994), 13.

24. Sidra DeKoven Ezrahi, "Representing Auschwitz," *History and Memory* 7, no. 2 (Winter 1996): 122.

25. Thomas W. Lacquer, "Introduction," *Representations,* no. 69 (Winter 2000): 8.

26. Geoffrey Hartman, "Public Memory and Its Discontents," in *Holocaust Remembrance: The Shapes of Memory* (Oxford, England, and Cambridge, Mass.: Blackwell Publishers, 1994), 24–29.

Acts of Impersonation

Barbaric Spaces as Theater

SIDRA DEKOVEN EZRAHI

"About Hitler, I have nothing to say."

Karl Kraus, 1933[1]

Mirroring Evil: Nazi Imagery/Recent Art, **may be the most daring** exhibition ever mounted by The Jewish Museum— not only because, like so much modern abstract art, the images that appear on its walls and floors are neither immediately intelligible nor eminently beautiful, and not only because of the transgressive— and defiling—nature of these pieces, but

because the curatorial framework is not immediately self-evident and determining it is an interactive process. The personal engagement demanded of the spectator may be greater than in any other exhibit on themes related to World War II and the Holocaust. There will be as many responses as there will be visitors to this exhibition, but one thing should be shared by everyone who passes through these portals: a destabilized sense of the discontinuity of the worlds addressed—of the radical disjuncture between a world we designate as normal (if infinitely vulnerable) and the space of the barbaric.

The degree of trespass involved in creating and exhibiting this work is a kind of visual validation of Theodor W. Adorno's much (mis)quoted dictum about the lyrical imagination, that "to write poetry after Auschwitz is barbaric."[2] "Barbaric" has a number of connotations, the most common being acts beyond the human realm that are, therefore, monstrous in nature. But in its original Greek form, the term signified anyone outside the speech community, the community of selves. I mean here to invoke both dimensions of barbarism, as subject and as artistic principle: Nazism as perverse national ideology and genocidal system and transgressive acts of representation that take place beyond consensual boundaries—acts that in fact test and challenge the parameters of collective identification. The works of art in *Mirroring Evil* interrogate boundaries that designate consensus, as both racial and aesthetic categories.

BISOCIATION

Our immediate physical sense of discomfort or outrage in the presence of this art, that nervous laugh or shudder, betrays an instinctive understanding that every installation has been chosen for what Arthur Koestler calls its "bisociated context," the simultaneity of incompatible worlds, the safe and quotidian with the barbaric and monstrous.[3] We do not, however, stand securely on this side gazing over an abyss at the other; the assumed identification with the victimizer undermines any sharp demarcation between that side and this. As we encounter each of the works in this exhibition, it may not even be immediately clear how—or where—the precipice has been reached, since contemporary culture provides the material for representation of the past, and the continuities may appear at first more salient than the discontinuities; paradoxically but inevitably, these artifacts confuse by self-consciously mirroring aspects of material culture that we thought had been "safely" contained in the barbaric space of the discarded past. If the spectator feels the burden of having to redraw the lines of demarcation, it is by recognizing how fluid they are, given the insidiousness, seductiveness, and immanence of the forces that gave rise to Nazism. In the work of Roee Rosen, Zbigniew Libera, and Alain Séchas, childhood as an innocent "nature preserve" has been violated in—and illuminated by—the "toys" or portraits of children tainted by association with Hitler, Hitler Youth, Nazi insignia, and concentration camps. Civil society as the marketplace of ideas and commodities has been defiled by—and challenged in—the presence of Nazi cultural artifacts or fascist aesthetics in the works by Tom Sachs, Alan Schechner, and Maciej Toporowicz. Hollywood as laboratory of the democratic imagination—an extension of the sculptor's and the photographer's studio that captures the faces of the times—has been subverted in the portraits appropriated by Rudolf Herz and Piotr Uklański and the sculpture commissioned by Christine Borland; Borland's invitation to her fellow artists to sculpt the face of Mengele is matched by Roee Rosen's "summons" to the viewer to enter the mind of Eva Braun. There is, then, we begin to realize, a subtle collusion between the artist appropriating the object or person associated with these heinous crimes, and us, the visitors, who begin by alienated

role-playing and then discover, to our horror, that some of the features in these portraits are all too familiar.[4]

Some moral imperative is being camouflaged behind acts of projection that are riskier than anything we are normally asked to perform in coming to terms with Nazism or the Holocaust. But what is that moral imperative? To be revulsed, outraged, at any signs of the recidivism of Nazi barbarism? To be unequivocal and self-distancing in our condemnation? Or perhaps to see the humanity of those barbarians and to perceive the incipient Nazi in all of us? The moral imperative is as elusive and shifting as the boundaries that were meant to protect consensus, and its ongoing redefinition is a function of a dynamic, courageous self-examination and self-exposure.

Still, we rebel against the burden of such interpretive responsibility, against the absence of a clear, protective division between the worlds represented. Unlike the film *La Vita è Bella* (Life Is Beautiful), where there is an unambiguous demarcation between the foregrounded enchanted world of the father and son and the background world of evil and death in concentration camps, here they appear utterly intertwined. What is common to most of this art is a form of appropriation that is always in danger of becoming, or being confused with, collaboration.

IMPERSONATION AS BOUNDARY-CROSSING

The last boundary to be crossed in the evolution of a postwar moral discourse was that which kept the Nazi beyond the pale of human imagination. *Mirroring Evil* suggests that it is through acts of impersonation that this boundary is finally crossed—and demonstrates the price of such crossings. As spectators, we know that when we walk out of the exhibition we can shed the costumes and gestures and

retrieve our (safe) lives, our distance from these monstrous figures, but only after having subjected ourselves to the danger of imagining ourselves among the perpetrators. There will be many who will prefer not to engage in such a self-indicting activity and will either avoid the exhibition or leave it in disgust. Those who choose to stay the course are participating with the artists themselves in a transformative event, the imagination of oneself as metamorphically "other."[5]

This essay argues that what is at stake here is not so much the representation of Nazism or the Holocaust, as the various languages through which societies recreated in the shadow of Auschwitz formulate their post-Holocaust legacies. That process, whose most transgressive visual expressions we encounter here, actually spans nearly thirty years of literature and theater in America, Europe, and Israel. If the visual media come somewhat belatedly to this engagement, the lag may be in part attributable to the salience of the visual in Nazi aesthetics and the taboo that extended to all iconographic representations of Nazism in the postwar period. That this taboo has been attenuated is part of the internal dialogue taking place within each culture, as we shall see below. The artists participating in this exhibition are all working at a distance of nearly fifty years and one or two generations from the events themselves. At the center of their work are acts of impersonation that enter the contemporary ethical debates on very specific terms: they are predicated on an acknowledged distance from the character or event impersonated, and on an interchangeability of historical roles that both separates and conflates victim and perpetrator.

It is relatively easy to follow the imaginative projections of the self as victim on the part of those at one or more removes from the events. To be a victim is morally safe even if it is mortally dangerous. And one can move easily, imperceptibly almost, from empathy to impersonation. Over the years there

have been a number of intriguing instances of impersonation of the victim by non-Jewish European writers—the most scandalous of which is Binjamin Wilkomirski's so-called memoir, *Fragments*. Critical opinion over what turned out to be an invented memoir of infancy and young childhood in Riga and then in Majdanek and other camps in Poland has been divided between those who condemn the impostor and his act and those who embrace what they consider to be the remarkable literary achievement of a deranged mind. Only by pathologizing Wilkomirski do readers spare him the opprobrium of fraud.[6]

The Wilkomirski case illustrates the potential overlap between impersonation and imposture. In ordinary usage, "impersonation" can connote either a fraudulent assumption of identity or the appropriation of the identity of an other for heuristic purposes. At the collective level, both impersonation and imposture may function as touchstones of changing social dialogue.[7] Impersonation, as we are exploring it here, is a voluntary act undertaken as performance, as ritual of identification. The crucial distinction between "imagination" and "identification," which will be blurred as we proceed into the hidden depths of this exhibition, will struggle to maintain its tenuous hold. As Richard Wollheim argues, to say "I imagine myself being Sultan Mahomet II," who directed the siege of Constantinople in the fifteenth century, is not to posit identification. "Imagining myself being Sultan Mahomet II" is not the same thing as "imagining Sultan Mahomet II being me."[8]

One of the more powerfully explicit and self-conscious acts of identification with the Holocaust victim through impersonation is Jaroslaw M. Rymkiewicz's *The Final Station: Umschlagplatz*. In this narrative, part fiction, part documentary, the non-Jewish Polish narrator reinvents his own childhood in wartime Warsaw and indulges in a gesture of solidarity with the boy from the Warsaw Ghetto by mimicking his iconic act of submission, lifting his own hands in the air to relieve the boy's desperate loneliness.[9] The theatricality of such retrospective acts of conscience and expiation, particularly for German, Polish, and French writers and artists, consists in revisiting the very place we live, now perceived as "the site of one of the greatest crimes in history"—and enacting a redemptive scenario.[10]

THE SHLEMIEL:
BUTTONS, HATS, AND MUSTACHES

Impersonating the perpetrator is a far more complex undertaking, as this exhibition demonstrates. But in its earliest manifestations, it was performed in a state of innocence or grace not unlike that enjoyed by the victims and their impersonators. The first well-known example of a public boundary-crossing through Jewish impersonation of the Nazi was Charlie Chaplin's *The Great Dictator* (1940).[11] Shooting of the film began just after that other shooting had begun, after the German invasion of Poland and the declaration of war by England and France. Although Chaplin himself said, much later, that had he known of the atrocities of the concentration camps, he could never have made the same film,[12] the masquerade at the heart of this film is a significant chapter in the history of representation and empowered future filmmakers ranging from Mel Brooks to Woody Allen to Roberto Benigni.

One of the events that may have inspired Chaplin to undertake this film relates to photography's ambiguous role in establishing identity in the twentieth century. Sergei Eisenstein's associate Ivor Montagu, hoping to induce Chaplin to produce an anti-Nazi film, sent him a copy of a Nazi photo album of Jews entitled, *Juden Sehen Dich an* (Jews Are Looking at You), which included a photo of Chaplin with the caption: "the little Jewish tumbler, as disgusting as he is boring."[13] That photo album

Figs. 1 and 2. Charlie Chaplin in the film *The Great Dictator,* 1940. © Roy Export Company Establishment.

can be viewed as the prototype to which the photographic installations of both Piotr Uklański *(The Nazis)* and Rudolf Herz *(Zugzwang)* are postwar parodic responses.

There are three levels of impersonation in *The Great Dictator* analogous to the projections demanded of the visitor to *Mirroring Evil*: Chaplin impersonating the Jewish barber (explicitly taking on the identity that he equivocally embraced throughout his life); Chaplin impersonating the "Furor" Adenoid Hynkel, dictator of Tomania (figs. 1, 2, 3), delivering a garbled Teutonic diatribe *("frei sprachen stunk")* and performing a ballet of world-historical leaps and bounds before his country's banner, the Double Cross, to the strains of Wagner's prelude to *Lohengrin*; and, finally, Chaplin imperson-

Fig. 3. *The Tramp as Storm Trooper,* illustrated in David Robinson's *Chaplin: His Life and Art,* 1994.

ating the barber impersonating Hynkel. But the final act of impersonation remains incomplete. In this, Charlie Chaplin's first talking motion picture, the third impersonator "loses voice." The circumstances that catapulted the Jewish barber onto the grandstand allow him to become, in Chaplin's words, the "clown" turned "prophet."[14] In place of Hynkel's incendiary speech, the barber's language of decency, pacifism, and voluntary disempowerment based on a utopian social vision prevails; the address with which the film ends is an unabashedly wishful dictate to the dictator:

> "I'm sorry but I don't want to be an emperor, that's not my business. I don't want to rule or conquer anyone. I should like to help everyone—if possible—Jew, Gentile, black man, white. We all want to help one another—human beings are like that. We want to live by each other's happiness, not by each other's misery. We don't want to hate and despise one another. In this world there is room for everyone. . . . The inventions of the airplane and the radio have brought us closer together. The very nature of these inventions cries out for the goodness in men, for universal brotherhood, for the unity of us all." [Then, pan to the Barber's beloved Hannah in the fields, recovering from her beating at the hands of Nazis.] "Wherever you are, look up, Hannah! . . . The clouds are lifting—the sun is breaking through, we are coming out of the darkness into a new world—where men will rise above their hate, their greed, and their brutality. . . ."

Speaking truth to power, Chaplin-as-Jew spoke to an as yet unwritten chapter of history, even to Hitler himself,[15] as America was bracing for war and the British were in the midst of the Blitz (*The Great Dictator* opened in London on 16 December 1940). What has appeared to some as naïve utopianism or knee-jerk communism on Chaplin's part, or as shameless romanticism from the master of cinematic illusion, is hardly credible. Having witnessed the atrocities of World War I and the Spanish Civil War, Chaplin should rather be seen here as invoking a strategy employed by some of his predecessors in the art of the comic: the appeal to a vision of radical innocence at a moment when the scales of history are about to tip.

That innocence remains a primary resource for any regenerating postwar culture; for us, however, in reference to World War II and the Nazis, it involves a self-conscious act of denial. Every similar act of impersonation on our part, such as Benigni's masquerading as an Aryan in a local school or his "translation" of an SS officer's speech (fig. 4)—or, for that matter, his address to his wife over the loudspeaker in the concentration camp—is both a quotation from *The Great Dictator* and a counterhistorical, counterfactual reference to an edenic vision and a universal ethic that can be apprehended only against the backdrop of historical devastation, suffering, and evil—the tainted birthright of every survivor of the twentieth century.

For those pawns of history who do not seem to be addressing themselves so directly and dramatically to history's tyrants, what might be the objectives and the effects of such (tentative) border crossings? They serve, in the first instance, as an exposé of conventional norms on the part of society's outcasts and strategies of self-empowerment for its helpless victims. Mikhail Bakhtin explores a rich history of border-crossings through self-masking in western narrative and performative traditions.[16] Within the precincts of Jewish humor, such masquerades belong to an engagement with Jewish powerlessness that accepts inherent divisions between Jews and non-Jews and constructs a circumscribed moral space for the Jew based on those divisions. They derive their poetic license from the "Purim spirit" of inversion, in which, for a day each year, saints and villains become interchangeable through an exchange of clothing and other theatrical gestures. These mas-

Fig. 4. Roberto Benigni impersonating a fascist officer in the film *Life Is Beautiful*, 1998. © Mirimax Films.

querades inform what we now associate with a distinctly Jewish expression of the comic based on both self-mockery and self-congratulation; its master practitioner was the Yiddish fiction writer, Sholem Aleichem (1859–1916).

Sholem Shachnah is the central character—not exactly a "protagonist," hardly a figure who plots or cuts his way into the world—in Sholem Aleichem's story *Iber a hitl* (On Account of a Hat). He has just completed a modest business transaction and is waiting for a train to take him from Zolodievka to his hometown of Kasrilevke, where most of Sholem Aleichem's shtetl Jews live. He sits down next to a man asleep on the bench—in a "uniform full of buttons [and a] military cap with a red band and a

visor." He designates the uniformed man "Buttons" and weaves his identity out of whole cloth:

> "He could have been an officer or a police official," thinks Sholem Shachnah. "It's not such a bad life to be a Gentile, and an official one at that, with buttons . . . Nowadays you never can tell whom you're sitting next to. If he's no more than a plain inspector, that's still all right. But what if he turns out to be a district inspector? Or a provincial commander? Or even higher than that? And supposing this is even Purishkevitch himself, the famous anti-Semite (may his name perish)?"

Before he can elevate Buttons to the status of the arch enemy of Israel—Haman or Amalek—Sholem Shachnah falls asleep. Awakened some time later by Yeremei the porter, he inadvertently takes Buttons's hat and runs to catch his train. Treated deferentially by all the officials in the station and on the train, he is in a state of utter confusion until he catches sight of his image in a mirror in the first-class carriage to which he has been ushered:

> He sees not himself but the official with the red band. That's who it is! "All my bad dreams on Yeremei's head and on his hands and feet, that lug! Twenty times I tell him to wake me and I even give him a tip, and what does he do, that dumb ox, may he catch cholera in his face, but wake the official instead! And me he leaves asleep on the bench! Tough luck, Sholem Shachnah old boy, but this year you'll spend Passover in Zolodievka, not at home."[17]

What is reflected back to Sholem Shachnah from the "real world" is his image as his own nemesis. Even when the successful sartorial exchange seems to point to the superficiality of such demarcations, the boundaries remain clear; Yeremei must have awakened the wrong man. *If I am other, I cannot be myself.*

Granted, what has been introduced into the psychic space of self-representation is the imagination of otherness. But the shlemiel, in the form of Chaplin's barber or Sholem Aleichem's petty merchant, becomes only a tyrant-for-a-day, never sharing the victimizer's mysterious power, appropriating the regalia of brutality only for the purpose of showing his radical alienation from that power and encountering none of the moral dilemmas of identifying with it. "Mirroring evil" in these fictions is a clear case of mistaken identity.

This form of masquerade is relatively innocuous and fairly continuous with comic Yiddish self-representations in the pre-Holocaust era. The characters are in a state of mortal danger but remain morally safe. In the second half of the twentieth century, some of the most charming, and "redemptive," of post-Holocaust counternarratives—such as *Life Is Beautiful* or *Train de Vie* (Train of Life)[18]—are founded on similarly provisional acts of impersonating the enemy, allowing for the same comic spirit to preside even in the face of imminent death.

At the same time, other acts of impersonation based on disguise, imposture and deception are "dead" serious and contain none of the charm of the innocent masquerade. Although they may include elements of the grotesque or black humor, they provide us with a transition to the more radical forms of appropriation represented in this exhibition. One of the best examples is Agnieszka Holland's film *Europa, Europa* (1990), in which Shlomo Perel, a young and very beautiful Jewish male, succeeds in passing himself off as Aryan and is adopted as a kind of mascot by a series of German military units and Nazi institutions. Standing in for countless children who lost their identity while saving their lives by hiding as their own nemesis, the "impersonated" self will become an agonizingly inextricable part of their reconstructed postwar identity.[19]

NAZISM DEMYTHOLOGIZED: THE HAT FITS

From the antics of the temporarily empowered shlemiel and the blood-curdling self-disguise of the victim, there is a short but significant distance to acts of imagination premised on an assumption of power, on a sense of empowerment in the world sufficient to envision oneself as a potential abuser of power. Impersonation in this context becomes one of the most dramatic gestures in a counterhistorical narrative that denies immunity to any individual or collective. The rest of this discussion will focus on works of art that demythologize Nazism by de-demonizing the Nazi—the final step toward reconstructing a post-Enlightenment humanism after World War II.

In *Explaining Hitler,* Ron Rosenbaum argues that "the shapes we project onto the inky Rorschach of Hitler's psyche are often cultural *self*-portraits in the negative. What we talk about when we talk about Hitler is also who we are and who we are not."[20] The works I am about to consider, which constitute the atmospherics for the present exhibition, explore the psyche of the Nazi the way (mutatis mutandis!) we explore the brain of Einstein: to detect not only its unique folds and turns, which set the genius apart from the rest of humanity, but also its familiar, phylogenic patterns.

This process evolved as a series of public encounters. Its first and most natural venue was the film industry. Hollywood's Nazis were, as Piotr Uklański's photographs show, initially poster boys for the war effort. In both the fictional (1948) and cinematic (1958) versions of Irwin Shaw's *The Young Lions,* the Nazi Christian Diestl (portrayed by Marlon Brando in Uklański's rogue's gallery) is typical of the Manichean approach to the Nazi—the inviolate stereotype of evil as otherness. The act of impersonation takes place here not within the drama, where all empathy lies clearly with the American soldiers, but for the

actors themselves in the masquerade and the limited degree of internal accountability that it seems to invite. The role of the actor who impersonates the Nazi in films such as *The Young Lions* is akin to the first stage encounter of the spectator with *Mirroring Evil*: one feels drawn but still internally immune to the summons to enter the Nazi psyche. But what is natural for an actor whose professional identity is constructed of acts of impersonation, what is natural for Brando as Christian Diestl, or for Chaplin when as an actor he is playing the role of the dictator Hynkel, is qualitatively different from what the "barber" does when he assumes the identity of Hynkel/Hitler (however tentative he may be in that role)—or for that matter, from what as spectators we are asked to do as we go further into this looking glass.

For many years after the war, the deeper levels of self-exposure were unthinkable in the public sphere. But while historical research and testimonial projects began to make the victims visible, a series of trials, beginning with those at Nuremberg, were the "performative" context that eventually made the Nazi available to more radical acts of imaginative projection. Largely informed by Hannah Arendt's interpretation of the Eichmann trial—culminating in her controversial book, *Eichmann in Jerusalem: The Banality of Evil*—demonization gave way to a measure of "humanization" of the Nazi in American culture. From poems like Denise Levertov's "During the Eichmann Trial" ("He stands/ isolate in a bulletproof witness-stand of glass,/ a cage, where we may view ourselves") through novels and dramas like Robert Shaw's *The Man in the Glass Booth* (1967), in which a presumed Nazi is actually a Jew masquerading as a Nazi masquerading as a Jew, the cumulative effect has been both to deflate the menace of a demonic force and to project this entire history into a universal, and therefore accessible, moral space.[21] It has engendered political and cultural theories throughout a world that defines itself by the legacies of

World War II, but it has affected no communities more powerfully than those in Germany and Israel.

GERMANS AND JEWS

As he waited in front of the new invention,
Danton said, "The verb *to guillotine*
(this brand-new verb of ours) is limited
in the tenses and persons of its conjugation:
for example, I shall not have a chance to say
I was guillotined."

Acute and poignant, that sentence, but naive.
Here am I (and I'm nobody special),
I was beheaded
I was hanged
I was burned
I was shot
I was massacred.
I was forgotten
(But why give an opening to Satan?—
he might still recall
that, morally at least,
for the time being, I've won.)

Dan Pagis, *"An Opening to Satan"*[22]

To be a victim is to acquiesce in—while lamenting— the judgment of history, or the "privilege" of theodicy. Morally, at least for the time being, I've won. The literary representations of the Holocaust are manifold, but the ethical discourse particular to Germans and Jews is shaped by a dialectic in which the boundaries between victims and victimizers have been quite clear and inviolate. To reach some place where the dialectical other becomes immanent as well as irreducible, Germans and Israelis had to go through two preliminary stages, both entailing acts of impersonation. In the first stage, Nazism is manifested either as diabolical, mythological evil or as a form of madness that infects everyone it touches. In

the second, the universe is reduced to primordial archetypes and patterns of repetition in which the only alternative roles, "Nazi" and "Jew," are available to both actors. Each of these stages maintains the radical innocence of the Jew or of the Jew-impersonator, and the radical evil of the Nazi, or of the Nazi-impersonator. It is only in the most recent versions of this struggle that go beyond acts of impersonation to a recognition of the deepest seeds of creation and destruction, of the passions that can breed any form of human behavior, that this dialectic may have been superseded. A brief consideration of the German context may help to illuminate its counterpart in Israeli culture.

The danger of residual effects and concern for controlling cultural mechanisms are at the center of the artistic appropriations, and critical evaluations, of images of Nazism in the 1960s and 1970s, especially in Germany. Impersonation as "possession," a form of madness in which postwar identity is constructed as a kind of obsessive mimicry, can be found in Romain Gary's French novel, *Dance of Genghis Cohn* (1967; BBC television film version, 1992), where a Nazi officer is haunted by the ghost of a Jewish comedian he shot in a mass execution,[23] and in Anselm Kiefer's Occupations series (*Besetzungen,* 1969) *(see page 5),* in which the German painter assumes *Sieg-heil* poses at a number of public and private sites throughout Europe. Kiefer, whose exploration of the mythological forces in the German psyche provides the artistic license or inspiration for many of the artists in the present exhibition, allowed Hitler and his paraphernalia to invade the domestic spaces of a regenerating postwar Germany. Similarly, his rendering of the female figures from Paul Celan's "Todesfuge" in the Margarete/Shulamith series is a visual representation of the eternal embrace/stranglehold of Germans and Jews.

In violating the taboo on "any cultural iconography even remotely reminiscent of those barbaric years," the very "self-abstention" that Andreas

Huyssens argues was "at the heart of Germany's post-war reemergence as a relatively stable democratic culture in a Western mode," Kiefer and other German artists who have revivified the mythic in the visual media are attempting to demonstrate that "irony and satire" are "really the appropriate mode for dealing with fascist terror."[24] They seem confident these images will not escape the controlled context of satire or parody and dissipate into the ether with their own poison intact. The danger that parody will be misconstrued as collusion or—to use the Freudian vocabulary often invoked in this context—that what is meant to be the "working through" of trauma becomes, instead, a form of "acting out" or "repetition compulsion," is part of a long debate.[25]

For a German like Kiefer or Hans-Jürgen Syberberg or Rainer Werner Fassbinder to impersonate, imagine, or invoke the Führer or any of his henchmen, whether or not their daring rituals of "occupation" or "possession" succeed as exorcism, highlights the haunting continuities that persist in Germany after *Stunde Null*—the zero hour of a new calendar, beginning in 1945, that was meant to allow Germans to "start over."[26] For a Jew to engage in such an act can be even more far-reaching because it is, in a sense, gratuitous. The Israeli exploration of this territory dramatically demonstrates how images of Nazism test the boundaries of a "safe" encounter with the past.

For many years the Nazi had remained invisible in Hebrew culture either through effacement or demonization, as in poet Uri Zvi Greenberg's reference to a separate species called "Ha-German" (the German) or in novelist K. Tzetnik's (Yehiel Dinur's) reference, in his testimony at the Eichmann trial, to Auschwitz as the "Other Planet." In both cases, the Nazi inhabited a never-revisited barbaric space. Nevertheless, a slow process of engagement ensued, beginning with the exploration of the landscape of insanity and continuing with more self-indicting questions of collective agency and the discarded notions of the

(diasporic) self. Direct acts of impersonation that deprived the (Israeli) Jew of the shield of moral immunity would transform the ethical vocabulary.

It was Yoram Kaniuk's *Adam ben kelev* (Adam Resurrected) that first directly challenged the categorical separation between Nazis and their victims. The setting of this novel is an asylum in Arad, in the Negev desert ("Mrs. Seizling's Institute for Rehabilitation and Therapy"), to which a group of survivors has been committed. The reenactment of the effects of Nazism as psychic "possession" are reminiscent of the work of Kiefer and Gary, but with particular resonances for postwar Israeli society. This narrative invokes the space vacated by the Nazis at the liberation as the space of madness, both in the abiding pathology of those who survived the atrocities and in the place beyond the pale to which these misfits are relegated by principles of social engineering, by the intolerance of an emerging Israeli society for any forms of deviant memory that could undermine the utopian categories of the new order. At the center of this novel is a Purim party in which the inmates masquerade as the monsters they have internalized—as Ilse Koch, Rudolf Hess, Heinrich Himmler, Reinhard Heydrich. One of the main characters in the novel, Adam Stein, engineers the Purim pageant from the recesses of his psychotic state. The voice of Commandant Klein, the Nazi officer who saved Adam's life by forcing him to assume the posture of a dog, continues to speak in the echo chamber of his victim's mind: "You understand Adam, that you are me, because I am you, both of us dogs but I have a whip and you don't." Rehabilitation and therapy recede like the desert landscape; Adam shrieks: "There is here. Here is there," and turns to his fellow inmate:

"Wolfovitz, who are you? . . . Raise your hand, roll up your sleeve. Look, what's written there?" Wolfovitz reads slowly, "8 . . . 1 . . . 9 . . . 8 . . . 7."
"Well, then, who are you?"

Wolfovitz: "Yes, I am not Wolfovitz. I never was and never will be. I am 81987."

An orgiastic frenzy ensues, culminating when the tattooed arms of the masked inmates freeze in a massive "heil Hitler" salute.[27] In such a world, Jews are experientially linked to their oppressors in a danse macabre, a series of interlocking mirrors, from which neither can be fully extricated.

Kaniuk's novel drew little critical notice when it first appeared in 1969. But by 1981, when it was adapted for the stage and presented as *Mesibat Purim* (The Purim Party),[28] it entered into a culture that was coming to be self-defined not only as post-Holocaust but, more importantly for the issues of power and powerlessness at the core of this exhibition, "post-Zionist." The term as I am invoking it refers to the Israeli engagement in a critical self-examination of the sources of Jewish power that are commensurable with power wielded by other human communities, and therefore subject to the same standards. The impersonation is not the exchange of clothes for an hour or a day, but the assumption of the uniforms of power in the construction of a new polity. The moral division between victim and victimizer is acknowledged, but no longer assigns an "unassailable" place to the Jew as victim. What we are about to consider are among the bravest acts that any Israeli artists have undertaken, or that any Jewish audience or reader has been called upon to endorse:

No no: they definitely were
human beings: uniforms, boots.
How to explain? They were created
in the image.

I was a shade.
A different creator made me.

And he in his mercy left nothing of me
 that would die.

And I fled to him, floated up weightless, blue,
forgiving—I would even say: apologizing—
smoke to omnipotent smoke
that has no face or image.

Dan Pagis, *"Testimony"*[29]

What is radical in this highly textured poem is the recognition that Nazi and Jew are both historical particulars *and* tropes of power and powerlessness. And the more responsible are the powerful ones, those with a presence in the world, an image (tse-lem), the ability to make and break worlds. Imagining the Jew and his persecutor not as part of a theodicy with Jewish martyrdom at its heart, but as part of the ongoing tale of fratricide and free will, Dan Pagis, himself a survivor of Nazi labor camps, presents the sons of Adam as interchangeable players in a paradigmatic human drama; Cain and Abel are at the center of a lifelong meditation on the artifacts and archetypes of genocide. Pagis's poems created a Hebrew space for the imagination of the Jewish exercise—and abuse—of power, not in its explicit political or social manifestations, but in its most naked acknowledgment of the human condition as one of inevitable inequality. The one with power has image and the ability to sacrifice; the one without is smoke, eternally sacrificed.

While for a writer like Kaniuk, Nazism is a pathology that sends its venom coursing through the veins of victims as well as perpetrators, for Pagis, the Nazi exemplifies the unbridled exercise of will. Both sensibilities will shape the poetics of the "second generation" encounter of Jews with Nazis, of Israelis with Germans, a generation whose Holocaust scars are a legacy but not a direct experience. Distance is built into the encounter, the freedom to imagine counterpoised against the force of memory. As a palette of colors but not forms, the past is claimed as the artist's omnipresent yet unstable resource. The canvas is the post-utopian society of post-1967 Israel.

ISRAELIS AND ARABS

In the twenty-five years preceding the turn of the millennium, a series of fictions and theatrical performances brought German-Jewish and Arab-Israeli enmity into a kind of dialogue in Israeli culture.[30] In the political arena beginning in the late 1970s, archetypal language of victimization was invoked among hard-line nationalists and religious fundamentalists, identifying the Arab enemy as descendant of Amalek or Haman or—Hitler.[31] At the same time, and partly in response to such fatalistic notions of collective destiny and responsibility, a group of artists began exploring parallel structures, working within the same conceptual framework.[32] The universal propensity for evil is acknowledged, but there is something stronger: the inexorable stranglehold of Nazi and Jew, of Margarete and Shulamith, that, in its reverse logic, automatically renders any Jew who is not a victim a victimizer. Acts of impersonation based on this logic reflect inherited patterns of relating to self and other but engage in a significant leap of imagination: unlike Sholem Shachnah, the Israeli Jew not only behaves or looks like but actually imagines himself as the oppressor. The fascination with what Marx called "names, battle cries, and costumes" becomes more than a Purim masquerade; terrifyingly, the hat fits. If I am no longer in mortal danger, I am in deep moral danger.

Following the 1982 Israeli invasion of Lebanon, which was a watershed in popular perceptions of the mandate of Israel's defense forces, several plays were produced in which Israeli Jews assumed postures iconically suggestive of the images of Nazis circulating in the mass media. Samuel Hasfari's play, *Tashmad* (Nineteen Eighty-Four), whose title carries the same apocalyptic overtones in the Hebrew original as in the English, focuses on the messianic fantasies of a group of Jews living in a settlement on the West Bank. The Jewish inhabitants, who are about to be expelled by the Israeli army as part of the implemen-

tation of a peace agreement, take on the symbolic gestures of Nazism, a swastika and a "heil Hitler" salute. In Hanokh Levin's *Ha-patriot* (The Patriot) (1982), which the playwright defines as a "satirical cabaret," the Arab boy Mahmud assumes the capitulatory pose of the Warsaw Ghetto child in the photograph that has become an icon of Jewish martyrdom and Nazi bestiality. Lahav, the Israeli soldier in Levin's play, addresses his own mother while aiming his revolver at Mahmud's head:

> He will avenge your blood and the blood of our murdered family, as then, mother, when your little brother stood alone in front of the German at night, in the field, and the German aimed his revolver at his head, and your little brother, trembling with fear, said [and he sings as he aims the revolver at Mahmud]:
>
> *Don't shoot*
> *I have a mother*
> *She is waiting for me at home.*
> *I haven't eaten yet.*
> *Dinner.*
> *Don't kill me.*
> *I am a child.*
> *I am a human being like you.*
> *What did I do?*
> *What difference would it make to you*
> *If I yet lived?*[33]

BEYOND THE DIALECTICS OF MEMORY

Impersonation as a reversal of roles in which the Arab plays the Jew and the Nazi-infected survivor his oppressor culminated in the context of the Intifada. As the political event that transformed the Palestinians from a powerless collective into a strategically empowered nation, the Intifada evoked in Israel brazen acts of projection that began to move beyond the mechanistic Nazi-Jew dialectic represented by

Levin and Hasfari into something far more nuanced and philosophically challenging. Foremost among these was the Acco Theater production, *Arbeit Macht Frei,* directed by Dudi Ma'ayan (1991–94). The title, that inscription seared into the Jewish soul like the numbers on Jewish flesh, also points to another form of *Arbeit*: the *Trauerarbeit* or work of mourning that Jews, like Germans, are—or are not—engaged in and how such "work" affects the moral challenges in the present. The performance lasted five hours, incorporating a visit to the Holocaust museum at Kibbutz Lohamei Ha-getta'ot, a meal, conversations between actors and audience, a musical cabaret, and elaborate stage effects. The four actors who carried the whole production represent the entire spectrum of Israeli identity: Ashkenazi and Mizrahi Jews and a Palestinian from northern Israel. The role of the Palestinian, Haled (Haled Abu 'Ali), encompassed the two "repressed others" in Israeli society: as both "tour guide" explaining the model of Treblinka to visitors at the museum, and as the hired-hand of the main character, Selma (Semadar Ya'aron-Ma'ayan), he is the reincarnation of the *Arab* as *Galut Jew*.[34] In the penultimate scene of the play, after having been humiliated and mistreated at the hands of his employer, herself a survivor of Hitler's worst atrocities, he is seen dancing naked on the "torture table" that was earlier identified as an artifact from Treblinka, beating himself and inviting the spectators to beat him (which, in some performances, they did). The last tableau reveals Selma and Haled in a naked *pietà,* the Israeli answer to Kiefer's Margarete and Shulamith.[35]

There is an explicit suggestion in *Arbeit,* as in *The Patriot,* that the theatrics of identification is also a strategy for purging the Jewish victims and their progeny of the most traumatic modes of encounter— theater as ritual revenge through mimicry. Once again, as in the German context, the danger of "slippage" is always there, the danger that "working through" will yield to "acting out," the danger that

the seduction or fascination or *frisson* of fascism will prevail, leading to a kind of collusion that is mimicry not as catharsis but as imitation of the behavior of the oppressor. Unlike *The Patriot,* however, which bends over backwards to redress the moral imbalance of a Jewish claim to immunity to the excesses of power, *Arbeit* explores, in nonlinear and nondialectical ways that anticipate much of the work in this exhibition, the moral and aesthetic complexities that could break the chain of traumatic repetitions.

The incendiary innuendoes of Israeli "mimicry" of German nationalism continued to be explored in various forms throughout the 1980s and 1990s, most provocatively in the trilogy of plays on the Vilna Ghetto by Joshua Sobol. But the portraits of both Nazis and Jews continue to take on more nuanced tones. Produced in Haifa in 1984, the first of Sobol's trilogy, *Ghetto* (figs. 5, 6), would generate a complex external as well as internal dialogue in Israel and in Germany. The SS officer in the play, Kittel, appears also in another role, that of a scholar of Hebrew culture whose task is to preserve the "remnants" of Jewish civilization for the museum collection of the Third Reich ("Dr. Alfred Rosenberg's Bureau for the Investigation of Judaism without Jews").[36] Kittel engages in a dialogue (in Yiddish!) with Hermann Kruk, a Jewish socialist and the librarian of the Ghetto, exploring the relative virtues of Zionism, Bundism, and other forms of Jewish utopianism. The dialogue between Nazi and Jew, victimizer and victim, also becomes a debate over power and powerlessness, over territorial nationalist vs. diasporic culturalist self-definitions, over various forms of active resistance vs. the *galut* values of cunning and accommodation. The German is humanized by a subtle exploration of sympathetic as well as sadistic traits, his love of music and theater as well as his fanatic dedication to the execution of his nefarious office. And as the Nazi becomes available within the empathetic space of dramatic imagination, the moral complexity of choices faced by the Judenrat, that

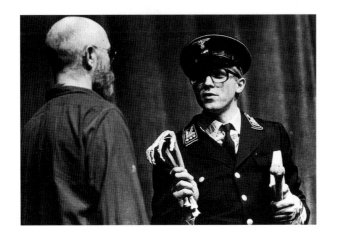 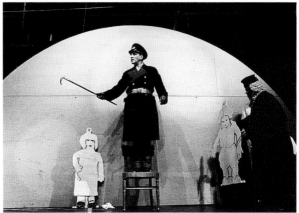

Figs. 5 and 6. From *Ghetto: Schauspiel in drei Akten,* 1984, directed by Joshua Sobol. Courtesy of Deutsches Theatermuseum, Munich. Photographs by Klaus Broszat.

twilight zone of Jewish power in the dark night of powerlessness—a subject only gingerly touched upon heretofore in Holocaust representations—is starkly explored through the figure of Gens, Chief of the Ghetto, and his council.

Ghetto is a self-conscious drama with a theatrical production as its centerpiece and acts of impersonation and imposture as its structural elements. In his introduction to the printed version of the play, Uri Rapp describes Sobol's vision of theater as the epitome of the human community: "Oppressors and oppressed, murderers and martyrs, Germans and Jews, are inextricably bound together, by hatred, by contempt, by fear, by unwilling admiration—puppets on strings from somewhere outside the stage, the puppet master unseen and inscrutable."[37] Does this make both Germans and Jews *pawns*—or *agents*—of history? The question is explored on both stages. When the casts of *Ghetto* and *Arbeit Macht Frei* traveled to Germany, where they were enthusiastically embraced, the implicit dialogue between today's Germans and Israelis became explicit in a joint performative context.[38]

LNIY (THE LITTLE NAZI IN YOU)

That dialogue continues as a more internal explo-
ration on the repercussions of transgressive leaps of
imagination in David Grossman's *Ayen erekh: 'ahava'*
(See Under: LOVE, 1986). Here the encounter of Jew
and Nazi is a counterhistorical fantasy emanating
from the mind of Shlomo, an Israeli writer who grew
up in Jerusalem in the 1950s as a child of survivors.
Its iconoclastic power lies not only in imagining the
Nazi, and imagining oneself as Nazi, but also in
reclaiming discarded diasporic forms of Jewish self-
empowerment through storytelling. The four sections
of the novel are grounded in four different literary
conceits; in the section entitled "Wasserman," the
eponymous character, Anshel Wasserman, has mirac-
ulously (and piteously) survived the gas chamber
and all subsequent attempts to deliver him to his
"rightful" death. When it is discovered that this
recalcitrant Jew is none other than a great writer of
children's stories, the commandant of the camp,
Obersturmbannführer Neigel, makes a pact with him,
promising to try to put him out of his misery in
exchange for a story. This continues day after day:
Wasserman finishes another episode of his saga, "The
Children of the Heart," and Herr Neigel shoots him.
But the Jew, the most mortal—and combustible—
material of the Third Reich, becomes immortal,
reverting in a way to his mythological position in the
Christian imagination as the eternal lost soul, while
the Nazi is humanized and particularized.

Here, as in *Arbeit* and *Ghetto,* the existential
struggle goes beyond the Nazi/Jew dialogue to posit
the human psyche as the place that can be as easily
invaded by the poison of acquiescence to fascist
doctrine as by the milk of human kindness and
respect. Shlomo, the narrator of the story, engages
in a prodigious act of impersonation that breathes
life into Herr Neigel: "In the White Room [where
Shlomo writes and confronts the ghosts from "Over
There"], everything comes out of your own self, out

of your own guts, victim and murderer, compassion
and cruelty."[39] But there are moments when his Ger-
man character tries to assert too much humanity and
such moments are enlisted in an ongoing meditation
on the character's "autonomy" vis-à-vis his creator.
Struggling over the degrees of control he can or
must exercise in the creation of his Nazi character,
Shlomo reflects on what comes to be referred to
acronymically as the "little Nazi in you (LNIY)":

> That night, on a narrow bed in a rented room in a
> strange city, a dream was dreamed. Neigel was
> dreamed in the guise of a certain person. Neigel's
> children were also in the dream, and were encoun-
> tered without enmity. They were even deemed
> 'sweet.' They were cared for gently and with devo-
> tion by Neigel (who was a certain person). In the
> aftermath of the dream, the dreamer awakened
> with the following thought: A certain person has
> been dreamed of as a Nazi, and all this evoked was
> a mild depression, which soon lifted, having noth-
> ing much to hang on to. The strange thought
> occurred that they always say the little Nazi in you
> (henceforth LNIY) with reference to the wrong
> things, the obvious things like bestial cruelty, for
> instance, or racism of one sort or another, and
> xenophobia, and murderousness. But these are only
> the superficial symptoms of the disease . . . The
> real problem, the disease, lies much deeper. And it
> may be incurable.[40]

Diagnosing the "disease" and agonizing over
degrees of contamination and control are inherent to
this enterprise in all its forms. Transgression does
not involve an abandoning of the idea of limits; as
we have already seen, the danger that the invention
will exceed the grasp of the inventor, or that while
the character of the Nazi may become more human
than his creator intended, the bacillus of Nazism
may escape into the open air, is never far from the
artist's mind. But there is an implicit disclaimer

here, which *Mirroring Evil* is meant to highlight: whether the unseen forces are imagined as puppeteers or deadly bacteria, and their creations Frankensteins, Golems, or diseased organisms, the challenge to free will and historical agency is what is at stake. The medicalization or pathologization of both the creative and the critical discourse endangers the ethical concerns it is meant to address.[41]

IMAGINING HITLER[42]

There remains an important distinction in all the works under consideration between the appropriation of a kind of "generic" Nazi, the banal bureaucrat now become available to our imagination, and the two masterminds of the "Final Solution" who are singled out for the most daring projections: Mengele and Hitler. Both are represented in this exhibition, and both have received literary and dramatic treatments that either maintain a clear divide between human and demonic (as in Rolf Hochhuth's *The Deputy* or Franklin J. Schaffner's *The Boys from Brazil*) or invest them with an eminently human voice—and defense. George Steiner's *Portage to San Cristóbal of A. H.*[43] is one of the most controversial examples of the latter and illuminates the cultural frames that mirror evil.

As perhaps the ultimate act of trespass of the late twentieth century, George Steiner's is a novel-turned-play whose central conceit is the myth that Adolf Hitler never actually committed suicide (see Roee Rosen's ambiguous rendering of the "double" suicide), but managed to escape to South America.[44] In this fantasy, he (designated as A. H.) is eventually captured by an international espionage team in the jungle and, because of his frailty and age, tried on the spot. The appearance of the novel caused something of a stir—especially given Steiner's heretofore critical advocacy of a kind of restraint on the unbridled use of language in representing the

Holocaust. But it was the novel's dramatic adaptation, giving body and voice to Hitler, that caused an uproar. What some have argued is Steiner's own polemic with Zionism, ventriloquized through Hitler's voice as the Führer's defense, bears resemblance in many ways to the agonized debates on power and powerlessness in Sobol's plays and the Acco Theater's production of *Arbeit Macht Frei*. The differences are, however, more instructive than the similarities. And they relate primarily to the performative context, the primary audience to which this work is addressed. Like Kiefer in Germany, Sobol and the Acco Theater in Israel are part of a lacerating collective self-examination. *Ghetto* and *Arbeit* in Germany, like Celan and Kiefer's Margarete/Shulamith in Israel, enter the space of the polemic other. To the extent that the artistic works and performative events we are discussing are evidence of a collective dialogue with the legacy of the past, Steiner's drama was not really part of such a conversation; his voice remains a phantom of some unidentifiable "we".

At the beginning of *Ghetto*, the walls of the Tel Aviv apartment where the survivor-narrator lives collapse to make way for the Vilna Ghetto. But Tel Aviv remains the primary reference and bisociative corrective for the ghetto. If, as Ron Rosenbaum writes, in Steiner's *Portage* "a character named A. H. escapes from its famous literary creator,"[45] it may be because the jungle in which the capture of A. H. takes place is a no-place; the creator's laboratory has no walls. Hitler's defense, the last speech in the play, is not only left unanswered; it is cast not in a social or moral engagement with the temptations of Nazism or even with the incarnation of absolute evil but, as Rosenbaum so convincingly shows, as an ontological engagement with Judaism. It remains unbridled, uncontrolled by irony or bisociation, free to escape and free as reproach not of LNIY but of LJIY, the Little Jew in You, whose very existence is a cosmic flaw.

In that regard the work of Roee Rosen, *Live and Die as Eva Braun*, which bears close resemblance to

Steiner's *Portage* in other respects, stays just within the collective bounds that allow for a roundtrip ticket to barbaric spaces. The first gatekeeper is linguistic. The looking glass through which the spectator is invited to pass involves, at the verbal level in the original Hebrew, a sex-change operation (invisible in the nongender-marked second-person pronouns of the English translation): "lakoah yakar: . . . ata mit-bonen ba-re'i, rokhen kadima, u-demutkha mitgale le-eynekha be-fa'am ha-rishona. Ata blondinit, . . . shadekha [shadayikh?] shof'im" ["Dear Customer: . . . You [m.] look in the mirror, leaning forward, and your own image is revealed to you for the first time. You [m.] are blond [f.] your [m. or f.] bosom ample"].[46] After that the spectator is summoned into the psyche of Hitler's lover, sharing her experience of Hitler's bodily fluids and the moment that he grabs her to murder her. The final scenes trace the residue of her afterlife consciousness through purgatorial space to land in a wax museum, where the moment of her death is enacted ad perpetuum. The use of Rosen's own baby pictures along with the facial features and hand gestures of Hitler is both a quotation of the famous baby pictures of "the Führer"[47] and a complex commentary on innocence and human potential projected backward.

When shown at the Israel Museum in Jerusalem, Rosen's exhibition created a great furor *(sic)*, as one would expect. The cacophony of the debate that ensued is disciplined only by its borders—the acoustics of shouting voices in the Judean desert. But such a context, as amorphous as it might seem, makes all the difference.[48] The visitor should bear that in mind, even when invited into the psyche of Eva Braun without the protection of that space. The walls of The Jewish Museum provide another, complementary, context: the boundaries of a "Jewish" conversation as (tentative) control for all visitors, Jews and non-Jews, to *Mirroring Evil*.

There are those who will, no doubt, claim that the images of Nazis on the walls and the floors of The Jewish Museum are expressions of self-hatred on the part of the artists participating in the exhibition and the curators who selected their work. Sander Gilman argues that "self-hatred arises when the mirages of stereotypes are confused with realities within the world, when the desire for acceptance forces the acknowledgment of one's difference. . . . One cannot escape one's ethnic, religious, or class identity. One cannot escape these labels because of the privileged group's myth that these categories are immutable."[49] The portrait of the shlemiel in Jewish literature is seen by Gilman as having originated in the internalization of German stereotypes of Jews on the part of Enlightenment Jewish writers and thinkers who were trying to assimilate into the surrounding culture. Whether or not one would agree that the shlemiel is a product of Jewish self-hatred and mimicry, its counterpart, the self-representation of the Jew as oppressor, must herald the very opposite. It is too facile, then, to label the impersonation of the Nazi in Israeli culture as an act of self-hatred. The appropriation by a "privileged group" of a universally despised image of otherness would, rather, be a sign of enormous self-affirmation and confidence in the claim of one's own group to a responsible (response-*able*) stake in the world, of a determination to undermine the myth that these categories are "immutable," that anyone is immune to the abuses of power and the temptations of claims to racial superiority.

THE SIXTH ACT

Finally, the act of impersonation must give way to the impulse out of which it was created. The barber, mistaken for the "Furor" by Hynkel's own soldiers, slips out of that character and back into his own when he alights the podium and addresses the mass rally in words against tyranny and oppression—creating a desideratum that, for all of us who view it in the tragedy of hindsight, is the scenario of a history that should have been. The theatricality of our dis-

tance from these events allows us to reclaim our
sane postwar lives:

> For me the tragedy's most important act
> is the sixth:
> the raising of the dead from the stage's
> battlegrounds,
> the straightening of wigs and fancy gowns,
> removing knives from stricken breasts,
> taking nooses from lifeless necks,
> lining up among the living
> to face the audience. . . .
>
> The bows in pairs—
> rage extends its arm to meekness,
> the victim's eyes smile at the torturer,
> the rebel indulgently walks beside the tyrant. . . .
>
> But the curtain's fall is the most uplifting part,
> the things you see before it hits the floor:
> here one hand quickly reaches for a flower,
> there another hand picks up a fallen sword.
> Only then one last, unseen, hand
> does its duty
> and grabs me by the throat.
>
> From *"Theatre Impressions,"* by Wisława Szymborska[50]

Mirroring Evil, like a theater production, ends with
the merciful return of the quotidian. As an invisible
curtain descends, we can imagine the artist putting
down her tools, the model shedding the parapherna-
lia of the Third Reich for his ordinary street clothes.
And we, the audience, straighten a skirt here, a tie
there, and prepare to exit. But as we are about to
leave, perhaps—just perhaps—an invisible hand
grips our throat and we realize that something of
these acts of impersonation will continue to haunt
us even into the sunshine of a world after Auschwitz.

NOTES

1. Karl Kraus, *Die Dritte Walpurgisnacht* (Munich: Kosel-
Verlag, 1952), 9.

2. Theodor W. Adorno, "Cultural Criticism and Society," in
Prisms, trans. Samuel and Shierry Weber (London: Nevills
Spearman, 1967), 34. Adorno himself revisited this sentence
many times, and asserted both his ongoing discomfort with
the consolation that the (poetic) imagination can provide
and his conviction in its value as an essential expression of
human suffering: "It is now virtually in art alone that suffer-
ing can still find its own voice, consolation, without immedi-
ately being betrayed by it." Ernst Bloch, Georg Lukács,
Bertolt Brecht, Walter Benjamin, and Theodor Adorno, *Aes-
thetics and Politics,* ed. and trans. Ronald Taylor (London:
NLB, 1977), 188.

3. Arthur Koestler develops the idea of "bisociated con-
texts" as the condition for comedy, a subject reflected in the
discussions of the comic spirit by Henri Bergson and others.
Koestler, "Comedy," in *Insight and Outlook: An Inquiry into
the Common Foundations of Science, Art and Social Ethics*
(New York: Macmillan, 1949), 37.

4. See, on this, Kendall L. Walton's distinction between
"work worlds" and "game worlds" as the distinction between
the fictional world *within* a work of art and the ways in which
the spectator or reader "plays," "makes believe," vis-à-vis the
work. The one "authorizes" the plausible parameters of the
other but should not be confused with it. *Mimesis as Make-
Believe: On the Foundations of the Representational Arts*
(Cambridge: Harvard University Press, 1990), 58–69.

5. Postmodern ethics based on a concept of relation to
otherness rather than on object relations between essential
beings, as articulated by Emmanuel Levinas, Jacques Derrida,
Edith Wyschogrod, and others informs this discussion, even if
most of the acts of impersonation we are focusing on are
premised on a more mechanical presumption of an inimical
otherness. "The challenge of encountering the other is to
withstand his/her irreducible difference and yet at the same
time to recognize this difference as human, as being locat-
able in a humanity we can see as 'common.'" Steve Copeland,
private communication with the author, August 14, 2000.

6. There is already a vast literature on this subject. For
overviews of the book, its author, and its reception, see
Philip Gourevitch, "The Memory Thief," *The New Yorker,* June
14, 1999, 48–68; Elena Lappin, "The Man with Two Heads,"
Granta, no. 66, 9–65; and the work of Stefan Mächler. For a
consideration of the issues it raises with regard to the
authenticity and narrative avenues of memory, see Susan
Suleiman, "Problems of Memory in Recent Holocaust Memoirs:
Wilkomirski/Wiesel," in *Poetics Today* 21, no. 3 (Fall 2000).
Suleiman reviews all the generic questions raised by the dis-
covery of the fabricated nature of this "memoir," and rather

than relegating it, as many have done, to the dustbin of "fiction," she suggests labeling *Fragments* a "false—or better, a deluded—memoir." Ibid.

The discourse on madness and the Holocaust goes back at least as far as Bruno Bettelheim's essays in the early 1940s, when he identified structural similarities between concentration camp behavior and schizophrenia. We shall see below how this discourse informs the Israeli encounter with the disturbing presence of survivors who cannot be "rehabilitated." Wilkomirski represents the sinister implications of such a discourse. He seems to be saying that the only sufficient "objective correlative" for his psychosis is the Holocaust: "If I am so crazy, I must have been spawned in Majdanek . . ." See also the more recent controversy over the "false fiction" of Wolfgang Koeppen.

7. See Natalie Zemon Davis, *The Return of Martin Guerre* (Cambridge: Harvard University Press, 1983), and *Remaking Impostors: From Martin Guerre to Sommersby,* Hayes Robinson Lecture, 1997 (Egham, Surrey: Royal Holloway, University of London, 1997).

8. Richard Wollheim, *The Thread of Life* (Cambridge: Harvard University Press, 1984), 75. Quoted in Walton, *Mimesis as Make-Believe,* 33. See also Wollheim, "Imagination and Identification," in *On Art and the Mind* (Cambridge: Harvard University Press, 1974).

9. Jaroslaw M. Rymkiewicz, *The Final Station: Umschlagplatz,* trans. Nina Taylor (New York: Farrar, Straus & Giroux, 1994).

10. The quote is from Albert Camus's *The Fall,* trans. Justin O'Brien (New York: Knopf, 1957), 11. See Shoshana Felman's discussion of Camus in Shoshana Felman and Dori Laub, *Testimony: Crises of Witnessing in Literature, Psychoanalysis and History* (New York: Routledge, 1991). For another self-conscious fictional impersonation or appropriation of the victim, see Henri Raczymow, *Writing the Book of Esther,* trans. Dori Katz (New York: Holmes & Meier, 1995). For analysis of this theater of expiation, see Eric Santner, *Stranded Objects: Mourning, Memory and Film in Postwar Germany* (Ithaca, N.Y.: Cornell University Press, 1990); Ezrahi, "Representing Auschwitz," in *History and Memory* 7, no. 2 (Winter 1996): 121–54; and Froma Zeitlin, "The Vicarious Witness: Belated Memory and Authorial Presence in Recent Holocaust Literature," *History and Memory* 10, no. 2 (Fall 1998): 5–42.

11. One of Chaplin's predecessors was John Heartfield, who, in the 1930s, created grotesque photomontages of Hitler.

12. "I could not have made fun of the homicidal insanity of the Nazis," Chaplin writes in his autobiography. Quoted in David Robinson, *Chaplin: His Life and Art* (London: Collins, 1985), 485.

13. Kenneth S. Lynn, *Charlie Chaplin and His Times* (New York: Simon & Schuster, 1997), 395. The resemblance between Chaplin and Hitler, centering on the mustache, has

been a focus of considerable curiosity and representation.

14. Quoted in Robinson, *Chaplin: His Life and Art,* 503.

15. There is a report that Hitler watched the film. On this, and also on the question of Chaplin's "Jewish" origins, see John McCabe, *Charlie Chaplin* (London: Ronson Books, 1978), 189–200.

16. For Bakhtin, the clown, the fool, and the rogue are the precursors of the novelist in exposing social conventions. Their masks "grant the right not to understand, the right to confuse, to tease, to hyperbolize life; . . . the right to not be taken literally, not 'to be oneself'; the right to live a life in . . . the chronotope of theatrical space, the right to act life as a comedy and to treat others as actors, the right to rip off masks . . . and finally, the right to betray to the public a personal life, down to its most private and prurient little secrets." *The Dialogic Imagination: Four Essays,* ed. Michael Holquist, trans. Caryl Emerson and Michael Holquist (Austin: University of Texas Press, 1981), 163.

17. "On Account of a Hat," trans. Isaac Rosenfeld, in *The Best of Sholom Aleichem,* ed. Irving Howe and Ruth R. Wisse (Washington, D.C.: New Republic Books, 1979), 107–11.

18. *Train de Vie,* French-Romanian film directed by Radu Mihaileanu, 1998.

19. In *Europa, Europa,* the line between impersonation and imposture is again blurred, with grave psychological consequences. In this case, the camouflage is systemic and underscores the cultural dimensions of visibility: The boy's act of delusion is matched by the self-delusion of the perpetrators; even when they use their "scientific measurements," the Nazis simply don't "see" the Jew in front of them, so intent are they on having him as a perfect specimen of Aryan beauty. See also the bizarre case of Kurt Gerstein, a German who insinuated his way into the SS with the intent of sabotaging the organization from within. Saul Friedlander, *Counterfeit Nazi: The Ambiguity of Good* (L'ambiguité du bien), trans. Charles Fullman (London: Weidenfeld & Nicolson, 1969); Rolf Hochhuth, *The Deputy,* trans. Richard and Clara Winston (New York: Grove, 1964).

20. Ron Rosenbaum, *Explaining Hitler: The Search for the Origins of His Evil* (New York: Random House, 1998), xxv. As we shall see below, imagining Hitler *himself* remains the ultimate form of trespass, and very few take that leap.

21. Denise Levertov, "During the Eichmann Trial," in *The Jacob's Ladder* (New York: New Directions, 1961), 63. Robert Shaw, *The Man in the Glass Booth* (New York: Harcourt, Brace & World, 1967). See Mark Cory, who argues that when the officer played by Maximilian Schell in the film version of *The Man in the Glass Booth* turns out not to be Lagerkommandant SS Col. Dorf but the survivor Arthur Goldman, "the giveaway is his humor, his characteristically Jewish humor." "Comedic Distance in Holocaust Literature," *Journal of American Culture* 18, no. 1 (Spring 1995): 35. See also Michael Hamburger, "In

a Cold Season," in *Ownerless Earth, New Selected Poems* (New York: Dutton, 1973), 67–70, and Muriel Spark, *The Mandelbaum Gate* (New York: Knopf, 1966), 210–12.

22. *Variable Directions: The Selected Poetry of Dan Pagis,* trans. Stephen Mitchell (San Francisco: North Point Press, 1989), 30.

23. Romain Gary, *The Dance of Genghis Cohn,* trans. by the author with the assistance of Camilla Sykes (New York: New American Library, 1968).

24. Andreas Huyssen, *Twilight Memories: Marking Time in a Culture of Amnesia* (New York and London: Routledge, 1995), 214–15.

25. Huyssen discusses this at length in ibid., 208–47. The earlier probings of this subject include Alexander and Margarete Mitscherlich, *The Inability to Mourn: Principles of Collective Behavior,* trans. Beverley R. Placzek (New York: Grove, 1975), and Peter Homans, *The Ability to Mourn: Disillusionment and the Social Origins of Psychoanalysis* (Chicago: University of Chicago Press, 1989). On the specific seduction of certain images that retain their hold over the public, even after they were to have been chastised by the parodic, satiric, or allegorical frame in which they appeared, see Saul Friedlander, *Reflections of Nazism: An Essay on Kitsch and Death,* trans. Thomas Weyr (Bloomington and Indianapolis: Indiana University Press, 1984); Susan Sontag, *Under the Sign of Saturn* (New York: Farrar, Straus & Giroux, 1980); and Anton Kaes, *From Hitler to "Heimat": The Return of History as Film* (Cambridge: Harvard University Press, 1989). In discussing the films of Hans-Jürgen Syberberg as "allegories of grieving," Eric Santner explores the German filmmaker's argument that an unmourned "'Hitler'—not Hitler [but the Führer as phantasm]—would remain a vampiric threat to the postwar republic." In *Hitler, A Film from Germany (Hitler, ein Film aus Deutschland),* Syberberg invites his audience to "inhabit consciously, self-reflexively, the particular space in which he stages his surreal *Trauerspiel* of history: the film studio." Nevertheless, argues Santner, "Syberberg's black studio of the imagination seems to be a space in which the work of mourning has largely been usurped by a melancholic repetition compulsion." *Stranded Objects,* 136, 141, 146.

26. Anton Kaes points to the "utopian hope to begin once more, to create a pure moment of origin that is not contaminated by history." "The Holocaust and the End of History: Postmodern Historiography in Cinema," in Saul Friedlander, ed., *Probing the Limits of Representation: Nazism and the "Final Solution"* (Cambridge: Harvard University Press, 1992), 222.

27. Yoram Kaniuk, *Adam Resurrected,* trans. Seymour Simckes (New York: Harper & Row, 1971), 232–33. See also Yossi Hadar, *Biboff* (Tel Aviv: Or-'am, 1987) for a similar exploration of the pathology of the survivor and its transmission to the next generation within the context of the Israeli struggle for collective empowerment. This play is also set in a mental hospital; in order to reach his patient, the attending physician must assume the garb of the Nazi. In both of these texts, the therapeutic context substitutes for the religious in providing rites of exorcism.

28. *Mesibat Purim,* directed by Nola Chelton, was first produced at the Hebrew University of Jerusalem and then at the Neve Zedek theatre in 1981; in 1993, the Gesher Theatre produced it, first in Russian and then in Hebrew as *Adam Ben Kelev* (Adam Son of Dog).

29. Dan Pagis, "Testimony," in *Variable Directions,* 33.

30. Some of the literature of the 1948 War of Independence, including the fiction of S. Yizhar, began to engage in this dialogue. And, in the aftermath of the Six-Day War, this became one of the dominant themes in the nonfictional discourse. Soldiers who participated in a roundtable discussion after the war admitted to feeling uneasy about having taken part in a victorious military exploit and invoked images of the Holocaust to express their unease. As one soldier put it: "If I had any clear awareness of the World War years and the fate of European Jewry it was once when I was going up the Jericho road and the refugees were going down it. I identified directly with them. When I saw parents dragging their children along by the hand, I actually almost saw myself dragged along by my own father." *The Seventh Day: Soldiers Talk about the Six-Day War,* recorded and edited by a group of young kibbutz members (Harmondsworth, England: Penguin Books, 1971), 216–17. It bears mentioning that many other soldiers expressed the counterpart of that dread that is also the legacy of the Holocaust: the fear that a defeat of the Israeli forces might mean extermination and a common fate with the Jews of Europe.

31. For a discussion of the public rhetoric under Menachem Begin's government that reintroduced archetypal references to the Arab enemy (during the 1982 invasion of Lebanon, for example, Begin claimed to have seen Arafat in Beirut as a reincarnation of Hitler in Berlin), see Tom Segev, *The Seventh Million: The Israelis and the Holocaust* (Jerusalem: 1991), 396–404.

32. On the intersection of the Israeli-Arab and Nazi-Jewish discourses, see Don Orian, "The Holocaust and the Arab Question in Israeli Theater" (in Hebrew), *Dappim le-mehkar tekufat ha-shoah* (1993): 85–103, and Gad Kiner, "Nazism and the Holocaust as Metaphor for the Self in Israeli Drama," *Bamah,* no. 138 (1994).

33. From the program notes of *The Patriot* (Neveh Tzedek Theatre troupe). It was this very passage that the board of censors, which still operated in Israel in 1982 under an antiquated code enacted during the British Mandate, excised from the play.

34. For an illuminating discussion of *Arbeit Macht Frei,* see Amnon Raz-Karkotzkin, "Galut be-tokh ribonut" ("Exile within a Sovereign State"), *Te'oria u-vikorit* (Theory and Criticism), no. 4 (Fall 1993): 122–24. He develops the idea that,

together, Selma and Haled represent the two repressed forms of memory precipitated by the formulaic Israeli engagement with the Holocaust: its repression of the "European" memories of its victims and its impact on the Israeli-Arab encounter. He also points to the eclectic, postmodern structure of the performance as a critique of the linear narrative that establishes causality between events as complex as the Shoah and the construction of the State of Israel.

35. This can also be seen as an inversion of the trope of the Jewish Jesus, which has appeared in Jewish art and literature since early in the twentieth century and culminated in Marc Chagall's series of crucifixes.

36. Joshua Sobol, *Ghetto,* trans. Miriam Shlesinger (Tel Aviv: Institute for the Translation of Hebrew Literature, 1986), 55. In his introduction to the English version of the play, Uri Rapp writes: "The impossibility of staging the events of the Holocaust derives from the impossibility of viewing the German mass murderers as part of our common humanity, although this is exactly what should be done in order to confront the murderer lurking in all of us." Ibid., 6. The three plays, *Ghetto, Adam,* and *Ba-martef* (In the Cellar), were produced between 1984 and 1990.

37. Sobol, *Ghetto,* 8.

38. Asher Tlalim produced a film about the performance, *Al tig'u li ba-shoah* (Don't Touch My Holocaust), which documented the meeting between the Israeli actors and Germans of their generation, self-defined as "children of murderers." See also *Balagan,* A. Vetel, director, 1993.

39. David Grossman, *See Under: LOVE,* trans. Betsy Rosenberg (London: Jonathan Cape, 1989), 210.

40. Ibid., 291–92.

41. Surveying the subject out of a determination to avoid the "dubious pathologization of historical processes or personalities," Dominick LaCapra attempts instead to "link . . . historical inquiry to explicit ethical and ethicopolitical concerns bearing on the present and the future." *History and Memory after Auschwitz* (Ithaca, N.Y., and London: Cornell University Press, 1998), 180.

42. This subtitle is borrowed from Alvin Rosenfeld, *Imagining Hitler* (Bloomington: Indiana University Press, 1985). I have deliberately avoided a discussion of kitsch, pornography, and sadomasochistic and neo-Nazi images in popular culture, which are treated elsewhere in this catalogue, as well as by Rosenfeld, Friedlander, and others.

43. *The Portage to San Cristóbal of A. H.* originally appeared as a short novel in *The Kenyon Review,* 1979; it was later performed in London.

44. On the evidence, mysteries, and fantasies surrounding the death of Hitler, see Ada Petrova and Peter Watson, *The Death of Hitler: The Full Story with New Evidence from Secret Russian Archives* (New York: W. W. Norton, 1996).

45. Rosenbaum, *Explaining Hitler,* 300. For an interesting presentation of this work, based on interviews with Steiner, see ibid., 300–18.

46. On impersonation as cross-dressing, see Marjorie Garber, *Vested Interests: Cross-Dressing and Cultural Anxiety* (New York: Routledge, 1997).

47. On the fascination with Hitler's baby pictures, see Rosenbaum, *Explaining Hitler,* xi–xviii.

48. Even the fact that such an installation was shown at the Israel Museum is a measure of how open certain public institutions in Israel have become to the most painful reexaminations of the past. Rosen's exhibit provides the context for Ariella Azoulay's exploration of the "museological space" and its manipulation of material culture in relation to the "Shoah discourse." The 'handling' of Hitler's 'body' through the exercises to which Rosen invites the spectator are interpreted by Azoulay as a kind of mocking Jewish response to Hitler's last will and testament, that his body not fall into the hands of Jews, and a (temporary) answer to the relentlessly haunting presence of the unburied dead. See also Azoulay's definition of the process of imagination/identification with the perpetrators as that of "becoming" (in Gilles Deleuze's sense of *devenir*). "Shoah in the Eyes, Hitler on the Wall"—or "Would you believe that you can read German!" [Hebrew], *Teoria u-vikorit,* No. 15, Winter, 1999, 49–62.

The radical shift in position of Yehiel Dinur ("Ka-tzetnik") provides another "public" site for measuring the transformation of the moral discourse in Isreal. The original spokesperson for Auschwitz as the "other planet," (safely) removed from the human arena, Dinur, in his later work, made a complete about-face. As Omer Bartov writes, "Ka-Tzetnik had set out by dividing humanity into monsters and men, time into 'then' and 'now,' the world into 'there' and 'here.' Forty years later he finally fuses them all together into one continuous apocalyptic vision encompassing our own present reality. . . . If the Germans are for Ka-Tzetnik the personification of evil, they are also and simultaneously men just like ourselves." *Mirrors of Destruction: War, Genocide, and Modern Identity* (New York and Oxford: Oxford University Press, 2000), 204, 207. See also Bartov's exploration of the implications of the increased humanization of the Nazi in Israeli and western culture, ibid., 185–212.

49. Sander L. Gilman, *Jewish Self-Hatred: Anti-Semitism and the Hidden Language of the Jews* (Baltimore: Johns Hopkins University Press, 1986), 4. See also his "The Jew's Body: Thoughts on Jewish Physical Difference," in *Too Jewish? Challenging Traditional Identities,* exh. cat., The Jewish Museum, New York, ed. Norman Kleeblatt (New Brunswick, N.J.: Rutgers University Press, 1996), 60–73.

50. Wisława Szymborska, *View with a Grain of Sand: Selected Poems,* trans. Stanisław Baranczak and Clare Cavanagh (San Diego: Harcourt Brace & Co., 1995), 67–68.

Childhood, Art, and Evil

ELLEN HANDLER SPITZ

This essay is dedicated to the memories of
Betty Felsenstein Handler and to Henry Zacharias,
in memoriam.

Silence is the facilitator of destruction.

Sue Grand[1]

Magda took Rosa's nipple, and Rosa never stopped
walking, a walking cradle. There was not enough milk;
sometimes Magda sucked air; then she screamed.

Cynthia Ozick[2]

If the human species is differentiated from the beasts
by the marvel of consciousness, then we enact our
humanity and the very authenticity of our being by
straining to "know" through awareness the "unthink-
able" experience of others.

Lawrence L. Langer[3]

hy did it happen? How could it have happened? Because we
cannot understand, we keep asking—like small chil-
dren—over and over again. Then, like the parents of
those children, we keep trying to answer but fail.

Artists working on the theme of the Holocaust
today are often too young to remember World War II,
so young, in fact, that in some cases their parents

were small children then or not yet born. Still, these far-flung artists, living in eastern and western Europe, Israel, the United States, and elsewhere, continue to ask and to try to find answers. Permanently marked by stories that could never be told to them, by secrets that were kept and carried into graves, by public rituals like perennial school visits to the sites of former concentration camps or Holocaust memorials that were dutifully but superficially observed,[4] they make art that continues to grapple with their, and our, unassimilable past. In their art they "act out" and attempt to "work through" this past,[5] which remains present, and they attempt to take us with them. We must try to go there.

What is the effect of keeping secrets from children? And from the grandchildren and the nieces and nephews of victims, perpetrators, and bystanders?[6] All suffer. Adults have concealed the past either because they were helpless and afraid, guilty or ashamed, or because they believed they could protect the next generation by covering them each night with a thick blanket of ignorance. But the wish to know, the need to make sense, always bursts forth. In the work of these artists it explodes, burning us at times in the fallout from its flames.

Mendel, a film made in 1997 in Norway by Alexander Rosler,[7] explores the theme of keeping secrets about the Holocaust from young children (fig. 1).[8] Rosler was born in Dachau. Deeply concerned with not knowing and not telling, his work is an autobiographical fiction that demonstrates how florid symptoms can arise in children even when they (as one character in the film puts it) are "born too late" to have experienced brutality firsthand. Little Mendel Trotzig has nothing to remember. The first words in the film are his: "I don't have any bad memories from Germany." He utters them as his family leaves Germany to be relocated in Norway in the early 1950s. His older brother, David, does know what happened. Roughly, David slams down the window of their train compartment, blocking the view of what to him is a terrifying country.

Mendel does not understand. His stepfather nervously chain-smokes, repeats ethnic jokes, and mocks religious rituals, but he wakes up at night with terrible dreams. Mendel's mother sings sadly at night in Yiddish to David, who weeps softly. Whenever Mendel responds positively to any Christian symbol, song, or holiday, he is slapped and reprimanded by his brother. When Mendel asks for an explanation, he is rebuffed. He is told to be quiet, that the knowledge he seeks is "not for children," that he is too young to know.

With power and clarity, *Mendel* goes on to portray the effects of adult secrecy on children. Parents may wish to keep children safe from knowledge that might prove overwhelming (to themselves as well as to their children), but these wishes do not lead to peace of mind. "Not telling," we are made to see, produces its own forms of terror. At the milder end of the spectrum, Mendel is confused and bewildered. He cannot make sense of the world around him. At the more extreme end, he begins to exhibit actual symptoms. Like his stepfather, he has nightmares. He wets his pants (symbolic of his incapacity to exert cognitive control over the world around him). He snoops and tries to keep "secrets" of his own. He grows anxious and fearful. He acts out dangerous, misplaced aggression, attempting to shoot someone with a gun. Thus, broad questions are raised about the conditions for learning—learning about matters that are difficult, if not impossible, to teach.

In *Mendel,* such learning comes with maximum risk for the little boy. Playing with his Norwegian friends, Mendel hears about their fathers' bravery against the Germans during the war. He confronts his brother, asking why the Jews who were about to be slaughtered stood around like sheep. They just stood there and prayed, he says, insolently repeating "baaaa." He, Mendel, would not have been so cowardly. He would have grabbed a gun from a member of the firing squad and died resisting bravely. At this point, David silently rises from his chair in a rage, grabs his little brother, and pins him to the floor.

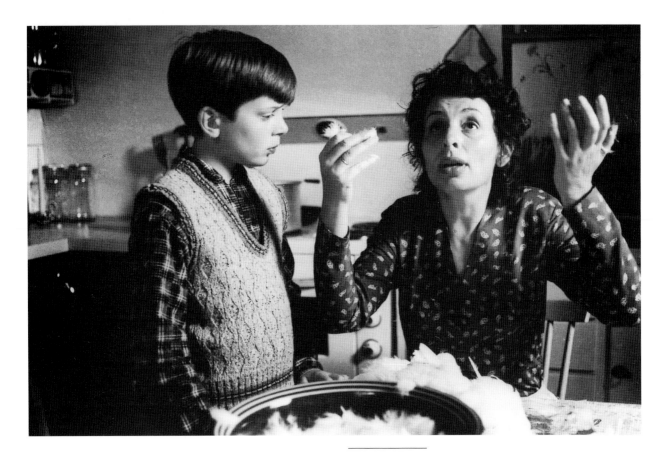

Fig. 1. Thomas Jungling Sorenson and Theresa Harder in Alexander Rosler's film *Mendel,* 1997. Courtesy of First Run Features, *www.firstrunfeatures.com.*

Once again, there is no discussion or explanation. Holding the child down, David demands an apology from him. But Mendel, who understands nothing about the Holocaust, repeats his "baaaa." David picks him up, and then, in an unforgettable scene, holds the child by his feet out of a second-story window and demands, "Say you're sorry or I'll let you go." When Mendel finally murmurs the necessary words, David also makes him say "mercy."

Back inside, the older brother comments succinctly, "Your pride ran out." Yet the little one, momentarily subdued but unvanquished, runs and locks himself in the bathroom. When he finally opens the door, an ensuing tussle melts into an embrace. "You're awfully irritating, but you're brave,"

David admits. "Then tell me . . . ," begs Mendel. Only now, after learning with his own life that one cannot stand in the place of another, can the boys begin to talk. Truths about the war are spoken, and shapes of the past come into clearer focus.

Who can compare silences? The inability to return, to recount, to reconnect—the frozen muteness of a former victim of trauma with that of a former perpetrator, whose malignant self may have been encapsulated and dissociated from other more empathic modes of being?[9] For their offspring and for the generations to come, the stillness is toxic. Terrifying imaginary spaces appear in the voices of silence.[10] Artists working within these spaces pull us down into them. Their work may frighten and even disgust us, but we must go there ourselves.

We must go because, for Jews, history has always been a reenacting as well as a retelling. Central to the text of the Haggadah is the story of the four sons, which is repeated annually at the beginning of the Pesach seder, when even the youngest children are not yet too tired or hungry to pay attention. Each of the four sons, normally "played" by children at the table, asks about the Exodus in a different way and is answered by the leader according to his special needs. There is a wise child, a wicked child, a simple child, and a child who cannot ask any question at all.

The wicked child asks, "What does this service mean to *you*?" By choosing the exclusionary "you" rather than the embracing "us," he removes himself from the community. This notion recurs throughout the Haggadah and is emphasized in songs such as "Dayenu," where "we" are fed manna in the wilderness, and "Echad mi yodeah," and through ritual practice in which each person must taste the acerbic raw horseradish, the bitter herb that is symbolic of "our" harsh treatment as slaves in Egypt. In this way, Jewish children are taught, year after year, that the story of the Exodus is a part of their own personal story: "In every generation, each of us should feel as though we ourselves had gone forth out of Egypt . . . It was we who were slaves . . . we who were strangers."[11] Thus, a continuous autobiographical self emerges in childhood that blends with the history of a people and provides a framework for the interpretation of one's acts.

Both gentleness and aggression, love and hate, are part of our human heritage, and artists who explore the theme of the Holocaust are telling us that we must try to see them both. No matter how hard it is. Can we try, they ask us, to imagine the childhood and inner state of perpetrators as well as victims and to dwell momentarily within the malignant splits that permit perpetrators to experience a subjective state of innocence in a condition of actual guilt?[12] I think of a small child who disowns his acts, who knocks a family treasure to the floor, shattering it forever, and, almost believing himself, explains, "It fell down all by itself." Can we adults behave this way—disavowing agency, separating ourselves from our own deeds and from the consequences of those deeds? Can we—cut off from memory, history, and imagination—experience ourselves as not implicated in the actions of our bodies?[13] Many of the artists who today explore the Holocaust try dramatically to represent such disorders of knowing, such malignant dissociations, with, as one author has described it, their terrifying potential for contagion.[14]

They also ask us to make analogies between the defenselessness of small children and of the victims of evil and to consider similarities between innocent and malevolent ignorance and between innocent and malevolent ideologies. They want us to find links between ancient voices of children and the strident, raucous clamor of political and economic propaganda,[15] between the fanciful building blocks of our nursery days and the stark architectural units of mass incarceration and annihilation.[16]

To say the word "bad" may be to utter a simple indication of disapproval, even momentary or mild.

"She is a bad parent" (possibly unresponsive or hypercritical). "He was a bad child" (rude, perhaps, or disobedient). "Last night we saw a bad play" (poorly executed or tasteless). When we switch, however, from bad to evil, we enter a universe of discourse that implies morality. We enter a realm where bad becomes malignant. Where its opposite is not only good but also right (as in right versus wrong). And evil seems to fascinate us. What about an art that speaks to us of evil? I do not mean an art, familiar to us now more than half a century after the Holocaust, that compels us to open our hearts to the victims of evil, but rather an art that asks us to share our sheltered psychic spaces with its perpetrators? An art that won't let us dissociate ourselves from evil but that, by representing and re-creating the very disjunctions that breed it, lures us, pushes us in, seals us up inside, and then ejects us feeling sick, stirred, titillated, sullied, betrayed, contaminated, and embarrassed. And shaken, perhaps, with deep, unformulatable questions.

For many of these contemporary artists the leitmotif is childhood. Perhaps we can begin to understand why. Brutality directed against the young is normally felt to be so heinous that for many years linking thoughts of children with genocide was avoided. Transgressing a sacred boundary, it was pushed away for almost four decades after the Holocaust, and only relatively recently have scholars begun to focus on it, even though the youngest children were the first to perish.[17] To picture childhood stories and toys and youthful faces and games in one's art in this context, then, is to perform a certain sort of violation even before the details of any individual representation are considered.

But if you are trying to understand something, you must go back to the beginning—to have that possibility. For some of these artists, childhood counts in that way. As a beginning. Consider how each child's dawning awareness of his or her own immediate past (yesterday's holiday parade or train ride or bedtime story) leads to the sense of history on a grander scale. Biography morphs into history. As children play and grow, their self-centered stories of "me" expand into broader accounts that include an increasing number of "not-mes" and merge with cultural chronicles that exceed the life span and geographic range of any given individual. This matters because, when the capacity for historical memory is in place, it forms the ground of personal identity, of an ongoing, meaningful sense of self, not only psychologically but ethically. It forms the basis of individual responsibility. Without connections to and recollections of the past, how can we braid the strands of causative and associative meaning that influence our deeds and are in turn affected by them? Thus, by invoking childhood play and storytelling, some contemporary artists of the Holocaust are beseeching us to return to the ground of their own and of our own individual ethical conscience.

When I look at their art I tremble to imagine what it might feel like to be deprived of that ground, that deep-rooted sense of history and memory and the means to make ethical choices that begins in childhood. Or to be where there can be no choices because one is stripped of everything. Where one is unrecognized and unseen and where one can no longer see oneself. What terrible inner isolation must ensue, what aloneness.[18] A deadness, an emptiness that, to be rendered endurable, can sometimes be belied by facts and numbers or mechanical behaviors that, nonetheless, no matter how often they are repeated or reiterated or recorded, can never assuage inner chasms of inaccessible pain. The art makes me see that when one cannot love or be loved because one has lost touch somehow with that possibility one can turn to others only destructively. Imagine a lonely child with lethal toys, behind thick panes of defensive glass—an invisible barrier that, if one could ever break through it, would smash and shatter, causing unbearable pain. The images of Adolf Eichmann come to mind—how he twitched,

Fig. 2. Roee Rosen. *Live and Die as Eva Braun #2,*
1995. Acrylic on rag paper, 6¾" x 11". Courtesy
of the artist.

flipped pages, and polished his eyeglasses, mechanically rising and sitting, a grown-up child behind the glass panes of his isolation booth in Jerusalem.[19] This is where the art is trying to take us: into that booth, behind that glass.

In Roee Rosen's *Live and Die as Eva Braun* (1995), childhood is completely betrayed, for we must become Hitler's paramour and wait for him and, when he is naked, have sexual intercourse with him before he shoots us to death in the bunker. If I can go there, even for a few seconds, I am split off from my world, without memory, in a prison of eternal presence. Everything outside becomes nonexistent. Rosen brings me so close to evil that I am sick—in my mouth and throat and stomach and skin; as the scene horrifyingly surrounds me, the sensation is intolerable.[20] Rosen draws on images from childhood. One is a photograph of himself as a boy graffitied with the adult Hitler's mustache (fig. 2), surmounted by interlocking pairs of scissors taken from the cover of *Der Struwwelpeter* (Slovenly Peter), a famous children's book (fig. 3). Written in Frankfurt-am-Main in 1844 by Heinrich Hoffmann, a middle-class doctor, for his three-year-old son, *Struwwelpeter* tells of wicked children who are punished grotesquely for their transgressions. When they prove recalcitrant, these children are viciously chastised. A disobedient little girl, Paulinchen, plays with matches and is burned alive (fig. 4). Kaspar, who does not wish to eat the food his parents give him, is killed by starvation. Another small fellow, Konrad, sucks his thumb and ends with having both offending fingers chopped off by enormous shears (fig. 5). Why do

Fig. 3. Cover illustration from the original Frankfurt edition of *Der Struwwelpeter* by Heinrich Hoffmann, 1844, (Loews Verlag Ferdinand Carl).

Fig. 4. Illustration of Paulinchen being burnt alive, from *Der Struwwelpeter*.

Fig. 5. Illustration of Konrad's thumb being cut off, from *Der Struwwelpeter*.

Fig. 6. The Tiger Lillies' Martyn Jacques and Adrian Stout in *Shockheaded Peter,* An A.C.T. production, 2000. Courtesy of Cultural Industry. Photograph by Gavin Evans.

such images belong here, in art that asks about the Holocaust?

Perhaps a contemporary performance piece can help us understand. A mixed media "junk opera" (so called) based on *Struwwelpeter* and titled *Shockheaded Peter* (fig. 6) is a musical adaptation of Hoffmann's book.[21] Created in England, it has attracted wildly enthusiastic crowds in London, New York, and San Francisco.

Beguiled by its daintily hand-painted sets with a cleverly elevated puppet theater, I was, despite my knowledge of *Struwwelpeter,* unprepared for the cruelty of this show and dazed by the howls of glee that followed each sadistic act performed or recounted. Although the British adapters tried to provide an ironic frame for each story, I was horrified by the uproarious laughter that surrounded me as child after child, depicted as a monster, was mutilated, murdered, and sent to an onstage grave. At one chilling moment, the narrator, a countertenor with whiteface clown makeup, an accordion, and an ear-splitting voice, elicited direct audience participation.

After yet another child character had been hideously punished, the narrator began to insinuate interrogatively, "Johnny was . . . ? Johnny WAS . . . ? Johnny **WAS** . . . ?" and, tentatively, one or two voices in the theater responded, "dead. . . ." But the narrator-clown was dissatisfied with this insipid rejoinder. His pitch rose as he hectored the crowd with shrill taunts. In just a few seconds, he had succeeded. The entire audience was shrieking "DEAD! DEAD! DEAD!" and the air felt thick with bloodthirsty screams. Weakly leaving the theater afterward, I felt I had witnessed a stunning example of our fascination with evil. Evil profoundly connected with children, and evil represented through art.

Shockheaded Peter succeeds as art, I think, because it gives its adult audiences the chance to vent aggression openly toward children. It allows us to revel vicariously in behavior that, if carried out in

real life, would render the task of fostering the next generation impossible. It subverts the very foundation of parent-child relations—the basic trust of which Erik H. Erikson has written—a sacred and necessary trust that grounds our sense of safety in the world.[22] This birthright of every human infant entails the right to count on one's parents as a sanctuary, to count on them for consistency, responsiveness, nurturance, protection, and a refusal to give way to vindictiveness, even in the face of childish naughtiness and greed. For adults, the behavioral consequences of children's vulnerability is that we must suppress, modulate, or redirect our own aggressive instincts toward them. This is what *Shockheaded Peter* turns upside down. Unless adults restrain themselves from direct attack, there can result, if not the actual deaths of children as depicted in *Struwwelpeter,* emotional death—an inner deadness that may persist for an entire lifetime. Therefore, perhaps one question the art we are examining asks us to consider is the connection between this betrayal of basic trust in childhood and the inner world of those who perpetrate evil. And to watch ourselves as we consider the question.

Children, like all victims of evil, are powerless. Small, unskilled, unable to survive on their own, they must depend entirely on adults who love and nurture them and who normally suppress their hostile feelings. This strong/weak hierarchy makes children a ready metaphor for the victims of evil. Stripped one by one of their privileges, rights, sustenance, and finally their bodily integrity, the Nazis' victims were, in myriad horrific ways, subjected to what Christopher Bollas has called "a radical and catastrophic infantilization."[23] By undressing them, then shaving, starving, immobilizing, and prostrating them, rendering them speechless *(infans),* impotent, unable to influence or even to grasp the meaning of what was being done to them, the perpetrators reduced them to a state of "seemingly endless terrorizing infancy."[24] By making them into

helpless "children," moreover, the perpetrators (and here we may invoke the audiences at *Shockheaded Peter*) somehow empowered themselves psychologically to perform acts of untold cruelty.

How were they able to do this? How could they brutalize human beings already reduced to such helplessness? Why was there no empathy for people who, stripped of all their markers, deprived of all the signs of their lived years, known only by numbers, could be likened to unnamed infants in an obstetrics ward, deserving of being cosseted and loved? Was it because the next step was to render them nonhuman, like animals in a herd, as in the "baaaa" uttered by Mendel when he could not understand? For the victims were looked at by their murderers without being seen, and the violent acts performed on them were rendered void of consequence—like the killing of animals or like the brutalities I saw committed onstage against imaginary children. Were the disempowered ones, the Jews, seen, as in *Shockheaded Peter,* as "deserving" of what was "coming" to them,[25] something adults say to justify the use of corporal punishment against their children? And do artists who link the Holocaust with childhood draw on this betrayal and attempt to implicate us directly in it?

I think the artists also use our fascination with and curiosity about evil to entrap us, to seduce us into revealing whatever disavowed voyeuristic pleasure we can take in it. They give us the means to experience our own latent sadism and, later on, waves of shame and even remorse. Through our spectatorial power (to look) and our powerlessness (in being unable to resist their seduction), we become momentary doubles for both the perpetrators of evil and its victims. Through our participation in an art that co-opts us this way, we actually replay that codependent relationship.[26] Some pieces make us laugh, fast and raucously. They make us try—by humor, volume, and speed—to override the softer voices within and dissociate ourselves from

any memory or history that might spoil the effect. Other pieces guide us skillfully toward a slower process of reflection. In any case, by participating in these works of art and identifying with them, we become, as it were, their "victims." Having induced us to collude with them, they enact on us a species of psychic violence, a violence with which we go along. Arriving in the art museum or theater in a state of willing suspension of disbelief appropriate to the realm of the aesthetic, we are kidnapped. Simultaneously, conspiring with the perpetrators (real and imaginary), we evade the burden of our guilt, taste the juices of our own cruelty, and feast in fantasy on our brief mastery over what in real life would repel and/or destroy us.

Take Piotr Uklański's 1999 installation piece *The Nazis*. A room of head shots, mounted at eye level on stark white walls: all are male movie stars who have played roles as Nazi officers. Gazing at these icons of masculine strength and beauty, can we remain impervious to their erotic and heroic appeal toward men and women alike? Can we fail to be lured by chains of not fully remembered associations to other, more benign contexts in which we had admired and adored these faces, these busts—now garbed in the black, brown, red, and yellow Nazi regalia with braided crosses, swastikas, embroidered eagles, lightning bolts, insignias, woolen visored caps, and crystal monocles?

A double consciousness appears—that "link between the power of a tempter and the weakness of the subject's resolve,"[27] that betrayal of basic trust[28]—as when the small child's smiling grandmother turns shockingly into a wolf.[29] Sexuality and brutality twist themselves together in Uklański's installation, as do entertainment and instruction, fiction and history, the lie and the truth. These dualities bond and conflate while at the same time we are prevented from meaningfully, feelingly conjoining them. I am not sure how to orient myself in this profoundly disturbing space. Where can I stand emotionally here? The faces are all at my eye level. They

make uneasy contact with me. What fantasies do they impose? And how will I figure out how to evade them and thus to flee also from parts of myself?

Excited by the theatricality of Uklański's piece, its form and parodic content, we may in fact experience for ourselves an analogue of actual Nazi war propaganda—*its* use of film and pageantry, *its* regular-featured faces, even Hitler's own raucous and reiterated histrionics, his uncanny capacity to, as Erikson put it, "exploit his own hysteria."[30] The multiple heads arranged in this line are mesmerizing. They are, in fact, hypnotic, reminiscent of National Socialist programs for the training of German youth, in which the children's normal developmental conflicts and family dynamics were swept aside in favor of "simple patterns of hypnotic action and freedom from thought";[31] in which their parents no longer mattered, nor did personal ethics, nor friendships, nor learning. The imperative was to be on the move without looking back. Uklański's piece invokes, as well, the hypnotic quality of military marches into battle and forced marches by prisoners, the endless recurrent horrors of the Holocaust, the lists, the unrecorded faces of its dead. Behind each head shot on this wall, I can find a child in black and white, lonely, frightened, then lifeless. But to do that is to pull back from the piece, perhaps. Or is it?

For all those good-looking, evil-doing faces are staring at us but not seeing us, aren't they? Just as perpetrators must. They look closely at the victims of their crimes, but never see them. They dissociate. To escape personal accountability, they cannot know. Uklański's pageant looks like a parade to me. Suddenly, it reminds me of the haunting procession of sceptered kings that frightened Macbeth, himself a serial killer. Dazzlingly, Uklański surrounds us with evil.

As does Zbigniew Libera. In *LEGO Concentration Camp Set* (fig. 7) he shows us how LEGO pieces can be used to construct replicas of concentration camps, with crematoria, gallows, guard towers, barracks, and electroshock tables. Instead of co-opting

us emotionally, however, he invites us to come very close to his work, lured by our sense of familiarity with the toy. Then he gives us a shock and pushes us, just a bit roughly, back into a corner, where we are made to stand still and think. After our initial gasp at what he has done, he makes us face the processes at work here—the *not-seeings* that occur all around us and of which we ourselves are so perennially guilty. He shows, with his simple children's blocks, how evil penetrates unnoticed into ordinary life and perhaps especially unnoticed into the lives of children. His realistic toy constructions join terms we prefer to keep apart: like carefully planned construction and wanton destruction; like the giggling, thriving little boy who plays beside me on the floor as I write these words and the starving, panic-stricken children of his age who never lived beyond it; like carefree imaginative play and the rigorous, punitive, ideological bending of young minds. Libera will not let us segregate these categories. His LEGO boxes challenge our myth of an idealized childhood world that can be sequestered from the harsh realities that once afflicted and continue to afflict real children.

Unlike performances of *Shockheaded Peter,* Libera's installation art causes us not to scream but to be scared; to think about the incongruous connections it makes and the disconnections we make. His uncanny boxes in red, yellow, black, white, and blue remind us of Uklański's brilliantly colored installation, and of secrets we have tried to keep but failed to keep, and of the price we paid for those secrets and of the truth that children always know something even when we attempt to hide what we feel we must to protect them—and ourselves. LEGOs come, after all, from Denmark, from Copenhagen, where the iconic statue of Hans Christian Andersen's *The Little Mermaid* is admired by all. It is admired, however, by people who don't always remember the tale—how her tongue was cut out of her mouth, how her feet burned, and how every single step she took was accompanied by knifelike stabs of pain.[32]

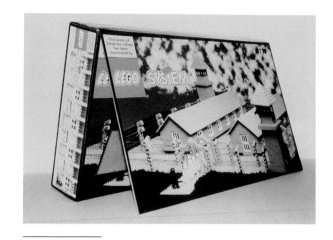

Fig. 7. Zbigniew Libera, *LEGO Concentration Camp Set,* 1996. One of a seven-box set. Courtesy of The Jewish Museum. Museum purchase with funds by the Fine Arts Acquisitions Committee and Thomas Healy and Fred Hochberg.

Fig. 8. Garance Nuridsany, *Untitled*, 1996. Courtesy of the artist. Photo by Christian Cambon.

The Danish manufacturers of LEGOs did not approve of Libera's artistic use of their toys because, as they said, "lego" comes from the words that mean "to play well."[33] If this is so, I beg to disagree with them and to proclaim, instead, that Libera's use of them is consistent, for he has indeed played well. He has made good art out of the terrible subject of evil.

In the early fall of 1998, I saw a work by Garance Nuridsany exhibited in Paris, *Ours en peluche en forme de roue* (Teddy Bears in the Form of a Wheel (1996), that seemed and still seems to me one of the most disturbing pieces of art I have ever encountered.[34] Imagine a typical white museum wall. Dead center is mounted a child's furry teddy bear (fig. 8), its head smothered in black and brown packing tape, the kind you use when you move. This tape has been ripped and smeared with blood-red paint that also stains the bear's whole body. Its arms are tied with sisal, the kind of rope that cuts into you and sears. A child's toy tortured. Desecrated, mutilated, it dangles there on the wall, illuminated by glaring spotlights from above. Hanging around it in a circle are more than twenty other toys, each one similarly tortured. A fuzzy gray elephant, bound, gagged, and blindfolded with tape; a blond dolly trussed so that her face is roughly masked by white-washed tape, her feet clamped, her hands forced back and immobilized, her inert body wrapped in transparent plastic.

Harsh rope confines another miniature teddy bear, whose tiny paws are cruelly pinched by clothespins. Still another poor bear has had its legs forced apart, the area between them daubed with more blood-red paint and a plastic fork stuck in between the rounds of string that grip its paw. Pieces of black cloth soaked in paint were used to torture another animal, and yet another has been completely decapitated, its once-white fuzzy head mounted on a sawed-off board of splintered wood.

What are we to make of these piteous creatures? To me, this devastating installation is concerned with the sinister issue of soul murder. With the wan-

ton violation of innocence; the brazen intrusion into protected realms. As I see it, it is a piece about the terrible aggression, often latent but all too real, of adults toward children, of the strong and powerful toward the weak. Sitting cross-legged on the floor, I wanted to see this piece without actually looking at it (but isn't that what perpetrators do?). So, I had to look. And the almost two dozen objects hanging on the wall above me seemed like abused and even murdered children. All the little animals and toys had been badly damaged, with dirty bodies, their faces masked so that they could not be identified or see what had been done to them, their extremities bound so they could never move or be moved. They made me remember how hard it is for so many parents to protect their growing children, keep them whole, intact, safe, healthy, clean, and warm. This artist tortured *us* as well as the bears by throwing the obverse of parental care at us. She had sacrificed each toy, one by one, to her art. Why? To reveal the cruel underside of nurturing? To show us that we can destroy our young; break and bloody them; mock, defile, taunt, degrade, and blaspheme them?

She placed the evidence before us on a spotless, pure-white wall in the form of a circle with a perfect center. So, perhaps her intention had something to do, in addition, with the notion of making something whole, something complete, or something cyclical and endless. Maybe a piece about the process of breaking things. And people. What was she feeling while she did all this? Perhaps she enjoyed it, or was she anguished as she worked? All the ambiguities forced on me by her art and by the work of contemporary artists facing the Holocaust have left me restless and without peace, as it should be. Yet, in the terrible times themselves, there were those who moved beyond ambiguity.

In her novel *Fugitive Pieces,* Anne Michaels has written about a Jewish child who managed to survive: "There's a precise moment when we reject contradiction. This moment of choice is the lie we will live by. What is dearest to us is often dearer than

truth. There were the few . . . who never confused objects and humans, who knew the difference between naming and the named."[35]

Will the making and viewing of art help us to become one of those few? Can it help by connecting us to a kind of vision and knowledge that facts and figures only obscure? Even if we run away after seeing these pieces, even if we can only peek at them and then cover our eyes, even if we shudder and recoil from them, the enduring itself will have been worthwhile.

NOTES

1. Sue Grand, *The Reproduction of Evil* (Hillsdale, N.J.: Analytic Press, 2000), 10.

2. Cynthia Ozick, *The Shawl* (New York: Knopf, 1989), 3.

3. Lawrence L. Langer, ed., *Art from the Ashes: A Holocaust Anthology* (New York and Oxford: Oxford University Press, 1995), 15.

4. For an account of the experience of Polish artist Zbigniew Libera, see Dean E. Murphy, "Artist Constructs a Volatile Toy Story," the *Los Angeles Times,* May 19, 1997, sec. A, p. 1.

5. For the application of these two psychoanalytic terms to Holocaust-survivor and second-generation experience, see Dominick LaCapra, *History and Memory after Auschwitz* (Ithaca, N.Y., and London: Cornell University Press, 1998). See also my review of LaCapra in *The Psychoanalytic Review* 87, no. 2 (April 2000), 314–21. Both "acting out" (which can be associated with Freud's notion of melancholia) and "working through" (which can be associated with his description of mourning) are processes deeply inflected with the need for repetition. "Working through," however, is distinguished from "acting out" by its greater self-consciousness and investment of time and patience, as opposed to manic swiftness, and, above all, by its deliberate efforts toward interpretation. Nevertheless, it must be stressed that "working through" does not imply arriving at an absolute psychic haven, either intellectual, as in some endpoint of understanding, or emotional, as in a capacity to put one's loss aside forever.

6. Bernhard Schlink, born in Germany in 1944, writes: "How could those who had committed Nazi crimes or watched them happen or looked away while they were happening or tolerated the criminals among them after 1945 or even accepted them—how could they have anything to say to their children? But on the other hand, the Nazi past was an issue even for children who couldn't accuse their parents of anything, or didn't want to." *The Reader,* trans. Carol Brown Janeway (New York: Pantheon Books, 1997), 169.

7. Alexander Rosler, director, *Mendel,* First Run Features, Norway, 1997.

8. The 1998 film *Life Is Beautiful,* directed and cowritten by and starring the Italian actor Roberto Benigni, is another example. In it, a clownish father fabricates stories to try to protect his small son from realizing what is actually going on around them during the Holocaust.

9. See Grand, *The Reproduction of Evil,* 73–74. While studying the inner world of the perpetrator of evil, she writes, powerfully, "I am opposed to the forgiveness of the unrepentant. . . . To embrace the unrepentant in the soft envelope of forgiveness is to abandon the perpetrator to the loneliness of his own depravity."

10. Ibid., 24.

11. See my *Museums of the Mind: Magritte's Labyrinth and Other Essays in the Arts* (New Haven: Yale University Press, 1995), 162–63.

12. Grand, in *The Reproduction of Evil,* writes: "Within his own depersonalized and derealized state, the perpetrator-survivor can also genuinely experience himself as innocent." (64).

13. Bernhard Schlink, in *The Reader,* writes:

"Once," he went on, "I saw a photograph of Jews being shot in Russia. The Jews were in a long row, naked, some were standing at the edge of a pit and behind them were soldiers with guns, shooting them in the neck. It was a quarry, and above the Jews and the soldiers there was an officer sitting on a ledge in the rock, swinging his legs and smoking a cigarette. He looked a little morose. Maybe things weren't going fast enough for him. But there was also something satisfied, even cheerful about his expression, perhaps because the day's work was getting done and it was almost time to go home. He didn't hate the Jews. He wasn't . . ."

"Was it you? Were you sitting on the ledge and . . ."

He stopped the car. He was absolutely white, and the mark on his temple glistened. "Out!"

I got out. He swung the wheel so fast I had to jump aside. I still heard him as he took the next few curves. Then everything was silent. (151).

14. Grand, *The Reproduction of Evil,* 16, 17.

15. "Ancient Voices of Children: A Cycle of Songs on Texts by Garcia Lorca" (1970) is the title of a brilliant piece of postmodern music by George Crumb that quotes, at one point, Gustav Mahler's "Das Lied von der Erde" and evokes the loss both of childhood and of children. See "A Cycle of Songs" in my *Image and Insight* (New York: Columbia University Press, 1991), 129–47.

16. See Tom Sachs's work *Prada Deathcamp,* 1998.

17. Their survival rate was 6 to 7 percent; 33 percent of the adults survived. See Karein K. Goertz, "Writing from the Secret Annex: The Case of Anne Frank," *Michigan Quarterly Review* 39, no. 3 (Summer 2000), 655. Among many sources, I note especially the writings of Serge Klarsfeld, including *The Children of Izieu,* trans. Kenneth Jacobson (New York: Abrams, 1985).

18. Roee Rosen's 1995 installation piece *Live and Die as Eva Braun* puts the viewer into the place of Eva Braun as she is about to make love to Hitler before he assassinates her in the bunker.

19. See the film on Eichmann, *The Specialist,* by Eyal Sylvan, 1998, screened at the Berlin Film Festival and at the San Francisco Jewish Film Festival, August 2000.

20. For an extended treatment of the relations between loneliness and evil, see Grand, *The Reproduction of Evil,* passim.

21. *Shockheaded Peter* was created by Julian Bleach, Anthony Cairns, Graeme Gilmour, Tamzin Griffin, and Jo Pocock.

22. Erik H. Erikson, *Childhood and Society* (New York and London: W. W. Norton, 1950), 247–51; see also Christopher Bollas, *Cracking Up* (New York: Hill & Wang, 1995), 186.

23. Bollas, *Cracking Up,* 198.

24. Ibid., 199.

25. Ibid., 197.

26. For a relevant clinical discussion, see Virginia Goldner, "The Treatment of Violence and Victimization in Intimate Relationships," *Family Process* 1 (1998): 266–67.

27. Bollas, *Cracking Up,* 186.

28. Erikson, *Childhood and Society,* 247–51.

29. Bollas, *Cracking Up,* 192.

30. Erikson, *Childhood and Society,* 330.

31. Ibid., 342.

32. Hans Christian Andersen, "The Mermaid," in *Tales of Grimm and Andersen,* ed. Frederick Jacobi, Jr. (New York: Modern Library, 1952), 658–75.

33. Murphy, "Artist Constructs a Volatile Toy Story," 1.

34. See my "Tattoos and Teddy Bears," *Studies in Gender and Sexuality* 1, no. 2 (2000): 207–22.

35. Anne Michaels, *Fugitive Pieces* (New York: Vintage Books, 1996), 166–67.

I wish to thank Norman Kleeblatt, Joanna Strauss, Joanna Lindenbaum, Nathaniel Geoffrey Lew, Alla Efimova, Amir Eshel, Yael Feldman, and the students in my "Holocaust, Art, and Psychology" seminar at the University of California at Santa Cruz (Spring 2000), each of whom helped me in untold ways to make this writing possible.

"Avant-Garde and Kitsch" Revisited

On the Ethics of Representation

LISA SALTZMAN

n 1939, Clement Greenberg penned the now canonical essay "Avant-Garde and Kitsch."[1] A scathing indictment of the pervasive presence of popular culture in modern industrial society, the essay expressed a deep commitment to avant-garde culture. The reasons for this commitment were more ideological than formal, more ethical than aesthetic. In "Avant-Garde and Kitsch," the

formalist critic actually devoted more time to a dis-
cussion of the perils of a political appropriation of
culture than to an analysis of the work of an aes-
thetic avant-garde.[2] For even if Greenberg could not
then imagine the atrocities that a fascist regime
would inflict upon European civilization, he was
deeply wary of kitsch as a cultural form and a politi-
cal tool, as a means for totalitarian regimes "to
ingratiate themselves with their subjects."[3]

Even as Greenberg's early writing was animated by
the undisguised elitism of an emerging critic anx-
ious to ally himself with the cultural capital of the
Western tradition, his aversion to kitsch, and to
popular culture more generally, was also bound to
the escalating political crisis in Europe. Increasingly
aware of the use and abuse of representational
images in the totalitarian regimes of Germany, Italy,
and Russia, Greenberg argued for the importance of
maintaining an art outside the purview of politics.
For him, that could be achieved only with an art of
rigorous purity, autonomy, and self-reflexivity—in
other words, with an art of abstraction. In Green-
berg's aesthetic utopia, abstraction would serve as a
lifeboat, rescuing and preserving the values not only
of high culture but of humanity.

The postwar triumph of abstract expressionism
foundered on, among other things, the persistence
of figurative practice.[4] With the advent of assem-
blage and then Pop, the visual field whose bound-
aries Greenberg had fought so hard to police and
patrol gave way not merely to figuration but to the
aesthetics of popular culture, to the aesthetics of
kitsch. Even Minimalism, a movement that pursued
the logic of formalist practice to its extreme limits,
bespoke as much an aesthetic commitment to the
language of industry as an ascetic commitment to
the rhetoric of purity. From the Pop silkscreen to the
Minimalist monolith, the art of the 1960s produced
culture as industry and industry as culture. Whether
critical of or complicit with the processes and prod-
ucts it both reproduced and represented, the art of

the 1960s lay claim to a world outside the frame
that had contained and defined Greenberg's mod-
ernist pictorial field.

In the aftermath of Pop, the aesthetic strategies
of appropriation and simulation so fundamental to
it have come to govern a significant body of art. In
the wake of Pop, art no longer cloaks its continuous
consumption of cultural images beneath the mythic
aura of originality and creation. Any claims to
beauty, to sublimity, give way to a posture of
studied sophistication and ironic detachment. Any
possibility of parody is lost to its semblance as
pastiche. Art after Pop is predicated on the post-
modern convention, if not conviction, that each act
of visual representation is but one more act of re-
presentation, repetition, or reproduction of a set of
culturally available and assimilable signs. It feeds
relentlessly, unabashedly, and conspicuously upon
the virtual archive of images that constitutes its
present. But where Pop drew its styles and subjects
from a relatively circumscribed set of strategies and
signs, the evolution of contemporary mass media
has exponentially expanded the array of images
potentially employed as aesthetic source, subject,
or situation.

Participating in this contemporary cultural
moment is the work assembled in *Mirroring Evil: Nazi
Imagery/Recent Art*. Steeped in the codes and
immersed in the strategies of a media-saturated,
commerce-driven world, the work in *Mirroring Evil*
mobilizes billboards and bar codes, LEGO sets, and
Prada purses, television and movies to achieve its
artistic ends. Through media and method, the work
forthrightly locates itself in aesthetic terms as com-
ing after. It locates itself as coming not only after
Pop, but after a subsequent generation of appropria-
tion artists, among them Sherrie Levine, Richard
Prince, Barbara Kruger, Robert Longo, and Cindy
Sherman. Indebted to the assimilative strategies of
the photographic activity of postmodernism, the
work in *Mirroring Evil,* photographic and otherwise,

recapitulates and refines its techniques of repackaging and recycling, consuming and critiquing the culture it takes as its relentless subject.

What distinguishes the work in *Mirroring Evil,* however, is the specificity of its cultural subject, its cultural referent. There is a focus to this work, a singularity of subject: the history of the Holocaust, of fascism, of genocide. More particularly, the history that it takes as its relentless subject is a history that is already highly mediated. It is a history that we know, for better or for worse, through nearly five decades of its cultural representation. This is a body of art that gives us history, but history as something already represented, something already mediated by the media of culture.

Poems and novels, films and photographs, paintings and performances, monuments and memorials, even—in the aftermath of Art Spiegelman's *Maus*—comics have been the cultural forms that engage us with the catastrophic and traumatic history of the Holocaust. Through these cultural forms we have come to know events considered by some to defy the very possibility of historical, let alone aesthetic, representation.[5] Through these cultural forms we have come to bear witness, even if only obliquely and belatedly, to history.

But if cultural representations have been employed in mediating that history, configuring that history, bearing witness to that history, and coming to terms with that history, so too have cultural representations been implicated in normalizing that history, neutralizing that history, trivializing that history, commercializing that history, and exploiting that history. For as much as such cultural activity has resulted in work that respects and retains that aspect of historical trauma that remains radically, stubbornly, necessarily unassimilable, it has also resulted in the production of work that assimilates history into consumable commodity. Where there is Claude Lanzmann's 1985 *Shoah,* there is also Steven Spielberg's 1993 *Schindler's List.* Or, to return to Greenberg, where there is avant-garde culture, there is also kitsch.[6]

The problem with kitsch as a cultural category and strategy is primarily ethical, not aesthetic, as even Greenberg was able to recognize in the late 1930s, even if kitsch stood as emblematic of a cultural and social resistance to the work of what he considered an authentic avant-garde. Exploitable and, under fascism, exploited, kitsch gives a function to form, an agenda to aesthetics. Kitsch, when coupled with politics, produces culture as propaganda and propaganda as culture.

Kitsch is easy, sentimental, commercial. Coupled with a representation of history, it transforms its traumas into fictional melodramas, renders its catastrophes sites of catharsis. It forgoes the reflective and enduring encounter demanded by avant-garde culture and offers in its place the pleasure of instant gratification. Kitsch, when coupled with a representation of history, a history of fascism, of the Holocaust, of genocide, makes that history all too assimilable, digestible, consumable.

The problem, then, or the challenge of the work in *Mirroring Evil* is as much historical as it is art historical, as much ethical as it is aesthetic. For the work in this exhibition and catalogue brings together a compromised history of a cultural category with a tainted history of a European nation. The work embraces kitsch, whose lure was exploited to unprecedented ends in fascist aesthetics. And it uses kitsch to frame an encounter with the very history that exploited the aesthetic of kitsch with devastating historical consequences. In so doing, and in so doing with such readily assimilable and recognizable forms, the work in *Mirroring Evil* demonstrates that such a history, despite the ethical presumption of its radically unassimilable nature, *has* been assimilated, packaged, consumed, over and over again, in cultural form, for decades.

The challenge of the work in *Mirroring Evil* is that it makes manifest that the representation of the

Holocaust can be too easy. The work shows us just how easy it can be. The power of this work, or its potential, is that an experience of such immediacy and ease leaves us feeling profoundly uneasy. And in producing an experience of such ease and unease, in inserting us into that spectatorial dynamic and dialectic, the work forces us to contemplate the strategies of representation and the situations of encounter through which we have come to know the history it takes as its highly mediated subject. The work in *Mirroring Evil* forces us to think about the endless stream of media, the cultural screens, the viewing situations, through which we come to know not only history, *this* history, but the world.

Saul Friedlander, the historian of Nazism and the Holocaust, wrote in *Reflections of Nazism: An Essay on Kitsch and Death* (1982) that contemporary culture becomes the source of historical insight. Troubled by the increasing body of cultural work in the seventies, primarily filmic and literary, that took up the legacy of fascism, producing what he terms a "new discourse" on Nazism,[7] he concludes that it may well be the very representation of fascism in contemporary culture that allows the postwar historian to "perceive something of the psychological hold Nazism had in its day."[8] For even as he cringes at the cultural fascination with fascism, at the cultural reproduction of the intertwining of kitsch and death so fundamental to the ideology and aesthetic of Nazism, this "new discourse" on Nazism reveals to him "structures of the imagination" previously hidden to the historical gaze.[9]

Even as Friedlander moves to suspend judgment from this new cultural work on Nazism, focusing instead on its potential for furthering historical understanding, he does establish a set of criteria for judgment—namely, his own feelings of uneasiness before some of these cultural forms. There are aspects of this "new discourse" on Nazism that make Friedlander profoundly uncomfortable, that transgress some intangible threshold, some inchoate yet

intractable sense of decency, propriety, and limit. For Friedlander, and for other critics as well, it is Hans-Jürgen Syberberg's 1978 film *Hitler, A Film from Germany,* a phantasmagoric narrative of the catastrophes of European history, that occasions discomfort and allows for the articulation of aesthetic and ethical limit.[10] One such critical voice that stands out in the field is Susan Sontag's, whose work on kitsch both intersects with and emerges from her attention to fascist aesthetics. Given the strength and clarity of her ethical position, Friedlander turns to Sontag's work, finding a kindred spirit to affirm and confirm his own instincts as he struggles to articulate a set of aesthetic and ethical criteria.

Even before writing on fascism, aesthetics, and kitsch, Sontag had penned one of the most ethically acute responses to the history of fascism and genocide, reflecting on the issue of its representation, even if that representation took the presumptively unmediated form of the documentary photograph. In her essay "In Plato's Cave," republished in the collection *On Photography,* Sontag articulated her own sense of limit, recalling her response at happening upon a set of photographs of Bergen-Belsen and Dachau in a bookstore in Santa Monica in 1945. Reflecting on this moment of viewing, this act of witness, this loss of innocence, she wrote:

> Nothing I have seen—in photographs or in real life—ever cut me as sharply, deeply, instantaneously. Indeed, it seems plausible to me to divide my life into two parts, before I saw those photographs (I was twelve) and after, though it was several years before I understood fully what they were about. What good was served by seeing them? They were only photographs—of an event I had scarcely heard of and could do nothing to affect, of suffering I could hardly imagine and could do nothing to relieve. When I looked at those photographs, something broke. Some limit had been reached, and not only that of horror; I felt irrevocably grieved,

wounded, but a part of my feelings started to tighten; something went dead; something is still crying.[11]

It is not in these words of limit and lament but in Sontag's penetrating essay "Syberberg's Hitler"[12] that Friedlander finds a confirmation of his discomfort, of his uneasiness at the "new discourse" on fascism, emblematized for him in the endless chain of ravishing images that concludes Syberberg's film. It is in Sontag's work on aesthetic rather than documentary representations of history that Friedlander finds the words to express his fundamental discomfort about Syberberg's filmic enterprise:

> Attention has gradually shifted from the reevocation of Nazism as such, from the horror and the pain—even if muted by time and transformed into subdued grief and endless meditation—to voluptuous anguish and ravishing images, images one would like to see going on forever. It may result in a masterpiece, but a masterpiece that, one may feel, is tuned to the wrong key; in the midst of meditation rises a suspicion of complacency. Some kind of limit has been overstepped and uneasiness appears: It is a sign of the new discourse.[13]

One thing he makes clear is that the ability to hear if a work is tuned to the "wrong key" is a matter of personal judgment, even if he and Sontag hear in Syberberg's work the same sour note. It is also clear that Friedlander's and Sontag's shared aesthetic and ethical criteria emerge from work that evinces a certain return to Romanticism. Their criteria emerge from work that reanimates an aesthetics of sublimity and beauty, from work that indulges in aesthetic excess, from such work, were we to shift from the domain of film to that of art, as that of Syberberg's compatriot Anselm Kiefer.[14] In short, their criteria emerge from work very different from the post-Pop practice assembled in *Mirroring Evil*.

If there is an art-historical precedent for the very particular project of the work in this exhibition, it is not in the insistently material surfaces, the esoteric subjects, the weighty monumentality of Kiefer's sustained meditations on German cultural identity and its traumatic historical legacy. Rather, it is in the glib gestures, the provocative postures, of the nascent neo-avant-garde of the 1960s, which, in an attempt to resuscitate the transgressive project of the historical avant-garde, trafficked in the taboo, and, in some instances, flirted with fascism, in all its illicit fascination. Perhaps most interesting for a history of visual modernism and the avant-garde is that it is abstraction, Greenberg's privileged preserve of cultural value, that serves as a site of origin for such transgressive practices.

Think, for example, of Frank Stella's reductive geometric black paintings of 1959, poignant paragons of the project of modernist painting. In the resolute economy of their means the canvases stripped painting of its expressive and figurative claims, fulfilling, if only to empty, the premise and promise of Greenbergian modernism. Where Jackson Pollock might be said to have put forth a return to painting's origins with his energetic primordial abstractions, Stella presented its end, delivering in this series something like painting's essence and evacuation. A point of beginning for Stella, in a career that would be unrelenting in its formalist exploration of the possibilities of geometric abstraction, his series also marked a certain point of conclusion, an end to the high modernist enterprise. A series of repetitions whose renunciations and refusals were as much the mark of stubborn melancholia as of modernist purity, in his inaugural artistic gesture Stella produced painting after painting that was barren, if not bereft.

And yet, even as these dark paintings stood as epitaphs to the moribund painterly project of postwar abstraction, they came to life through a reference to death, through their titular invocations of,

Fig 1. Frank Stella, *Arbeit Macht Frei,* 1958. Black enamel
on canvas, 85" x 121". © 2001 Frank Stella/Artists Rights
Society (ARS). Courtesy of Leo Castelli Gallery, New York.

among other things, Nazism and the death camps. In
such paintings as *Arbeit Macht Frei* (fig. 1) and *Die
Fahne Hoch,* Stella conjured up, through the sheer
allusive power of the word, a history that was only
just entering the domain of postwar American cul-
tural representation. Painted before the intense
media attention to the Auschwitz trials in the early
1960s, Stella's black paintings closed out a decade
in America that knew the Holocaust most immedi-
ately and affectingly through such cultural markers
as the English translation of *The Diary of Anne Frank*
(1952) and its subsequent stage production in
1955.[15] Painted before a postwar American public
had grown increasingly desensitized to representa-
tions of history and its atrocities, titled before a

Fig 2. Maya Lin, *Vietnam Veterans Memorial,* 1981, Washington D.C. Photograph by Hank Savage.

postwar American public had grown increasingly inured to the cultural treatment of such taboo subjects, historical or otherwise, Stella's black paintings exploited history for its shock value, its novelty, its "grisly chic."[16]

From our position in the present, in which explicitly memorializing work has tended toward an aesthetics of visual restraint, toward an aesthetics of abstraction and absence in the pursuit of remembrance (for example, Maya Lin's *Vietnam Veterans Memorial*) (fig. 2), Stella's spare black paintings may seem almost manifestly memorializing in gesture.[17] They may be seen to present a pictorial solution to the historical omissions and elisions of New York School painting, offering up history against the

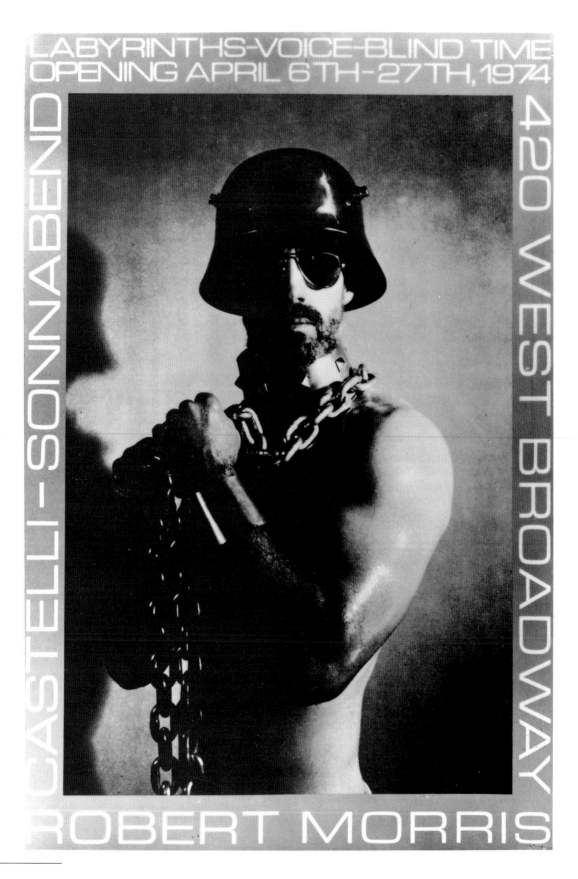

Fig 3. Robert Morris, *Untitled,* 1974. Offset lithography on
paper, 36¾" x 23⅞". © 2001 Robert Morris/Artists Rights
Society (ARS), New York.

blank face of abstraction, if only to foreclose its representation in a final emptying of painting's expressive possibilities. They may be seen, in an uncharacteristically Adornoesque moment, to have found a reductive pictorial language through which to commemorate the catastrophic historical events of the twentieth century. They may be seen to mourn not so much, or not only, the end of painting as the end of painting's capacity to figure history or bear witness to its traumas.[18]

And yet, the present is not the moment in which Stella's paintings were originally conceived or received. They were not a part of the manifestly memorializing culture that defines culture at the end of the millennium.[19] Instead, they were part of a culture that had barely begun the task of confronting the historical legacy of fascism and genocide. They were a part of a neo-avant-garde culture that flirted with fascism as a signifier of power, that trafficked in taboo as a gesture of defiance, that alluded to atrocity as an act of affront. If there is a context for Stella's early gesture, it is in the subsequent gestures of such fellow minimalists as Robert Morris, who pursued in a more sustained manner, in both sculptural and photographic form, the transgressive possibilities of fascism as signifier and subject.

In the 1960s, while Walter De Maria flirted with fascism in such works as *Museum Piece* (1966–67), a polished-aluminum sculpture in the shape of a swastika, Morris and other minimalists experimented with a more generalized aesthetics of violence and power.[20] Where Morris explored notions of entrapment and incarceration, discipline and punishment, in such works as the mesh steel cage *Untitled* (1967), Tony Smith aggressively occupied space with the imposing black steel cube *Die* (1962). But of these minimalist artists, it was Morris who continued to exploit the transgressive potential of fascism as referent, doing so in the most manifest and defiant of ways in a poster advertising his exhibition at the Castelli/Sonnabend Gallery in 1974 (fig. 3).[21]

It is in relation to this provocative poster that Sontag again emerges as a critical and ethical voice, turning to it in "Fascinating Fascism," her interrogation of what she diagnoses as a cultural fascination with fascism.[22] In that essay, Sontag expresses her discomfort at the postwar rehabilitation of the Nazi filmmaker Leni Riefenstahl, whose *Triumph of the Will* (1935) and *Olympia* (1938) emblematize for Sontag the Romantic excess, the idealization of beauty, the glorification of surrender, the glamorization of death so central to fascist aesthetics. But Sontag is even more unsettled by the popularization and eroticization of fascism that she finds in contemporary culture. And it is that phenomenon to which she devotes the latter half of her essay.

Troubled by her discovery of a pornographic magazine devoted to SS regalia, she links these photographs and the sexual subculture of sadomasochism to broader cultural patterns indicating a fascination with fascism, pointing to the literary work of Yukio Mishima and the films of Luchino Visconti and Liliana Cavani.[23] Within this discussion, Sontag isolates the work of Robert Morris, initially in the hope of finding a cultural model that performs differently. Sontag writes:

The solemn eroticizing of fascism must be distinguished from a sophisticated playing with cultural horror, where there is an element of the put-on. The poster Robert Morris made for his recent show at the Castelli Gallery is a photograph of the artist, naked to the waist, wearing dark glasses, what appears to be a Nazi helmet, and a spike collar, attached to which is a stout chain which he holds in his manacled, uplifted hands. Morris is said to have considered this to be the only image that still has any power to shock: a singular virtue to those who take for granted that art is a sequence of ever-fresh gestures of provocation. But the point of the poster is its own negation. Shocking people in the context also means inuring them, as Nazi material

enters the vast repertory of popular iconography usable for the ironic commentaries of Pop Art.[24]

Sontag turns to Morris in the interest of difference and as a gesture of defense. She isolates his very self-conscious citation and performance of fascist masculinity as distinct from a more general cultural appropriation of fascist motifs and regalia. Yet her analysis comes to suggest that even his knowing gesture fails. For even as Morris may take on fascism with utter awareness of its power as a shocking signifier, as taboo, his very act of representation participates in a cultural neutralization of that historical referent, inuring the public to the very subject he takes to be so transgressive.[25] And this inuring, this emptying, this neutralizing, as Sontag concludes, is the mechanism of Pop.

Certainly, there is a history of Pop-influenced and -inflected work that comes between Morris's poster in 1974 and the work assembled in *Mirroring Evil* at the dawning of a new millennium, just as there are traditions outside of America that pursue similar artistic ambitions. To mention just one such tradition, there is the work of such neo-avant-garde artists in Germany as Sigmar Polke and Gerhard Richter. Whether we look to Polke's inclusion of concentration camp guard towers in his signature silkscreen pastiches or to Richter's blurred black-and-white paintings of men in Nazi uniform drawn from amateur family photographs, they too may be said to participate in the appropriation and aestheticization of signifiers of fascism. They too may be said to constitute a tradition of mediating history in aesthetic, if not always popular, form.[26]

Given such a history, or histories, of representation, the work assembled here seems less a pointed provocation than a belated heir to an aesthetic project that began many years ago. The work assembled performs, as I have suggested, a repetition of motives and motifs that have already entered the cultural domain, and, more particularly, the aesthetic domain. In that sense, the issues at stake in

Mirroring Evil are ultimately as aesthetic as they are ethical, even as I have tended to stress the ethical over the aesthetic. For the subjects of representation and the representational strategies used to depict those subjects are as burdened by the history of art as they are by history. Even as the artists assembled in *Mirroring Evil* define their place in history, and in a history of postwar culture, by the forthrightness with which they explore and exploit the cultural imaginary and commodity that is the history of fascism and genocide, they are by no means the first. Their flirtation with the fascination of fascism, with the aesthetics of fascism and the fascism of aesthetics, sees its precedent, if not its origins, in a history of cultural representations, artistic and otherwise, that precede, if not predict, their own. Their work is but another instance of a cultural engagement with a subject that will continue to press the limits of representation, even as that engagement continues to be delimited by the pressures of representation, by the limits and limitations of form.

I would like to conclude by returning to Clement Greenberg's essay "Avant-Garde and Kitsch." In its introductory paragraphs, in words that are perhaps more relevant now than they were in 1939, Greenberg writes:

> A society, as it becomes less and less able, in the course of its development, to justify the inevitability of its particular forms, breaks up the accepted notions upon which artists and writers must depend in large part for communication with their audiences. It becomes difficult to assume anything. All the verities involved by religion, authority, tradition, style, are thrown into question, and the writer or artist is no longer able to estimate the response of his audience to the symbols and references with which he works.[27]

With the work in *Mirroring Evil* we are confronted with one such cultural and social moment. All the verities are thrown into question. And despite the

power of the historical referent, we are no longer able to estimate the response of an audience to the symbols and references contained therein. We may only hope that, in bringing these works together, in confronting an audience with such historical subjects and aesthetic strategies, certain critical questions will be asked, even if certain cherished verities may not be restored. And if that is the challenge of the work here, it is also its lasting contribution.

NOTES

1. Clement Greenberg, "Avant-Garde and Kitsch" (1939), in *Art and Culture: Critical Essays* (Boston: Beacon Press, 1961), 3–21.

2. Written with a political purpose absent from his later work of expressly formalist criticism, Greenberg's analysis of culture and politics has moments of uncanny resonance with Walter Benjamin's 1936 essay "The Work of Art in the Age of Mechanical Reproduction"; see *Illuminations,* trans. Harry Zohn (New York: Schocken Books, 1969), 217–52. In his concern for culture under industrial capitalism, exemplified in the extreme in the fascist regimes of Mussolini and Hitler, Greenberg looks to socialism as a means of countering the exploitation of mass aesthetics. I am certainly not suggesting that Greenberg, despite his work in translation during that period, read Benjamin, whose essay, although published in 1936 in the *Zeitschrift für Sozialforschung,* was not translated into English until 1968. But it is interesting to consider the point of congruence between two fundamentally distinctive cultural critics.

3. Greenberg, "Avant-Garde and Kitsch," 19.

4. As the work of Marxist art historians has revealed, even abstraction was not immune to ideology. For discussions of the relationship of New York School painting to Cold War politics, see, for example, the foundational work of Serge Guilbaut, Eva Cockcroft, and Max Kozloff, reprinted in *Pollock and After: The Critical Debate,* ed. Francis Frascina (New York: Harper & Row, 1985).

5. Certainly, Theodor Adorno's later qualified, if not regretted, postwar dictum "After Auschwitz, to write a poem is barbaric" has played a powerful role in the ethical and aesthetic debates surrounding (aesthetic) representation after Auschwitz. For a discussion, see "'Thou shalt not make graven images': Adorno, Kiefer and the Ethics of Representation," in my *Anselm Kiefer and Art after Auschwitz* (Cambridge and New York: Cambridge University Press, 1999), 17–47. Of course, Adorno is not alone in shaping postwar debates about ethics

and aesthetics. His voice is joined by those of Elie Wiesel, Primo Levi, Jean Améry, and George Steiner, to name just a few of the most prominent and influential figures.

6. As Greenberg wrote: "Where there is an avant-garde, generally we also find a rear-guard. True enough—simultaneously with the entrance of the avant-garde, a second new cultural phenomenon appeared in the industrial West: that thing to which Germans give the wonderful name of *Kitsch:* popular, commercial art and literature with their chromeotypes, magazine covers, illustrations, ads, slick and pulp fiction, comics, Tin Pan Alley music, tap dancing, Hollywood movies, etc., etc."; "Avant-Garde and Kitsch," 9.

7. Saul Friedlander, *Reflections of Nazism: An Essay on Kitsch and Death,* trans. Thomas Weyr (Bloomington and Indianapolis: Indiana University Press, 1984), 13.

8. Ibid., 18.

9. Ibid., 19.

10. For a treatment of this reception history, see Klaus Eder, *Syberberg's Hitler-Film* (Munich: Carl Hanser Verlag, 1980). Briefly, critics found Syberberg's phantasmagoric narrative of the catastrophes of European history not only reactionary but politically naïve. That is to say, they found his film mythologizing the very history that was its purported subject.

11. Susan Sontag, "In Plato's Cave," in *On Photography* (New York: Farrar, Straus & Giroux, 1977), 20.

12. Susan Sontag, "Syberberg's Hitler," in *Under the Sign of Saturn* (New York: Farrar, Straus & Giroux, 1980), 137–65.

13. Friedlander, *Reflections of Nazism,* 21.

14. Saul Friedlander, "Introduction," in Saul Friedlander, ed., *Probing the Limits of Representation: Nazism and the "Final Solution"* (Cambridge: Harvard University Press, 1992), 1–21. In that introduction, written ten years after *Reflections of Nazism,* Friedlander returns to the issue of Syberberg's films. Still consumed by the spellbinding, at times numbing force of Syberberg's insistently Romantic cinematic aesthetic, Friedlander makes reference, if only in a footnote, to the paintings of Anselm Kiefer, suggesting at once their fundamental similarity yet difference (337).

15. For the most recent, if polemical and cynical, account of the American cultural reception of the Holocaust, see Peter Novick, *The Holocaust in American Life* (Boston: Houghton Mifflin, 1999).

16. The phrase is Hal Foster's, from an essay on German neo-expressionism and its use of fascist motifs; see his *Recodings: Art, Spectacle, Cultural Politics* (Seattle: Bay Press, 1985), 42.

17. For a treatment of Holocaust memorials and the degree to which they embody an aesthetics of absence and restraint, particularly those in Germany in the 1980s, see James E. Young, *The Texture of Memory: Holocaust Memorials and Meaning* (New Haven and London: Yale University Press, 1993).

18. For an insightful and incisive interpretation and critique of Stella's black paintings, as well as the work of his fellow male minimalists, see Anna C. Chave, "Minimalism and the Rhetoric of Power," *Arts Magazine* 64, no. 5 (January 1990): 44–63.

19. For but a few treatments of this contemporary cultural condition, see Mieke Bal, Jonathan Crewe, and Leo Spitzer, eds., *Acts of Memory: Cultural Recall in the Present* (Hanover, N.H., and London: University Press of New England, 1999); Andreas Huyssen, *Twilight Memories: Marking Time in a Culture of Amnesia* (New York and London: Routledge, 1995); Marita Sturken, *Tangled Memories: The Vietnam War, the AIDS Epidemic, and the Politics of Remembering* (Berkeley, Los Angeles, and London: University of California Press, 1997); and "Constructions of Memory: On Monuments Old and New," a special issue of *Harvard Design Magazine* (Fall 1999).

20. See Chave, "Minimalism and the Rhetoric of Power," for a discussion of such minimalist work. Hers is the first to pursue an insistently feminist and political reading of that body of work. Most important, it is written against the reigning formalist accounts of the period. In attending to issues of title, signification, and subject, as well as issues of form, Chave lays bare the aesthetics of power, violence, and masculinity both manifest and implicit in minimalist work.

21. Morris continued to explore the seductions of fascism as aesthetic subject, turning to representations of corpses and conflagration in his altarlike sculptural pieces from the 1980s.

22. Susan Sontag, "Fascinating Fascism," in *Under the Sign of Saturn,* 73–105.

23. Against Sontag (although Sontag does not emerge as a point of reference in the article) is Jean-Pierre Geuens, "Pornography and the Holocaust: The Last Transgression," *Film Criticism* 20 (Fall–Winter 1996): 114–30. In his essay, Geuens contends that even the most exploitative, Sadeian, pornographic films involving images and scenarios indebted to a history of fascism do not go far enough. He concludes his essay by stating that "the wounds should be repeatedly and mercilessly stabbed open with a knife for the Holocaust to remain the mirror that truly defies our limits" (127).

24. Sontag, "Fascinating Fascism," 101.

25. Much as Anna Chave has changed our understanding of the history of minimalism with her 1990 article "Minimalism and the Rhetoric of Power," she has continued that quest in her article "Minimalism and Biography," *Art Bulletin* 82, no. 1 (March 2000): 117–48. There, she deepens her investigation of the period by including biographical information about not only its practitioners but its critical proponents. One piece that is further illuminated by her work is the Robert Morris photograph in question.

26. It bears noting, if only for what admittedly may be the shock value of such a revelation, that there exists a body of pornographic Holocaust literature in Israel, the foremost example of which is authored by a Holocaust survivor. For a discussion of that work, see Omer Bartov, "Kitsch and Sadism in Ka-Tzetnik's Other Planet: Israeli Youth Imagine the Holocaust," *Jewish Social Studies* 3 (Winter 1997): 42–76.

27. Greenberg, "Avant-Garde and Kitsch," 3–4.

Playing the Holocaust

ERNST VAN ALPHEN

PLAYACTING AND TOYS

n an interview in 1994 the French artist Christian Boltanski declared that

all his work was "more or less about the Holocaust."

This is not particularly surprising, in terms of the

work he began making in 1984. His installations,

generically titled *Shadows, Candles, Monuments,*

Canada, and *Reserve,* evoke the Holocaust com-

pellingly. But the statement isn't as obvious when

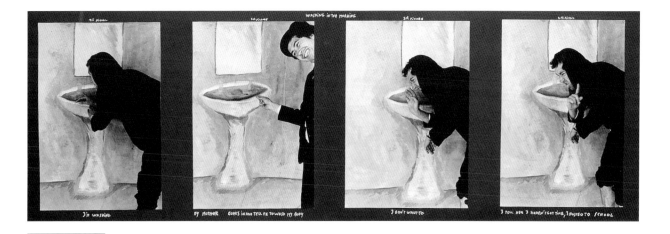

Fig. 1. Christian Boltanski. *Washing in the Morning,* from
the Comic Sketches, 1974. Watercolor and crayon on
black-and-white photograph, 39¾" x 30". Courtesy of
Marian Goodman Gallery and the artist.

applied to his earlier work. Just how do the Model
Images (1975) or the Comic Sketches (1974) relate
to the Holocaust?

Model Images shows ordinary snapshots from the
seventies, ones that are common in photo albums of
almost anyone who lived then in western Europe,
Canada, or the United States. Their normality is the
opposite of the apocalyptic horror of the Holocaust.
In the Comic Sketches of 1974 (fig. 1), a series of
stage photographs, Boltanski humorously playacts
ordinary scenes from childhood.

In *The Shameful Kiss,* for instance, he plays a boy
who meets a girl at the beach. He wants to kiss her,
but he is too shy. In *The First Communion* we see
Boltanski playing a young boy who receives the host
from a priest. In *The Doctor's Visit* we see him as a
boy who is ill. His mother is worried and calls for the
doctor, who comes and says that although the little
one is very ill, it is not serious. This is a great relief
to the mother.[1] In short, the Comic Sketches show
scenes that can be recognized by practically every-
one. They are the most ordinary and archetypal
childhood scenes imaginable.

Fig. 2. David Levinthal, *Untitled #13* from the Mein Kampf series, 1994–96. Color photograph. Courtesy of David Levinthal Studios. Photograph by Jason Burch.
Fig. 3. David Levinthal, *Untitled #33* from the Hitler Moves East series, 1977. Color photograph. Courtesy of David Levinthal Studios. Photograph by Jason Burch.

There is, however, a remarkable difference between the Model Images and the Comic Sketches. In the Model Images, Boltanski used found snapshots. Moreover, the images we see are "serious," not comic. The scenes in the Comic Sketches, in contrast, are playacted. Importantly, all the roles are played by Boltanski wearing the same dark suit. By adding something simple to this outfit he can become another character—with glasses, a doctor; with a hat and flower, a mother. This minimalist play of distinguishing characters, together with the facial expressions, makes the scenes comical.

It is this aspect of play that interests me. In the Comic Sketches Boltanski, the child of a Jewish father who survived the Holocaust through hiding, foreshadows a younger generation of artists whose work deals with the Holocaust "playfully." These artists are second- or third-generation descendants of survivors or bystanders, and they use play or toys to represent the Holocaust or Nazi Germany.

I would like to single out three of these artists. The first is David Levinthal, who photographed scenes from Auschwitz in his Mein Kampf series (1994–96; fig. 2), staged by means of little dolls or figurines. The figurines remind us of the little tin soldiers, for decades a popular toy for young boys and a collectors' item for adult men. In a work that he made with Garry Trudeau titled *Hitler Moves East* (1977; fig. 3), Levinthal represented, in the same way, Operation Barbarossa, Hitler's invasion of the Soviet Union in 1941. The second artist is the Israeli/Dutch Ram Katzir, who made a series of

Fig. 4. Ram Katzir, Image from *Your Coloring Book,* 1996.
Courtesy of Ram Katzir. A page colored in by a visitor to
the Israel Museum, Jerusalem, 1996.

installations in which the audience was invited to
color the images of a coloring book or to make addi-
tions to it (fig. 4). The images were based on Nazi
photographs or documentary Holocaust images. The
third, Polish artist Zbigniew Libera, made *LEGO Con-
centration Camp Set* (fig. 5), consisting of seven
boxes of different sizes from which a miniature con-
centration camp can be built.

These artists represent a group and their work a
particular genre. This genre has a specific epistemic-
artistic thrust, and the artworks raise a question:
What is the function of play in Holocaust representa-
tion? Since Holocaust art centers on the question of
remembrance, I rephrase this question more

provocatively: Is there a place for "playing" the Holocaust in Holocaust remembrance? The issue of generation is important. Until these artists came along, representing the Holocaust playfully had been taboo. Now it seems that a new generation of artists can relate to the Holocaust only in the mode of play. Why does the toy as memory occur now? What does it mean, and how can we evaluate this phenomenon in terms of remembrance?

I broach this issue through the question of Boltanski's playful Comic Sketches. Taking the artist's statement "all my work is more or less about the Holocaust," I am interested in speculating in what way these pictures relate to the Holocaust. Again, the exaggerated poses of his characters and the rather silly events they enact evoke collective, ordinary notions of childhood and parenthood. They don't represent the specificity of Boltanski's autobiographical childhood nor the situation of children in the Holocaust. I contend that their generic and ordinary plots are precisely the point.

For their point is replacement. By their normality, these Comic Sketches actively and playfully replace the abnormality that we expect of "Holocaust sketches" with sketches of ordinary childhood and parenthood. In an interview with Paul Bradley, Charles Esche, and Nicole White, Boltanski says the following about his work:

CB: When I am doing art, I am a liar and I am mostly an awful professional artist, disgusting, it is my job. . . . it is true that I really wanted to forget my childhood. I have spoken a lot about a childhood, but it was not my childhood. It was a normal childhood. I never spoke about something that was true, and in my art at the beginning it seemed biographical but nothing was true, and I was never speaking about the fact that I was Jewish or that it was impossible for my mother to move because she had polio. I never spoke about that and I never spoke about my weird grandmother. When I

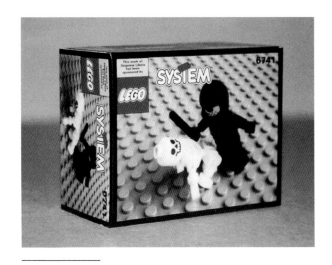

Fig. 5. Zbigniew Libera, *LEGO Concentration Camp Set,* detail, 1996.

spoke about my childhood, it was this normal childhood and when I decided to make a photo album, I chose the photo album of my friend called Durrant because Durrant is just Smith in England, Durrant is nobody, just a normal French man.

NW: Is this a way to re-create a better childhood?

CB: To erase and forget my own childhood. You know it was so tough, it was so awful, I mean all our parents are awful, but my father was so awful, my mother was so awful.

NW: But it is not just to forget, but to make something better.

CB: Yes, just normal.[2]

In this interview Boltanski again refuses to say anything specific about his childhood, only that his father was awful and his mother was awful. That's it. In doing so, he suggests that all parents are awful, your own always a bit worse than others. What he makes clear is that, for him, art is a mode of telling lies. Art does not represent reality, autobiographical or not. Instead, it is a mode of transforming an insufferable reality into something normal—something sufferable. Art is not mimetic, but performative instead. This makes it easier to understand how the Comic Sketches are works of art "about the Holocaust." In post-Holocaust culture they act upon an intense desire for normality.

Boltanski's remarks also clarify that within his oeuvre the Comic Sketches are not at all unique. They are not divergent because of their playfulness. On the contrary, they are emblematic of all his work, including the work he made in the late eighties and nineties. In another interview he explains how this is possible:

At the time of the *Saynetes Comiques* [Comic Sketches] I was asking myself questions about the nature of representation and the double meaning of the verb "to play." [. . .] In a small book of 1974,

Quelques interprétations par Christian Boltanski I ask myself what differentiates the act of someone who drinks a glass of water and an actor's interpretation of someone drinking a glass of water. I realized that art consisted of making something with the intention of demonstrating the reality of these two situations.[3]

The Comic Sketches emphasize an aspect of art that, for Boltanski, defines art as such. Art is "play" and "play" is its reality. The reality of play is fundamentally different from the reality that art mimetically refers to. This early work, then, has an artistic manifesto inscribed in its silly childishness.

In Boltanski's work, the notion of art as play has never been controversial. When this aspect of art becomes its theme, as happens in the Comic Sketches, the reference to the Holocaust is invisible or at most implicit. But that thematic restraint differs with a younger generation of artists that includes Levinthal, Katzir, and Libera. These artists enact the Holocaust playfully, with emphatic explicitness, using toys. Toys stand for the lightheartedness of children, the opposite of serious adult behavior. In this respect, we cannot ignore the "serious" dark suit that Boltanski wears beneath his children's attributes. In the context of modern art, toys are often considered bizarre or of marginal interest, but in the context of Holocaust representation they are provocative, even scandalous.

The work of Katzir and Libera has been extraordinarily controversial, especially because of the places where the art has been shown. When Katzir showed his installation *Your Coloring Book* in 1997 in the Israel Museum in Jerusalem, questions were even asked in the Knesset about how the installation might shock and hurt. Some people urged that it be closed down.[4] And when Libera showed and discussed his work in 1997 in Brussels at a conference on contemporary art and the Holocaust organized by the Fondation Auschwitz, many were scandalized.

Holocaust survivors in the audience became so emotional that they had to leave the room. Throughout the conference, people could not stop discussing the controversial nature of Libera's work.[5]

It seems safe to assume that artworks on the theme of the Holocaust using toys are controversial by definition because of the function automatically attributed to Holocaust art. Unlike other art that can claim autonomy or self-reflexivity, Holocaust art tends to be unreflectively reduced to how it can promote Holocaust education and remembrance. Art, teaching, and remembrance are thus collapsed without any sustained debate about the bond between these three cultural activities. In the context of Holocaust education and remembrance, it is an unassailable axiom that historical genres and discourses, such as the documentary, memoir, testimony, or monument, are much more effective and morally responsible in teaching the historical events than imaginative discourses. Accordingly, art in general is already problematic because it is imaginative, not documentary.[6]

This objection to artistic engagement with the Holocaust holds much more strongly for toy art. Obviously, if art is not "serious" enough in terms of historical reconstruction, it is clear that within the realm of the imaginative, toys represent the lowest and least respected activity. For they can be seen as doubly imaginative—as things to play with and to play out, as toys and as art. Fictional Holocaust novels also are problematic, as the controversies around Jerzy Kosinski's *The Painted Bird,* D. M. Thomas's *The White Hotel,* or Helen Darville's *The Hand That Signed the Paper* have shown. But at least such novels can teach something about the past, even though they are fiction. That is the why the hybrid genre of the historical novel has gained respect and popularity.

Other hybrid genres are not so lucky. Roberto Benigni's film *Life Is Beautiful* (1998), mixing the discourse of the Holocaust with that of fairy tales, caused great controversy because it was not histori-

cally engaged enough. The cardboard sets mocked realism; the script, the acting, and the filming itself emphasized that the film was a dramatic, slightly kitschy fairy tale. Ignoring the cinematic genre that the film itself flaunted, it was judged on the basis of its truthfulness, a test it could only fail and emphatically sought to fail. Hence, the play the father engaged in with his child to save him from the horrors around him was not seen as pedagogically interesting, as a refusal to subject the child to events his childhood entitled him to stay clear of, but as unrealistic. Sander Gilman, for instance, dismissed Benigni's film on such grounds: "Not purposeful action by adults but the accident of chance allows children to survive, and this underpins the falsity of Roberto Benigni's *claim.* . . . Benigni's *promise* is that there are no accidents, that at the end of the comedy the gods in the machine will arrive to resolve the action and rescue those in danger."[7] I have emphasized words that demonstrate Gilman's attribution of a realistic intention (claim) as well as a childish attitude of expectation (promise). This kind of misrepresentation is even more absurd for toy art. For one of the remarkable features of toy art is that it cannot be compared to such representational genres as novels and films or other narrative material used for education. Toys don't tell. But what do they teach? Do they teach at all, or do they do something else?

TEACHING AS A CULTURAL ACTIVITY

In order to understand if and how toys teach, and what they teach if they do, it is necessary to reflect on teaching as a cultural activity, especially the role teaching plays in Holocaust remembrance. As Shoshana Felman has argued, "Western pedagogy can be said to culminate in Hegel's philosophical didacticism: the Hegelian concept of 'Absolute knowledge' [. . .] is in effect what pedagogy has

always aimed for as its ideal: the exhaustion—through methodical investigation—of all there is to know; the absolute completion—termination—of apprenticeship. Complete and totally appropriated knowledge will become—in all senses of the word—a *mastery*."[8]

Learning, according to this traditional conception, is linear, cumulative, and progressive, and leads to mastery of the subject studied. Mastery over the Holocaust is, indeed, one of the main motivations behind Holocaust education. In order to prevent something like the Holocaust from happening again, later generations have to have as much knowledge as possible about the Holocaust. It is through knowledge that one can "master" the Holocaust. This conception of teaching assumes a collapse of two forms of mastery: to know and to dominate. If the past is known, the future can be dominated, kept under control.

But it is precisely that mastery that seems to fail in the face of the Holocaust. Ram Katzir, for instance, noticed the overfamiliarity with Nazi and anti-Nazi propaganda in the Israeli schools he attended. Even the most shocking images have been robbed of the power to move or to create serious attention by being turned into just another school subject. In response to that education, he felt the need to revitalize Nazi photographs by using them as models for a coloring book. Boredom, not mastery, seems to be the result of the Holocaust education Katzir received. Holocaust teaching and remembrance in Poland had a similar effect on Zbigniew Libera. At the conference on contemporary art and the Holocaust organized by the Fondation Auschwitz in Brussels, he defended his art as follows: "Of course, I was born fifteen years after the war and sometimes people call my art 'toxic' and actually it is toxic. But why? Because I am poisoned, I am poisoned of it. And that's all."[9] Poisoning, like boredom, is the opposite of mastery, for it weakens a person. The weakened person can no longer master

himself or herself. The person becomes unfit to master what is being studied. But, as Plato and, later, Jacques Derrida show as they borrow a metaphor from medicine, poison also can heal by homeopathy.

I completely sympathize with this negative assessment of Holocaust education. Elsewhere I have written about the effect Holocaust education in the Netherlands has had on me.[10] As someone born in the Netherlands in 1958, who attended primary and high school in the 1960s and early 1970s in the same country, I had the memory of World War II and the Holocaust drummed into my mind. Or rather, the Dutch school system tried to do so. But these efforts failed. I was bored to death by all the stories and images of that war, which were held out to me "officially" as moral warnings. At school we were shown documentaries on the war. Our teachers encouraged us to read books that informed us in great detail of what had happened not so very long ago. But I avoided my society's official war narratives. Until quite recently, for instance, I had refused to read *The Diary of Anne Frank*.

The kind of Holocaust teaching that Katzir, Libera, and myself have been exposed to fails because of two misconceptions. The first concerns the goal of teaching. That goal cannot be reduced exclusively to the mastery of a subject. Moreover, mastery as knowledge does not entail mastery as control. The second misconception concerns the nature of the Holocaust. The Holocaust is not just a history of memory that can be mastered by memorizing it. If that is impossible, the Holocaust cannot be taught along traditional pedagogical lines. For as we know, the traditional conception of learning implies first remembering and memorizing. The Holocaust, in contrast, is first and foremost a history of trauma, that is, a history of nonmastery. Teaching a history of trauma means teaching knowledge that is not in mastery of itself. Felman's assessment of literary knowledge and its implications for teaching this knowledge seem also a precise assessment of Holo-

caust teaching. This teaching *"knows it knows, but does not know the meaning of its knowledge—does not know what it knows."*[11] In other words, Holocaust teaching confronts us with the problem of how to master by teaching a past that has not been mastered yet and cannot be mastered.

Felman analyzes the dominant conception of teaching within a framework that asks whether psychoanalysis has renewed the questions and the practice of teaching. Unlike traditional methods and assumptions of education, she sees psychoanalysis as a radically new pedagogy. But in light of the traumatic, hence nonmasterable nature of the Holocaust, her remarks on psychoanalysis as a mode of teaching can also provide a model for Holocaust teaching. It can provide a model, that is, for teaching knowledge which is not in possession of itself. "Psychoanalysis is thus a pedagogical experience: as a process which gives access to new knowledge hitherto denied to consciousness, it affords what might be called a lesson in cognition (and in miscognition), an epistemological instruction."[12] The mode of learning practiced by psychoanalysis is radically different from the view that learning is a simple one-way road from ignorance to knowledge. It proceeds not through linear progression but through "breakthroughs, leaps, discontinuities, regressions, and deferred action."[13] This teaching has nothing in common with the transmission of readymade knowledge. It is, rather, the creation of a new condition of knowledge—the creation of an original learning disposition.[14] This disposition is "new" in the ways it handles and structures repression. And, as those familiar with the psychology of child rearing know, repression is one of the most important strategies of traditional pedagogy. Freud understood how an excessive practice of such repressive pedagogy breeds mental illness. He wrote:

The child must learn to control his instincts. It is impossible to give him liberty to carry out all his impulses without restriction. . . . Accordingly, *education must inhibit, forbid and suppress* and this is abundantly seen in all periods of history. But we have learnt from analysis that precisely this suppression of instincts involves the risk of neurotic illness. . . . That education has to find its way between the Scylla of non-interference and the Charybdis of frustration. . . . An optimum must be discovered which will enable education to achieve the most and damage the least. . . . A moment's reflection tells us that hitherto education has fulfilled its task very badly and has done children great damage.[15]

Freud's definition of overrepressive education, as structured by prohibitions and suppression, seems to have become the explicit guideline or epigraph for Holocaust education. In the education of the Holocaust, prohibitions usually take the form of their binary opposite: They are articulated as orders or commands. Those orders together constitute a Holocaust "etiquette," according to Sander Gilman.[16] But his own indignation in the face of a film like Benigni's that disobeys this "etiquette" demonstrates that the rules also entail prohibitions.

The moral imperative of the prescriptions for "respectable" Holocaust education and studies is more than explicit in the formulations of Terrence Des Pres. Appropriating, in a nice case of interdiscursive heterogeneity, the voice of God in his use of the "genre" of the Commandments, he dictates:

1) The Holocaust shall be represented, in its totality, as a unique event, as a special case and kingdom of its own, above or below or apart from history.

2) Representations of the Holocaust shall be as accurate and faithful as possible to the facts and conditions of the event, without change or manipulation for any reason—artistic reasons included.

3) The Holocaust shall be approached as a solemn or even sacred event, with a seriousness admitting no

response that might obscure its enormity or dishonor its dead.[17]

No wonder that later generations get a bit restless under such weight. The Holocaust art using toys may be a conscious violation of these commandments and their complementary prohibitions.

First of all, Levinthal, Libera, and Katzir represent the Holocaust not as "unique" but as a historical object that can be toyed with, one that is exchangeable with, let's say, the Wild West, knights and medieval castles, pirates and pirate ships. Second, accuracy and faithful representation do not appear to have a high priority in their artworks. That lack of representational truthfulness does not imply that these toy artworks can be blamed for being the product of Holocaust denial. They are not untrue. In logical terms they are neither true nor false. For they are not propositional statements. But something other than accuracy or historical truth is at stake. Third, the works seem to actively ignore the seriousness related to the Holocaust as "solemn or sacred event." Instead, these artworks make us imagine (and feel) the pleasure certain toys can provide. The toys imply pleasurable activities: identification and impersonation or playacting. They run against the grain of traditional teaching. But then, is this art at fault, or is such teaching?

IDENTIFYING WITH THE PERPETRATOR

To further probe the relationship between toy art and pedagogy, a tension must be acknowledged between the representation of documentation on the one hand, and identification on the other. Representation traditionally uses strategies that promote identification, but the relation is not reversible. Identification can be brought about outside the realm of representation. In the case of the artworks under discussion, indeed, identification is solicited while representation is at best mocked or otherwise discarded. The issue of identification becomes ticklish. First, *identification* predominates in the mode of looking that is stimulated by the works, at the expense of *representation*. Second, the target of identification has shifted in a drastic and rather shocking way, from that of the victim to that of the perpetrator. These two aspects of identification—its centrality and its predominance over representation and its shifted target—are inextricably bound together. They change Holocaust remembrance, art's role in it, and identification itself.

Presenting these artworks as toys (Libera and Katzir) or as images of toys (Levinthal) stimulates the viewer to envision herself or himself in a situation comparable to the "real" situation. Identification replaces mastery. So, the distance from the past required for mastery and which in Holocaust representation is so tenaciously guarded in the preference for historical genres and solemn tones—even, as we have seen, religiously so, speaking in a divine voice—is not respected but provocatively challenged.

But the use of identification as a pedagogical tool is not problematic, or ticklish, as such. Recently, it has been applied in several Holocaust museums in order to make visitors imagine what it meant to be victimized. For instance, in the Holocaust Museum in Washington, D.C., the itinerary leads visitors through a cattle car. The experience of being transported to the camps by cattle cars is not being told about or shown at a distance but is thrust upon the visitors. Inside a cattle car, identifying with those who were transported to the camps by those cars is almost unavoidable. In that museum, the kind of identification that is allowed, and even stimulated, is identification with the victims, not with the victimizers. But of course, in the context of an outing to a museum, such identification is not "real," not total, but partial. Getting a small and short taste of the experience, a tiny bit of the poison, is the goal.

What if the object of identification consists of the victimizers instead? The toy artworks under discussion facilitate identification not with the victims but rather with the perpetrators. This is, of course, much more difficult to do, as well as to justify. How do the toy artworks accomplish this, and how can it be argued that this is helpful for the cultural remembrance of the Holocaust? In other words, how can this unsettling kind of identification be an effective form of pedagogy? One way to achieve this identification with an undesirable position is through making, shaping, and forming the perpetrators. The visitors of Katzir's installations were invited to color in images based on Nazi photography. We as visitors are coloring Nazi leaders or members of the Nazi youth: we are giving them color, form, and substance, and in that process we "generate" them. This making of the Nazis is a convoluted yet real form of identification. In creating the perpetrators, we as visitors become somewhat complicit in the *possibility* of the Nazis—not, of course, with *actual* Nazis.

Libera deploys a different technique so visitors get a small taste of identification with the perpetrators. His *LEGO Concentration Camp Set* stimulates visitors of the museum or the gallery to envision the possibility of building their own concentration camp. Again viewers are put in the shoes of the victimizers, not of the victims. Here the identification concerns the acts perpetrated, conceiving of and constructing the physical tools of the Holocaust.

Levinthal's photographs are at first sight more ambiguous. His scenes of "playing the Holocaust" seem to facilitate identification with victims as well as with perpetrators. But the moment we start to take the title of these photographs into consideration (*Mein Kampf*) the ambiguity evaporates, and we end up with an enforced identification with Hitler, the author of *Mein Kampf*. We each have our own *Kampf,* our own ambitions that can be catastrophic. Here the identification triggers the ideological mindset out of which the historical disaster sprung.

This feature of toy art calls for extending the genre or linking it to a neighboring genre. Based on the artistic strategy of soliciting identification with the perpetrator, I claim a generic grouping on a much larger scale. Other art becomes understandable under the aegis of toy art. For example, the Israeli artist Roee Rosen's installation *Live and Die as Eva Braun* (1995) activates this mode and way of looking without the framework of toys and children and their emphatic relation to pedagogy. His installation consists of brief texts, printed in white letters on black columnlike strips that run from floor to ceiling. Between the text columns hang sixty black-and-white works on paper. The texts are written in the second person. This is a powerful semiotic mode to entice the addressee to respond to and hence endorse a position. This "message," although emanating from the first-person voice who is doing the addressing, may so strongly engage the second person—for example, for the first person to completely identify with the second—that endorsing the position put forward becomes hard to resist.[18]

This is the powerful rhetoric that Rosen deploys for the visitor to achieve identification—again, just a bit of it—with Eva Braun. The texts address the viewer. But they also address the historical figure Eva Braun, inviting the visitor to "become" Hitler's mistress, Eva Braun:

Excitement jolts through your body when you hear the steps outside. When he opens the door you gasp at the sight of his small mustache. Because you are not only Eva it seems menacing, almost monstrous. But everything around the mustache is so congenial. He comes towards you with such warmth, his smile tired, his arms open to embrace you. Remember—you are Eva. When Hitler closes his arms around you, the view darkens and you are almost overwhelmed with titillation when you feel the whiskers of that famous little facial tuft tickle your ear and the back of your neck.

Unlikely as it seems, this text so insists on intensely human qualities—warmth, a tired smile—so that identification on the part of "you," the second person, with the addressee of the text becomes quite plausible. The viewer *is* Eva Braun and he or she *is not*: "Because you are not only Eva it seems menacing." What is menacing is precisely the schizophrenic identification with someone you really don't want to be. The threat of collapse of two incompatible positions that nevertheless coincide is unsettling. Like the identification with the victims triggered by the cattle car installations at the Holocaust Museum, the identification is just a small taste of the actual experience. But unlike the cattle car, Rosen's work makes this restriction explicit. Moreover, focusing on Hitler's little mustache opens the story to a rather heavy-handed irony. These two devices create a small, bearable measure of identification and are Rosen's way of being a responsible educator. Nevertheless, identification and distance are being exchanged. This rhythm of alternation facilitates reflection on the experience of identifying with Eva Braun.

The texts follow a linear narrative. First, along with Eva Braun, the viewer experiences moments of romantic intimacy and sexual pleasure; then he or she is invited to co-experience Eva's suicide. The end of the story consists of a short trip to hell:

There's no question, you are being led to hell—but why?

As you wait for your tortures to be set, you view some of the other sinners. Particularly arresting is a group of two-dimensional people hanged by their sinning organs—hair, genitalia, breasts, tongues.

You realize with some dismay that hell seems to be based on a famous painting.

How would you be hanged? What of you should be minced, sliced, burnt? What, in your eager perfection, in your life dedicated to willful servitude, in your quiet harmony, is eternally punishable and damned?

All the events the viewer is asked to experience are totally set in the realm of affect and the physical: eroticism, sexual pleasure, suicide, and torture. This is precisely the point.

An artwork like Rosen's based on the Holocaust cannot be dealt with simply in the framework of art and aestheticism; the debate on Holocaust education and remembrance are inevitably activated. This makes cultural clichés acutely problematic. For it can be argued that, regardless of that context, the texts are, here and there, obscene. This obscenity produces a clash, again, a challenge to the solemnity of Holocaust education.

As Roger Rothman has pointed out, however, it is not in the context of art but in the context of Holocaust remembrance that Rosen's *Live and Die as Eva Braun* is "obscene":

For we are *taught* how to mourn, just as we are taught how to paint. There is nothing "real" or "natural" about it. The language of our mourning is not our own, it is given to us. This is perhaps the most repugnant of all the implications of *Live and Die*. Our mourning is clichéd. It is not real. It is virtual. It is a game. A game we know how to play well by now. We are good at it and we know it. And we teach it to others so they will be good at it, too. This is the "obscene" aspect of Rosen's work. But it is also the obscene aspect of Holocaust mourning, an aspect all-too-often-ignored or suppressed in mainstream memorials.[19]

Instead of rejecting the work for its obscenity, then, Rothman embraces that obscenity because of its relevance for Holocaust remembrance and mourning. Here, because of its mock-dramatic style, but even more because of its second-person address that comes close to dramatic form, I consider Rosen's installation together with the artworks of Levinthal, Katzir, and Libera in the framework of Holocaust remembrance through play. In this context, we are better off not jumping to conclusions. It is not nec-

essary to conclude that in their provocative refusal of the "commandments" of Holocaust education and representation, these artworks imply a wholesale refusal of the relation between art and education or art and remembrance. And Rosen's work, obscenity and all, is an instructive counterexample.

Rosen's insistence on the resonance between memory and painting retains a bond in the act that severs it. The bond with representations that are both imaginative and culturally commonplace, as well as recalled from the past—medieval paintings of Hell, for example—is simultaneously evoked, activated, and severed, indicted for its loss of adequacy. For, following Freud and Felman, we can say that the artists install a new condition of knowledge that enables a production of knowledge that is first of all affective instead of cognitive. It is precisely this affective quality that is crucial in these Holocaust artworks. These artists needed the concept of play and toys (or, in the case of Rosen, the reiteration of cultural commonplaces, such as sexuality, suicide, and torture) to replace cognition by affect on Holocaust remembrance and its pedagogy.

Rosen's are ambiguous texts in terms of identification; they both entice and relativize identification with the evil side of the Holocaust. Unlike the identification provided by the Holocaust Memorial Museum, this work and the toy works solicit a form of identification that is not only different in target, but qualitatively different. As Kaja Silverman has argued, identification takes one of two forms.[20] One form involves taking the other into the self on the basis of a (projected) likeness, so that the other "becomes" or "becomes like" the self. Features that are similar are enhanced in the process; features that remain irreducibly other are cast aside or ignored. Silverman calls this idiopathic identification. The other form is heteropathic. Here, the self doing the identification takes the risk of—temporarily and partially—"becoming" (like) the other. This is both exciting and risky, enriching and dangerous, and affectively powerful.

In the case at hand, it can be argued that identification with the victims, although useful in realizing their horror, is also a way of reassuring visitors, perhaps unduly, of their fundamental innocence. To put the case strongly, this reassurance is unwarranted, and unhelpful in achieving the ultimate goal of Holocaust education: preventing history from repeating itself. Victimhood cannot control the future. In contrast, soliciting partial and temporary identification with the perpetrators makes one aware of the ease with which one can slide into a measure of complicity. To raise the possibility of such identification with the fundamental, cultural other is appealing to heteropathic identification. Precisely because toys and play are not "serious," toy art is so eminently suitable to make such heteropathic identification, which begins to blur overly rigid boundaries.

ART AND PEDAGOGY

So far, I have put forward the notion that the traditional, dogmatic "rules" for Holocaust remembrance and education are inevitably a framing device for understanding the Holocaust art that challenges those rules. This frame is so powerful because when the Holocaust is concerned, education more than any other cultural practice is the transgenerational tool for remembrance. The danger that this view entails is its subjugation of art to the pedagogical pursuit of Holocaust education. Yet, toy art, through its reference to childhood, endorses this subjugation but changes its terms. This antagonistic pedagogy as a major feature of the toys suggests that Holocaust art is a special, negative case of aesthetics in its "interestedness." It is not autonomous, as art since modernism likes to see itself, but subordinated, put in the service of another, inevitably "higher" goal. In contrast, in the wake of Kant, art is usually seen as disinterested, free from educational ideals. The toy art discussed here breaks through this opposition. Distinct from such a subjugation of Holocaust

art to education, Libera's works seem to imply that Holocaust art and other kinds of art are not at all opposed. In this respect Holocaust art is not different, but perhaps only a stronger, more evident case of the pedagogical ambition of art in general. Hence, the shift this art brings to the pedagogy of remembrance also entails a change of aesthetics.

Libera's artistic interest is focused on those cultural products that serve to educate or to form the human being, and to "form" should be understood in the figurative as well as in the literal sense. The objects that he creates are made up of appliances that already exist in the contemporary cultural world through their resemblance to toys or to machines used in fitness clubs or beauty salons. These are not related to the Holocaust. Besides the *LEGO Concentration Camp Set,* for example, he made *You Can Shave the Baby*. These are five pairs of baby dolls, with shocks of red hair emanating from their heads and sprouting from their pubic areas, lower legs, and underarms. *Ken's Aunt (see page 130)* is a Barbie doll in the form of an overweight woman. These works have an upbeat tone to them that contrasts sharply with Rosen's suicide scene, yet in Rosen's work, the earlier, erotic fantasies have a similar artificial positivity to them. Libera's *Doll You Can Undress* is a doll that reveals her stomach area and visible intestines. And *Eroica* is a set of fifty boxes of small bronze figurines that look like toy soldiers. This time it is not the army but civilians, women, and the oppressed of society that are the toy "soldiers" we play with. The tone here is more unsettling. Other works by Libera present themselves as "correcting devices," such as *Universal Penis Expander, Body Master,* and *Placebo*. What matters in this non-Holocaust aspect of Libera's work is the emphasis on correction or "forming." "Forming" takes on a multiple-layered meaning. In light of this, the "making" that underlies them all receives yet another nuance.

Libera's artistic oeuvre shows that although his *LEGO Concentration Camp Set* is unique in having the Holocaust as its subject matter, all of his works address, literally or figuratively, the education of body and of mind. In an illuminating essay, Andrew Boardman has argued that Libera challenges the contemporary belief that aesthetic values are disinterested, fluid, or free-form. On the contrary, contemporary Western art is essentially a remnant from a indelible nineteenth-century construct according to which art and education go hand in hand with moral strength and prudence:

Although art produced today likes to believe that it has shed the majority of those stodgy 19th century precepts, it has carefully disguised them in the fine-woven cloak of pedagogy. The built-in assumption of art today is that it acts to inform us, develop our faculties and therefore deliver us from a transgressive and earthly ignorance into the safe arms of civilisation. [. . .] One might argue that Libera's work, because of its visual connection to child development and to learning, superficially epitomises this 19th century, bourgeois outlook. In fact, by wrapping his work in this upright mode of educational discourse, Libera questions the sweet platitudes and patronizing certainties of art that adhere in our educational aspirations for visual culture.[21]

From this perspective, the target of Libera's *LEGO Concentration Camp Set* is twofold. In addition to exposing the repressions and inhibitions of Holocaust education and its conceptions of remembrance, he also exposes the moral rectitude of (contemporary) art.

These two conclusions makes it clear that we cannot stop at the idea that in modern Western culture art unavoidably teaches and forms. The specificity of toy art remains *play,* which is also the tool for freedom from pedagogical lessons. The intricate relationship between art and teaching can neither be dismissed nor endorsed. No matter what art's pedagogical mission is, the function of play in relation to

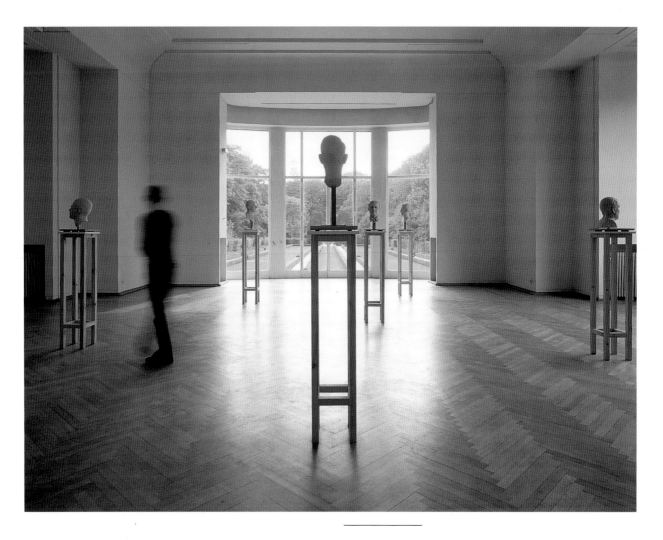

Plate 1. Christine Borland, *L'Homme Double*, 1997. Six clay heads on plinths, with framed documents. Installation view from Fundação Serralves, Lisbon, Portugal, 1999.

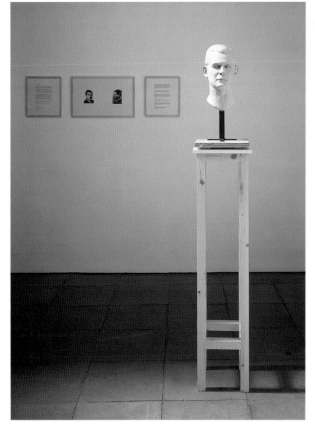

Plate 2. Christine Borland, *L'Homme Double*, 1997. Detail from an installation at Lisson Gallery, London, 1997.

Plate 3. Roee Rosen, *Live and Die as Eva Braun #34*, 1995.
Acrylic on rag paper. 26" x 22⅛".

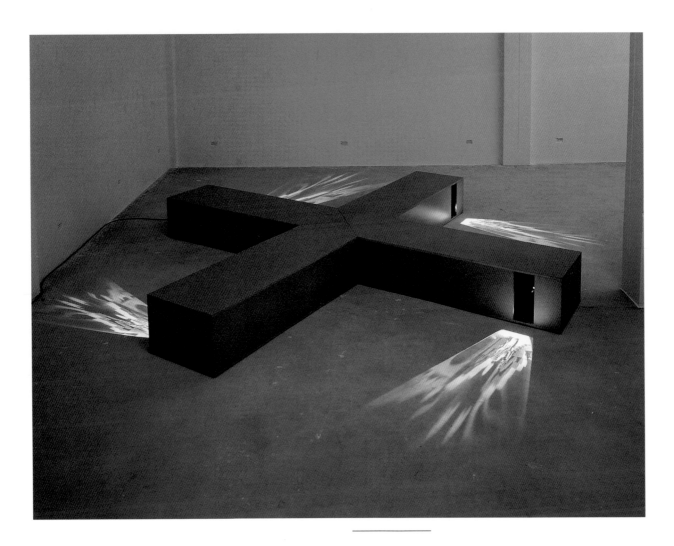

Plate 4. Mischa Kuball, *Hitler's Cabinet*, 1990. Plywood installation with light projection.

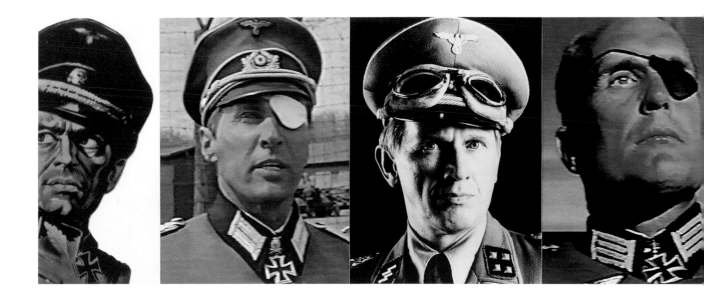

Plate 5. Piotr Uklański, *The Nazis* (detail), 1998. 166 C-prints. For full installation shot from Photographers' Gallery, London, see page 108. From left to right: Klaus Kinski in *Five into Hell*, directed by Frank Kramer, 1969; George Mikell in *Victory*, directed by John Huston, 1981; Jan Englert in *Zloto Dezerterow*, directed by Janusz Majewski, 1998; Robert Duvall in *The Eagle Has Landed*, directed by John Sturges, 1976; Hardy Krüger in *A Bridge Too Far*, directed by Richard Attenborough, 1977; Yul Brenner in *Triple Cross*, directed by Terence Young, 1966; Christopher Plummer in *The Scarlet and the Black*, directed by Jerry London, 1983; Cedric Hardwicke in *The Moon is Down*, directed by Irving Pichel, 1943.

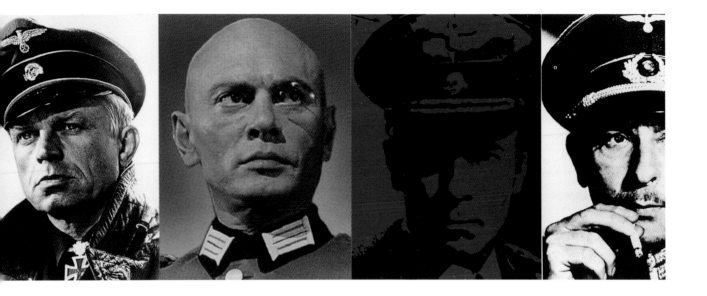

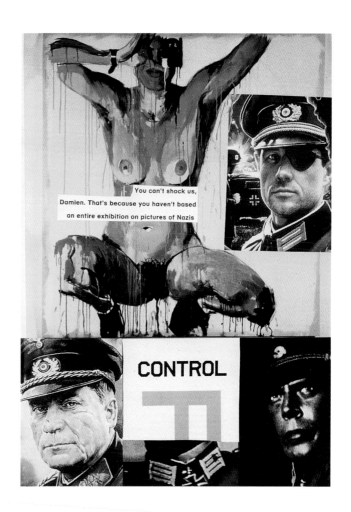

Plate 6 (this page). Elke Krystufek, *Economical Love (Pussy Control)*, 1998. Color photograph of collage with mixed media. 27½" x 19¾". Edition of 3.

Plate 7 (opposite page, left). Elke Krystufek, *Economical Love (Hitler Hairdo)*, 1998. Color photograph of collage with mixed media. 27½" x 19¾". Edition of 3.

Plate 8 (opposite page, right). Elke Krystufek, *Economical Love (Abstract Expressionism)*, 1998. Color photograph of collage with mixed media. 27½" x 19¾". Edition of 3.

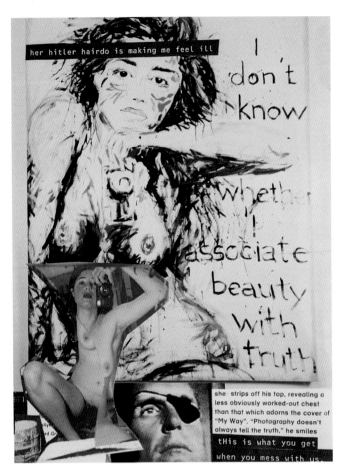

her hitler hairdo is making me feel ill

I
don't
know

whether
I
associate
beauty
with
truth

she strips off his top, revealing a less obviously worked-out chest than that which adorns the cover of "My Way". "Photography doesn't always tell the truth," he smiles

tHis is what you get

when you mess with us.

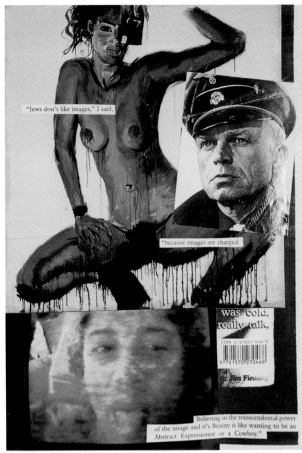

"Jews don't like images," I said,

"because images are charged.

was cold,
really talk,

Believing in the transcendental power of the image and it's Beauty is like wanting to be an Abstract Expressionist or a Cowboy."

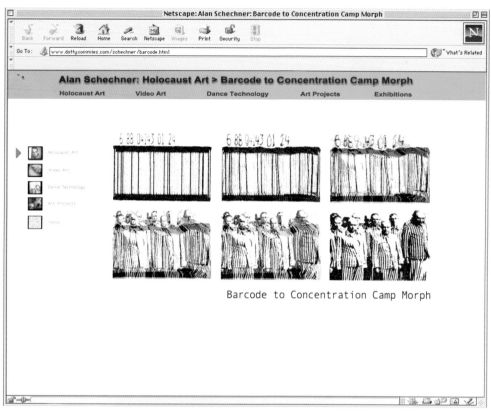

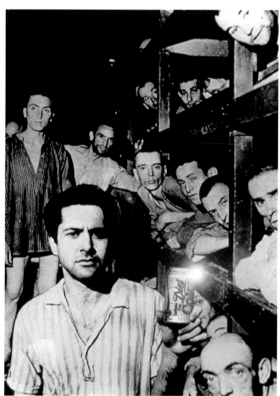

Plate 9 (top). Alan Schechner, *Barcode to Concentration Camp Morph*, 1994. Digital still. www.dottycommies.com. Internet project.

Plate 10 (bottom). Alan Schechner, *It's the Real Thing—Self-Portrait at Buchenwald*, 1993. Digital still. www.dottycommies.com. Internet project.

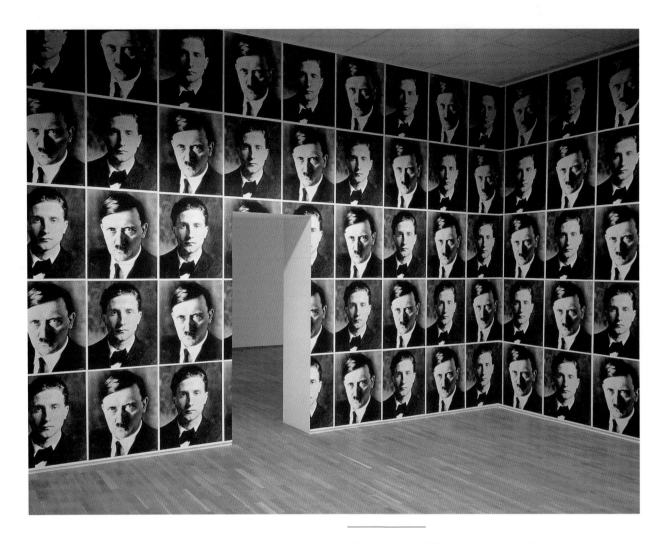

Plate 11. Rudolf Herz, *Zugzwang*, 1995. Photographic reproductions. Installation in Nationalgalerie Berlin, 1999.

Plate 12 (top). Boaz Arad, *Safam*, 2000. Still from a
black-and-white video with sound, 44 seconds.

Plate 13 (bottom). Boaz Arad, *Marcel Marcel*, 2000. Still
from a black-and-white video with sound, 30 seconds.

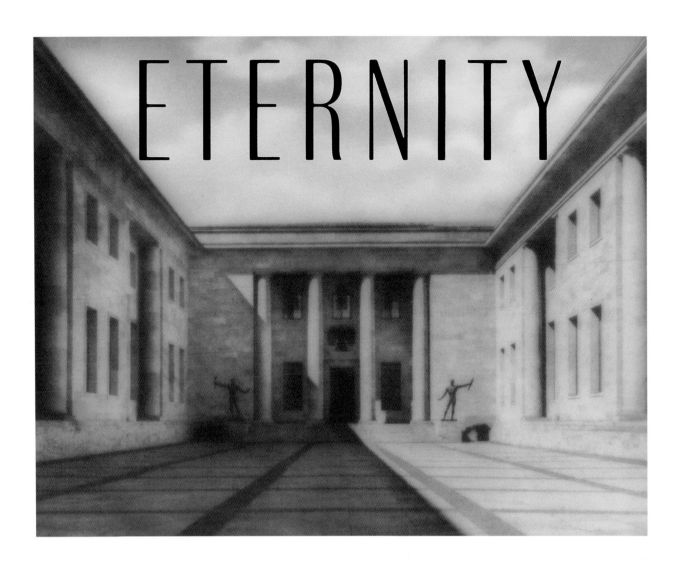

Plate 14. Maciej Toporowicz, *Eternity #14*, 1991.
Black-and-white photograph with silkscreen. 16" x 20".

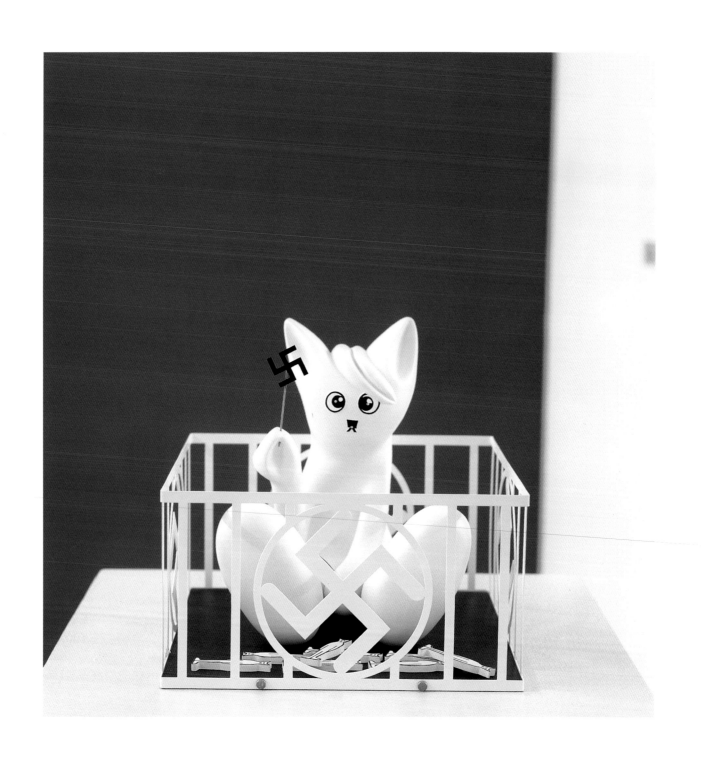

Plate 15. Alain Séchas, *Enfants Gâtés* (detail), 1997.
Installation with mixed media. Dimensions variable.

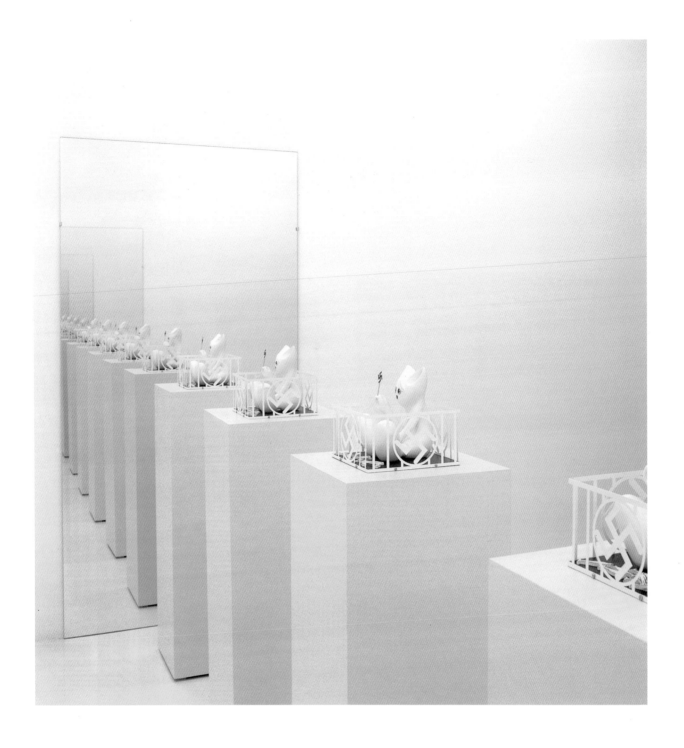

Plate 16. Alain Séchas, *Enfants Gâtés*, 1997. Installation
with mixed media. Dimensions variable.

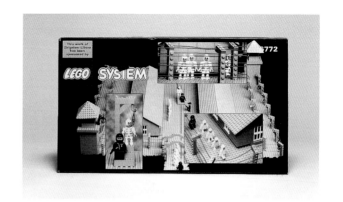

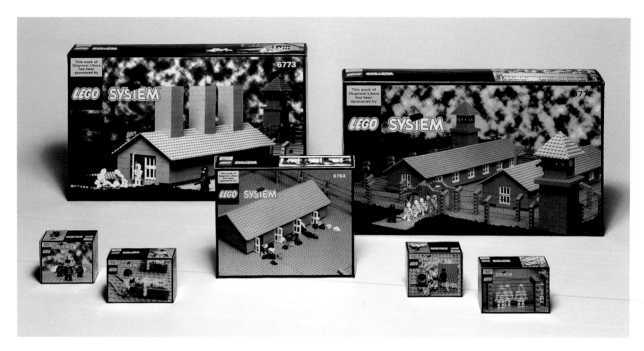

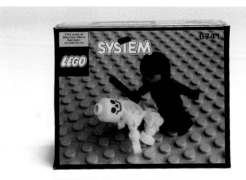

Plate 17 (top). Zbigniew Libera, *LEGO Concentration Camp Set* (detail), 1996. Cardboard boxes. Edition of three.

Plate 18 (middle). Zbigniew Libera, *LEGO Concentration Camp Set*, 1996. Seven cardboard boxes. Edition of three.

Plate 19 (bottom). Zbigniew Libera, *LEGO Concentration Camp Set* (detail), 1996. Cardboard boxes. Edition of three.

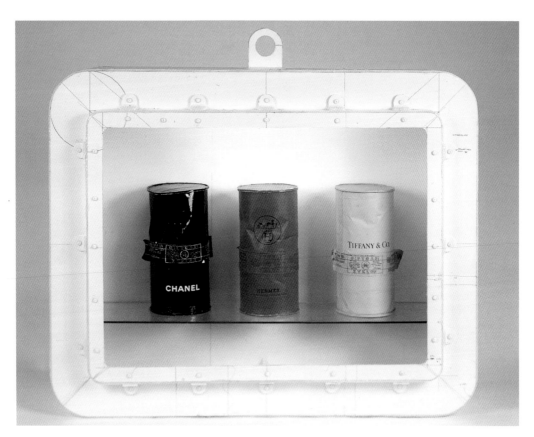

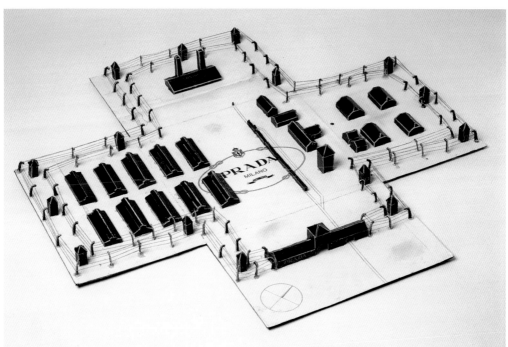

Plate 20 (top). Tom Sachs, *Giftgas Giftset*, 1998. Cardboard paper, ink, thermal adhesive, foamcore. 44⅛" x 12".

Plate 21 (bottom). Tom Sachs, *Prada Deathcamp*, 1998. Cardboard paper, ink, wire, adhesive. 27⅛" x 27⅛" x 2".

Plate 22. Mat Collishaw, *Burnt Almonds (Gustav and Helga)*, 2000. Three-dimensional transparency lightbox. 19" x 20".

both art and teaching needs to be considered. The question that is thrust upon us is also double: Does *play* teach, and how does play *teach* differently? Is the result or "mastery" provided by play of a different order than the mastery resulting from cumulative and progressive learning?

HOLOCAUST NARRATIVE
VERSUS HOLOCAUST DRAMA

To understand how the mastery provided by toys differs from the mastery provided by "learnable" knowledge, both modes of learning must be analyzed in terms of the generic discourse to which each belongs. "Learnable knowledge" of the Holocaust takes the form of narrative. Personal narratives in the form of testimonies, diaries, or memoirs are seen as especially instructive, teaching later generations not simply the facts of the Holocaust but its apocalyptic inhumanity. It is safe to assume that all Holocaust education, including that in the form of art, shares this goal. But the artworks by Levinthal, Libera, Katzir, and Rosen don't tell us much about the past. Like Boltanski's Comic Sketches before them, they envision playing the past. And I use the verb *envision* emphatically, because—with the possible exception of Katzir, who experimented with museum visitors actually coloring the books—these works are not real toys. Instead, they are artworks in the form of toys. These artworks are meant to be processed by adults, not by children. The distance between children playing and adults envisioning themselves as those children adds yet another layer of identification, in which adults act—or rather playact—like children. In the art under scrutiny, a shift in semiotic mode is at stake. The Holocaust is represented not by means of narration but in the mode of drama or a script for a drama. That is, of course, more literally true in the cases of Katzir's installation and Libera's LEGO box than in the case of Levinthal's

photographs. But I will argue that Levinthal's photographs should also be understood as drama. It is as such that they solicit heteropathic identification and the possibility to identify with the other. In the case of the Holocaust the other is the moral other, no longer an inevitably abstract evil force from the beyond, but a person with whom one can even feel complicitous. Drama, then, becomes a centrally important semiotic mode of education.

James E. Young has remarked that the photographs of *Mein Kampf* generate a powerful sense of the past through a measured act of simulation. He uses the phrase "a sense of the past" to distinguish an effect from an actuality.[22] What strikes me most, however, and in analogy to Young's view, is how these works generate a "sense of the present." I don't see fictional, narrativized images of a concentration camp. What I see, what I imagine, or even what I am is a subject in post-Holocaust culture playing with a (fake) concentration camp. The narrative images are embedded in, or produced by, an act that should be defined as drama. And this difference between narrative and drama is of crucial importance in understanding what is at stake in the artworks under discussion.

You cannot actually play with Libera 's LEGO boxes. But they evoke the possibility of a scene in which somebody in post-Holocaust culture performs Holocaust events within the setting of a camp. Constructing the setting, the artist facilitates the articulation of playacting Holocaust events. Katzir's work does not just envision the dramatic mode of representation, it really enacts it. In his installation *Your Coloring Book,* realized in different ways in Utrecht, Enschede, Jerusalem, Vilnius, Krakow, Berlin, and Amsterdam, visitors were invited to sit on school benches and to color or draw in the coloring books that had been placed on classroom desks or tables (fig. 6). The visitors were drawn into a performance in which they actualized, shaped, and colored—in other words, generated—Nazi characters.

Fig. 6. Ram Katzir, *Malzeit (Your Coloring Book. A Wandering Installation, Stage 6.)* Haus am Kleistpark, Berlin, 1998. Courtesy of Ram Katzir. Photograph by Stefan Muller.

This dramatic aspect of the toy works is important in terms of both education and, specifically, Holocaust remembrance. For the difference between narrative and drama is particularly relevant for understanding—a condition for curing—trauma. Drama is a very particular cultural form that is fundamentally different in form and effect from narrative. And this specificity of drama improves what toy art offers to Holocaust education and remembrance. In order to assess the crucial difference between works of art that narrate events from the Holocaust and those that perform or playact it, the distinctions the French psychiatrist Pierre Janet made between narrative memory and traumatic memory are helpful.[23]

Narrative memory consists of mental constructs that people use to make sense out of experience. Current and familiar experiences are automatically assimilated or integrated in existing mental structures. But some events resist integration: "Frightening or novel experiences may not easily fit into existing cognitive schemes and either may be remembered with particular vividness or may totally resist integration." The memories of experiences that resist integration in existing schemes are stored differently and are not available for retrieval under ordinary conditions. It is only for convenience's sake that Janet called these unintegratable experiences "traumatic *memory*." In fact, trauma is fundamentally (and not gradually) different from memory because "it becomes dissociated from conscious awareness and voluntary control."[24]

Trauma is failed experience, and this failure makes it impossible to voluntarily remember the event. This is why traumatic reenactments take the form of drama, not narrative. Drama just presents itself, or so it seems; narrative implies some sort of mastery by the narrator. This is a fundamental difference. In the words of Mieke Bal: "All the manipulations performed by a narrator, who can expand and reduce, summarize, highlight, underscore, or minimize elements of the story at will, are inaccessible to the

'actor' who is bound to enact a drama that, although at some point in the past it happened to her, is not hers to master."[25] Janet's clinical distinction between narrative and traumatic memory ultimately concerns a difference in distance toward the situation or event. A narrative memory is retroversive; it takes place after the event. A traumatic memory, or better, reenactment, does not know that distance toward the event because it is more immediate.

This distinction between narrative memory and traumatic memory does not apply literally to the artworks under discussion. Although these works are not narrative, it is of little help to see them as instances of traumatic memory. These works are not involuntary re-enactments of the Holocaust but rather purposeful attempts to shed the mastery that Holocaust narratives provide. Instead, they entice the viewer to enter into a relationship that is affective and emotional rather than cognitive.

Mastery is again the issue, but this time the method for obtaining mastery is totally different: not mastery through knowledge but mastery by admitting affect. This is by no means a passive opening up but an active countering of the closure brought about by narrative mastery. To explain how these imaginative attempts to work through *work,* yet another distinction must be invoked. I am referring to the distinction made by Eric Santner between "narrative fetishism" and mourning. He defines narrative fetishism as the construction and deployment of a narrative consciously or unconsciously designed to expunge the traces of the trauma or loss that called that narrative into being in the first place. The work of mourning, on the contrary, is a process of elaborating and integrating the reality of loss or traumatic shock by remembering and repeating it in symbolically and dialogically mediated doses. It is a process of translating, troping, and figuring loss.[26]

Santner uses, of course, Freud's discussion of the fort/da game in *Beyond the Pleasure Principle* to explain the mechanisms of mourning. The fort/da game was observed by Freud in the behavior of his one-and-a-half-year-old grandson. In this game the child was able to master his grief over his separation from the mother by staging, playacting, his own performance of her disappearance. (She was gone—fort; then she was there—da.) This little boy was involved in heteropathic identification with the person who was, in his everyday drama, the "perpetrator," the mother who left him. He did so by repetition, using props that D. W. Winnicott would call transitional objects. This game is based on a ritualized mechanism of dosing out and representing absence by means of substitutive figures. In the words of Santner:

> The dosing out of a certain negative—a thanatotic—element as a strategy of mastering a real and traumatic loss is a fundamentally homeopathic procedure. In a homeopathic procedure the controlled introduction of a negative element—a symbolic or, in medical contexts, real poison—helps to heal a system infected by a similar poisonous substance. The poison becomes a cure by empowering the individual to master the potentially traumatic effects of large doses of the morphologically related poison. In the fort/da game it is the rhythmic manipulation of signifiers and figures, objects and syllables instituting an absence, that serves as the poison that cures.[27]

In the Holocaust toys, similarly, the poisonous—also Libera's word—stuff, needed in a carefully measured dose, is the "Holocaust effect": to playact the camps instead of talking "about" them or looking "at" them.

This "playing the Holocaust" does and does not distance the Holocaust in the past. It does not, because through the programmed identification the viewer is situated *inside* the camp, building and generating it. The heteropathic identification with the perpetrator, moreover, is effectuated through the role

of the child. In the case of Freud's grandson, it was the child's own drama that was enacted. Here, the child stands for the next generations, who need to learn a trauma they have not directly lived, although, as Marianne Hirsch and others have emphasized, they may suffer from *postmemory*.[28] But at the same time, by the same gesture, a double distance is produced: play instead of reality, and play instead of, in the context of, "high art," an institutional frame that sets these toys apart. To playact the Holocaust in this way is to perform under the strict direction of a "director," a "metteur en scène," which is radically distinct from a "revival" or "repetition" of Nazism in the dangerous shape of neo-Nazism.

TOUCHING TOYS

Why is it that this trend of "playing" the Holocaust by means of toys characterizes the art of this current second, third, and fourth generation of post-Holocaust survivors and bystanders? How can this work contribute to the cultural necessity to shake loose the traumatic fixation in victim positions that might be partly responsible for the "poisonous" boredom that risks jeopardizing all efforts to teach the Holocaust under the emblem "never again"?

In the face of the overdose of information and educational documentary material, clearly, there is a need to complete a process of working through not yet "done" effectively. The overdose was counterproductive. In the face of that overdose, "ignorance" is needed. An ignorance, not in terms of information about the Holocaust but of everything that stands in the way of a "felt knowledge" of the emotions these events entailed. Primarily, of the narrative mastery so predominant in traditional education.

In this perspective, the toys, with their childish connotations, "fake" the ignorance that clears away the "adult" overdose of information that raises obstacles to felt knowledge. "Mastery," then, is no longer an epistemic mastery of what happened but a performative mastery of the emotions triggered by the happenings. Only by working through knowledge that is not "out there" to be passively consumed but rather "felt" anew time and time again, by those who must keep in touch with the Holocaust, can art be effectively *touching*.

NOTES

1. The series the Comic Sketches consists of the following "short stories": "le mariage des parents," "la maladie du grand-père," "les souvenirs du grand-père," "la toilette du matin," "la mort du grand-père," "la grosesse de la mère," "le baiser caché," "le grand-père à la pêche," "les bonnes notes," "l'horrible découverte," "la toilette de la mère," "le récit du père," "l'anniversaire," "la naissance de Christina," "le baiser honteux," "la tache d'encre," "la dureté du père," "la première communion," "la visite du docteur," "le père à la chasse," and "la grimace punie."

2. "An Interview with Christian Boltanski—Paul Bradley, Charles Esche, and Nichola White," in *Christian Boltanski: Lost* (Glasgow: CCA, 1994), 3–4.

3. The French expression *interprétation* means interpretation in the sense of explanation but also "performance." The quote comes from Delphine Renard, *"Entretien avec Christian Boltanski,"* in *Boltanski,* exh. cat. (Paris: Musée National d'Art Moderne, Centre Georges Pompidou, 1984), 85.

4. See, for the documentation of this controversy, Katzir's catalogue *Your Coloring Book: A Wandering Installation* (Amsterdam: Stedelijk Museum, 1998).

5. A transcript of this very emotional discussion can be found in *Bulletin Trimestriel de la Fondation Auschwitz,* special no. 60 (July–September 1998): 225–40.

6. See, for an elaboration of this argument, my book *Caught by History: Holocaust Effects in Contemporary Art, Literature, and Theory* (Stanford, Calif.: Stanford University Press, 1997).

7. Sander Gilman, "Is Life Beautiful? Can the Shoah Be Funny? Some Thoughts on Recent and Older Films," *Critical Inquiry* 26 (Winter 2000): 304. Emphasis added.

8. Shoshana Felman, "Psychoanalysis and Education: Teaching Terminable and Interminable," *Yale French Studies* 63 (1982): 28.

9. Zbigniew Libera, in *Bulletin Trimestriel de la Fondation Auschwitz* no. 60, 225.

10. Van Alphen, *Caught by History,* 1–15.

11. Felman, "Psychoanalysis and Education," 41.

12. Ibid., 27.

13. Ibid., 27.

14. Ibid., 31.

15. *The Standard Edition of the Complete Psychological Works of Sigmund Freud,* trans. and ed. James Strachey (London: Hogarth Press and the Institute of Psychoanalysis), vol. 22, 149; quoted by Felman, "Psychoanalysis and Education," 23. Italics are Felman's.

16. Gilman, "Is Life Beautiful?," 282.

17. Terrence des Pres, "Holocaust Laughter," in *Writing and the Holocaust,* ed. Berel Lang (New York: Holmes & Meier, 1988), 217.

18. See, on the issues of second-person narrative, Mieke Bal, *Quoting Caravaggio* (Chicago: University of Chicago Press, 1999), chapter 6.

19. Roger Rothman, "Mourning and Mania: Roee Rosen's *Live and Die as Eva Braun,*" in Roee Rosen, *Live and Die as Eva Braun: Hitler's Mistress, in the Berlin Bunker and Beyond. An Illustrated Proposal for a Virtual-Reality Scenario. Not to Be Realized.* (Jerusalem: Israel Museum, 1997), n.p.

20. Kaja Silverman, *The Threshold of the Visible World* (New York: Routledge, 1996).

21. Andrew Boardman, "Zbigniew Libera," Warsaw, 1998.

22. James E. Young, "David Levinthal's *Mein Kampf:* Memory, Toys, and the Play of History," in David Levinthal, *Mein Kampf* (Santa Fe, N.M.: Twin Palms Publishers, 1996), 72.

23. Janet, who was working at the beginning of the twentieth century, influenced the theories of Sigmund Freud. See, for a discussion of Janet's ideas, Bessel A. van der Kolk and Onno van der Hart, "The Intrusive Past: The Flexibility of Memory and the Engraving of Trauma," in Cathy Caruth, ed., *Trauma: Explorations in Memory* (Baltimore: Johns Hopkins University Press, 1995), 158–82.

24. Ibid., 160.

25. Mieke Bal, "Introduction," in Mieke Bal, Jonathan Crewe, and Leo Spitzer, eds., *Acts of Memory: Cultural Recall in the Present* (Hanover, N.H., and London: University Press of New England, 1999), ix.

26. Eric Santner, "History Beyond the Pleasure Principle: Some Thoughts on the Representation of Trauma," in Saul Friedlander, ed., *Probing the Limits of Representation: Nazism and the "Final Solution"* (Cambridge: Harvard University Press, 1992), 144.

27. Ibid., 146.

28. Marianne Hirsch, *Family Frames: Photography, Narrative and Postmemory* (Cambridge: Harvard University Press, 1997).

Playing It Safe?

The Display of Transgressive

Art in the Museum

REESA GREENBERG

hen people go to museums, especially art museums, they

expect to enter a realm of safety, a space where

their bodies and psyches are protected from danger.[1]

Art museums *are* exceptionally safe. Most are envi-

ronmentally controlled to a standard rarely found

elsewhere; guards and sophisticated security systems

protect visitors from a variety of possible mishaps,

and a large portion of the art on exhibit has passed the test of time. Visitors feel safe in museums, comfortable, at home. They have nothing to fear.

During the past twenty years, the best-attended exhibitions, the safest, have been exhibitions of Impressionist art. Almost half a million visitors saw and relished *Renoir's Portraits* at the Art Institute of Chicago in 1997 and 813,000 luxuriated in the Royal Academy exhibition *Monet in the Twentieth Century* in London in 1999. Yet the first Impressionist exhibitions were not considered safe at all. In the late nineteenth century, humanizing images of the working class dancing or swimming, prostitutes in the intimacy of their toilette, or landscapes dotted with polluting factories demanded that the bourgeoisie see their world for what it was—a place and time of unsettling change. The broken brush strokes were metaphors for a fragmented world. More than a century later, people interpret Impressionist art quite differently. Today's museum visitors tend to look at Impressionist art exhibitions with nostalgia for a sunny, simpler time that never was. Many of those who see Impressionist exhibitions use them as talismans against the dangers of contemporary industry, reassurance that despite the darkness of deep change, light and civilization prevail.

Why is it that museum visitors demand so much safety, become irate if they feel threatened, and are so willing to withdraw support or close down an institution if they object to an exhibition or even one artwork? Part of the answer lies in what art historian Carol Duncan has called "civilizing rituals."[2] Until relatively recently, museum visitors spent more time visiting permanent collections than temporary exhibitions. The selection of work and its installation positioned visitors as witnesses to a grand narrative of citizenship, be it local, national, ethnic, or aesthetic. Walking the evolutionary line through the permanent displays, visitors participated in a performance in which they had an assigned place, a ritual in which their role, accepted or not, could be

repeated time and again. Temporary exhibitions were just that. Visitors could always retreat to a museum very much intact.

All this has changed. In many museums, temporary exhibitions have become more important, more frequent, and more contemporary. When there is a marked lack of congruity between what is shown in permanent collections and temporary exhibitions, visitors feel betrayed, uneasy. It is difficult for them to reconcile what they believe belongs in a museum with what the museum is temporarily exhibiting. In survey museums or institutions with a conservative exhibition history, any major departure may be cause for discontent.

The shift is even more radical in such museums as the Tate in London or the Museum of Modern Art in New York City, where the permanent collection has been transformed into a series of temporary exhibitions, often arranged thematically rather than chronologically. Computer-conditioned visitors relish constantly changing display patterns, safe in the knowledge of an underlying image bank and the value of multiple modes of access. No longer given the stability of a truly permanent collection, many other museum visitors may fear the absence of a fixed template against which the unusual, the new, the disruptive, or even oneself might be placed. The rules of the game have changed and large numbers of visitors are unprepared. Their fear can be translated into anger, generalized or directed against a specific target.

As much as museum visitors want the reassurance of the familiar, they also expect new experiences. Their willingness to engage with the alien, the unpleasant, the dangerous depends on limited or graduated exposure and the assurance of support, either educational or emotional. In some ways, the museum can be seen as the equivalent of D. W. Winnicott's "good enough" mother who encourages her child to venture out into the world but is always there when the child returns.[3] Essential to the

process is what Winnicott calls the transitional object, a doll or a blanket, with which children build relationships as they begin to leave the security of their mother's sphere. Without a "good enough" mother, children cling, reject the toys they are given or have chosen, refuse to move on or out, and become very angry. They are terrified of being lost forever. Temporary exhibitions are the equivalent of transitional objects. The question for museums is how to be a "good enough" mother, how to provide a safe enough space for visitors to "play" with new ideas, how to transform the inevitable fear of the unknown into autonomy and independence.

Mothers can't guarantee safety, nor can museums. Danger is often unforeseen. When Jana Sterbak, an internationally acclaimed artist, exhibited *Vanitas: Flesh Dress for an Albino Anorectic* (1987; fig. 1) as part of her retrospective at the National Gallery of Canada in 1991, there was no way of predicting that the "meat dress" would become the focus of a strident debate about poverty, social justice, and government support of the arts.[4] *Vanitas* is a trenchant, poignant comment on female flesh and adornment. The dress is made of raw beefsteaks that take the form of the young woman on whom it was sewn. After a photography session, the dress was removed and hung to dry. Sterbak mercilessly plays on the fashionableness of thinness and the scorn for withering age. Before the National Gallery exhibition, *Vanitas* was shown for four years in commercial or artist-run galleries, and discussion remained intellectual, centered on current concerns, such as avant-gardism, performance, commodification, and feminism.

It was only when Sterbak's dress moved into the public arena of the National Gallery that the terms and tone of the debate changed. The work suddenly became politicized and controversial art, dangerous to the country.[5] As art historian and critic Johanne Lamoureux so astutely observes, in the public domain "the taxpayer does not see him- or herself as

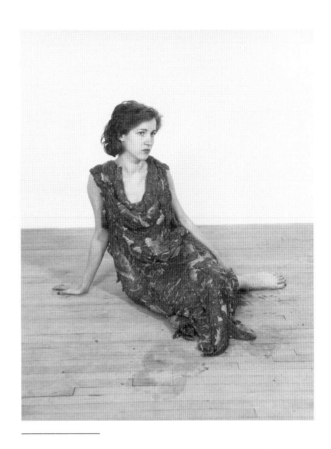

Fig 1. Jana Sterbak, *Vanitas: Flesh Dress for an Albino Anorectic,* 1987. In the Collection of the Walker Art Center, Minneapolis. Courtesy of Jana Sterbak and the T. B. Walker Acquisition Fund, 1993.

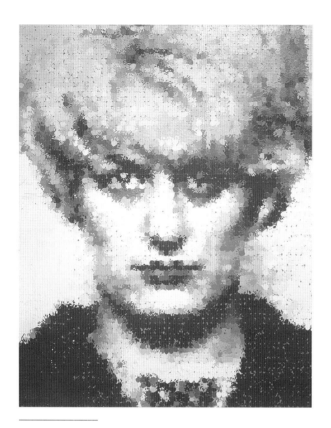

Fig 2. Marcus Harvey, *Myra,* 1995. Acrylic on canvas. 156" x 126". © The artist. Courtesy of Jay Jopling/White Cube and The Saatchi Gallery, London. Photograph by Stephen White.

the mere receiver of information; he or she challenges the position of the sender/speaker [artist/museum]. . . . It is from that position mainly that the issue of possible censorship is raised as a threat."[6]

The *Vanitas* debacle demonstrates that safety zones within the contemporary art world depend on context. What is safe in one sphere is not necessarily safe in another. When *Sensation,* an exhibition of works from Charles Saatchi's collection by young British artists, was shown at the Royal Academy in London in 1997, one protester threw eggs and another ink on Marcus Harvey's gray and white, larger-than-life *Myra* (1995; fig. 2), a portrait of the convicted mass murderer and child-killer Myra Hendley. Harvey had transformed the painterly, neutral tesserae of Chuck Close's giant portraits into a template of a child's handprints with what art historian Elizabeth Legge calls "vicious effectiveness."[7] Ensuing publicity made Harvey's portrait the emblem of an exhibition that the public and the press critiqued as distasteful. Initially, *Myra* seems a surprising choice for such attention given the presence of more obviously troubling works, such as Marc Quinn's self-portrait head made from eight pints of his own frozen blood; Damien Hirst's dead animals, split open and suspended in formaldehyde or the Chapman brothers' mutated and mutilated sexualized child mannequins.

As Legge points out, Harvey's portrait, exhibited so soon after the death of the Princess of Wales, was received "as a short-haired blonde demonic double of Diana-the-good-mother."[8] The focus on Harvey's painting, like that on Sterbak's *Vanitas,* suggests that when stereotypes of women and, by extension, mothers, are questioned, these works become flash points for protest. Rather than examine mother images that are other than idealized, dissenters prefer to remove them from view.

When *Sensation* was shown at the Brooklyn Museum of Art, the endangered work was Chris Ofili's

The Holy Virgin Mary (1996; fig. 3), attacked by New York's Mayor Rudolph Giuliani as blasphemous and "sick" because it was adorned with elephant dung and contained tiny images of angels fashioned from pornographic photographs. Giuliani was unaware that in Ofili's Anglo-African culture dung is considered a precious commodity. Picketers and protesters in support of the Catholic League massed outside the museum, and Giuliani used the offending painting as the cornerstone of a legal argument to evict the museum from its municipally owned building and reduce its funding, a suit lost in court.

Before the exhibition opened, the museum stated: "The contents of this exhibition may cause shock, vomiting, confusion, panic, euphoria and anxiety." Issuing the equivalent of a health warning widely reported by the press was instrumental in turning the event into a "sensation" and the museum into a dangerous space, daring the public to attend. The focus on exhibiting "offensive" art and the moral and legal questions raised by the exhibition made it impossible to discuss the art as art or its relationship to contemporary British or American society.[9] In choosing distanced irony to announce the exhibition rather than careful or caring communication, the museum abdicated its role as a "good enough" mother, leaving the art in the exhibition, future visitors, and itself without a safety net.

The *Sensation* debacle was reminiscent of the culture wars sparked by *The Perfect Moment,* the 1988–89 retrospective of Robert Mapplethorpe's photographs. The flash point in that exhibition was Mapplethorpe's *The X Portfolio* (1978), a series portraying male masturbatory and homosexual acts including bondage, mutilation, and fisting that crossed sadomasochistic boundaries.[10] The Corcoran Gallery of Art in Washington abruptly canceled the exhibition, and the Contemporary Art Center in Cincinnati, which bravely took the show in 1990, was put on trial on two misdemeanor counts: pandering obscenity and the use of minors in nudity-oriented materials. Insti-

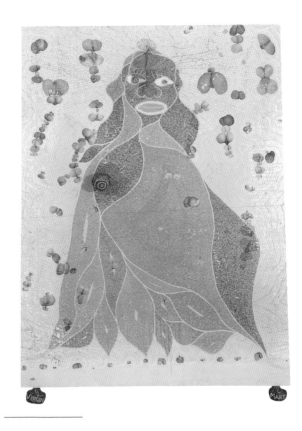

Fig 3. Chris Ofili, *The Holy Virgin Mary,* 1996. Paper collage, oil paint, glitter, polyester resin, map pins, and elephant dung on linen. 98" x 72". Courtesy of the artist, Victoria Miro Gallery, and The Saatchi Gallery, London.

tutions that exhibited *The X Portfolio* were in danger of losing their funding from the National Endowment for the Arts and artists whose work deviated from a very precise definition of pornography were in danger of being refused grants. Museums exhibiting Mapplethorpe's work were considered the equivalent of morally unfit mothers.

Like *Vanitas, Myra,* and *The Holy Virgin Mary, The X Portfolio* destabilizes conventional notions of Eros and Thanatos. Museum goers feel exposed, vulnerable, frightened when asked to reconsider in such a radical way assumptions about sex, religion, race, and death they hold sacrosanct, especially when entering what they anticipate to be a danger-free zone. Wanting safe ground, they are left wanting.

Yet Joseph Kosuth's 1992 exhibition *The Play of the Unmentionable,* at the Brooklyn Museum of Art, dramatically demonstrates that standards of tolerance for what is considered acceptable in museums depend on time and place, not some absolute criteria.[11] Kosuth combed the archives of the Brooklyn Museum for information on artworks in the collection once considered so controversial they were removed from display but which are considered so benign today that we wonder why they ever evoked such scandal. What often gets forgotten is that the museum may be at its safest when it exhibits "dangerous" art precisely because it insists on participating in rather than avoiding current debates occurring outside the museum. An exhibition can be a forum in which difficult issues are addressed without the expectation that all questions can be resolved or that closure is the desired result. There may be more value in raising doubts than in providing answers. When the museum balances pleasure and reality, encourages an understanding of the complex relationships between art and life, and takes measures to make potentially disturbing work safe, it may not be liked but it does function as a "good enough" mother.

When planning the installation of the Map-

plethorpe retrospective, curators and exhibition designers were very much aware of the dangers posed by exhibiting such explicit photographs in the public space of the museum. The exhibition contained 150 works spanning a twenty-year period, of which *The X Portfolio* was a small segment. At the Whitney Museum of American Art in 1988, curator Richard Marshall arranged the display so that the potentially dangerous photographs from the portfolio were isolated in a separate room that viewers could bypass entirely or suddenly stumble into. Esteemed critic Arthur Danto recounted the profound revelation he experienced from an unexpected encounter with hitherto-unknown photographs that challenged his every preconception about art and the body.[12]

Danto, however, was in the minority. After the Mapplethorpe retrospective, isolation, in and of itself, was not considered safe enough. In 1999, the Art Gallery of Ontario used a similar segregationist installation strategy for the more disturbing grotesques in a touring Cindy Sherman retrospective. But here viewers were warned in advance that they might not wish to see the artwork they were about to encounter and given the opportunity to exit the exhibition at that point. At *Without Sanctuary,* an extraordinarily brave exhibition of postcard photographs of lynchings in the United States at the New-York Historical Society in 2000, viewers were warned, both at the entrance to the museum and at the entrance to the exhibition itself, that material beyond the threshold would be extremely difficult to view (fig. 4).

In both instances, sober warnings prepared visitors for the possibility that what they would see might be disturbing and gave them the choice of entering the exhibition space or not. Rather than the abrupt, sudden, confrontational formula associated with the artistic or political avant-garde where visitors are not warned, as in *The Perfect Moment,* or warnings are used as a dare, as in *Sensation,* the

transformational potential of the exhibition experience can be conceived in terms of a developmental learning model that is gradual and slow. Risk, surprise, and confusion are reduced; the unexpected, destabilizing encounter is minimized to allow a safer space for contemplation.

Museum goers are far more familiar with warnings that protect art from the dangers *they* pose than vice versa. Visitors are repeatedly told, either perfunctorily or subtly, not to touch, not to get too close, not to photograph, because works of art are fragile, likely to be damaged by environmental elements such as the oils secreted by human hands or strong light from camera flashes. At the Louvre, a pane of safety glass shields the Western world's most venerated painting, *Mona Lisa*, from the enormous crowds that come to see it. The glass stands a few feet in front of the painting, functioning as both warning device and protective screen, a clear signal that the spectator is considered a danger to the artwork.

In 1981, when Picasso's antifascist *Guernica* was finally installed in Spain after spending the Franco era at the Museum of Modern Art in New York, safety measures were more elaborate. The enormous mural was encased in a bulletproof glass box, "safely and hygienically sealed from the public to protect against terrorists of the right and left and Basque separatists for whom it remains a special symbol."[13] Metal detectors, closed-circuit television, and armed civil guards screened spectators, adding to the safety of both the work and its viewers (fig. 5).

Museums today go to great effort to protect visitors from the dangers of art. When Sandra Rechico's *Shards II* (1997–2000; fig. 6) was exhibited in Montreal in *Vital Signs*, a group exhibition of experiential art, the gallery took extensive measures to ensure that all who came in contact with Rechico's floor of broken glass would be safe.[14] During installation, the air system was shut off and the floor regularly wet down so that technicians, wearing protective Tyvek

NOTICE

The exhibition
WITHOUT SANCTUARY
contains graphic photographs of
lynchings, which may be particularly
disturbing to young viewers.

While in the gallery, please help to
maintain an environment suitable to
reflection and quiet conversation.

Fig. 4. Warning sign at entrance of the exhibition, *Without Sanctuary* (at the New-York Historical Society), 2000. Courtesy of the Collection of the New-York Historical Society.

Fig. 5. Spanish civil guard with automatic weapon guards Pablo Picasso's *Guernica* when it was viewed by news media and art critics, October 1981. Courtesy of AP/Wide World Photos.

suits, would not breathe in the circulating, microscopic glass dust. A combination of watching, wall labels, and waivers kept visitors safe. The information desk was repositioned, allowing the guard to simultaneously survey the scene and be close at hand to answer questions. Wall labels advised that unaccompanied children were not allowed to walk on the floor and suggested that those who chose to step on the glass wear adequate footwear, "limit participation to walking," and wipe their feet on the mats provided to avoid carrying glass dust into the safety of their homes. In addition, anyone wishing to walk on the shattered glass floor, and seven hundred people did, was asked by the gallery to sign a waiver.

In signing a waiver, visitors enter into a contract with an institution, accepting full responsibility for any bodily damage that might occur during the experience and exonerating the institution from any liability. Waivers are a North American phenomenon, a response to the possibility of costly lawsuits. When Carsten Höller's *Slide—Tribute to Female Valerio* was exhibited at the Berlin Biennial in 1998, there were no waivers required of visitors wishing to use the tubular slide for quick transport from one floor of the exhibition to another, but when a version of the work was exhibited in New York at P.S.1 in 1999 in *Children of Berlin,* anyone entering the slide, which began inside the exhibition on the top floor and deposited participants in the courtyard outside, had to sign.[15]

Waivers, like glass, provide a layer of protection between what video artist Bill Seaman calls the "vuser" and the artwork. They also provide a layer of protection between the museum and the visitor, subtly transforming the relationship between the two parties. With waivers, visitors are addressed as adults, not children. Responsibility is shifted from the warning "good enough" mother to the participant. It is the visitor who must decide whether to risk exposure.

As of yet, museums have not devised waivers to cover possible psychic danger. Instead, a mix of educational material, audioguides, videos, feedback devices, ancillary programs, as well as carefully designed layout are used to help cushion shock, frame responses and activate alternative avenues of consideration. Without more overt interventions, museum goers may forget that museums do not exhibit dangerous art without anticipating strong emotional responses, that no matter what the museum provides, there are no fail-safe measures for feeling safe with unanticipated or negative responses. Museum goers may also forget that a crucial role of the museum is not to waver when it presents unpopular art or exhibitions.

In all the controversies mentioned, the majority of museums held their ground and argued passionately and effectively for the controversial art. Similarly, when the Anti-Defamation League and a member of the Whitney's national committee (who had promised the Whitney one million dollars) protested the display of Hans Haacke's *Sanitation* (2000; fig. 7), the museum did not withdraw the work from its 2000 Whitney Biennial. Haacke's installation, in a room of its own, without a warning, included six quotations, three from Mayor Giuliani and three from other politicians, decrying *Sensation*.[16] The quotes, written in the Fraktur script favored by the Nazis, were placed on either side of a multi-layered American flag inspired by Jasper Johns's once-controversial painting. On the floor, Haacke placed large garbage cans emitting the sound of marching boots and a copy of the First Amendment, which guarantees free speech. Haacke's installation linked responses to *Sensation* in the United States with censorship policies of the Third Reich and reopened recent debates about the relationship between art and politics, art and race, and art and money. Most importantly, *Sanitation* introduced a political comparison—Nazi Germany/right-wing America—considered taboo. The museum

Fig. 6. Sandra Rechico, *Shards II* (detail), installation view, 1997–2000. Dimensions variable from 2,000 to 4,000 pounds. Crushed and broken glass. Courtesy of the artist and Leonard and Bina Ellen Art Gallery, Concordia University, Montreal, 2000. Courtesy of the artist and the gallery.

Fig. 7. Hans Haacke, *Sanitation,* installation view from the Whitney Biennial, 2000. Collection of Lila and Gilbert Silverman. © 2001 Artists Rights Society (ARS), New York/VG Bild-Kunst, Bonn.

recognized the importance of not foreclosing discussion however inopportune, awkward, or unsettling, for without debate, albeit rancorous, hurtful, and misguided, the range and depth of feeling associated with the issues would not have emerged. It may take a form of "mother courage" to exhibit works a museum knows will provoke intense responses, but public debate, the basis of democracy, is safer than its alternative.

When an exhibition is framed as a forum for discussion, its success is not dependent on traditional aesthetic criteria. What matters more is how much discussion is generated, for how long, in which sectors of society, and, most importantly, to what effect. The emphasis becomes ethics rather than aesthetics, practice rather than theory, audience rather than artist. Predicated on dissonance, discomfort, and discordance, the exhibition as discursive event asks the audience to consider the value of situational ethics and transgressive aesthetics, to use the exhibition as a focusing device and a forum.

Mirroring Evil is a dangerous exhibition. It deviates markedly from what has become the norm, from what has been codified as acceptable, from what is considered safe in exhibitions of art about World War II in Jewish museums. Unlike most exhibitions about the period, *Mirroring Evil* does not focus on the disasters of war, the innocent victim, or the unending grief of the Holocaust. The enemy has been allowed inside the door. Any sense of safety that a Jewish museum might provide gives way in an exhibition that includes portraits of perpetrators, erotic fantasies about Nazis, toy reconstructions of Auschwitz, and games about the Holocaust. Or does it? The Jewish Museum is the only space safe enough for an exhibition like *Mirroring Evil* to take place, the only space where there is any possibility of a dialogue about art that raises a series of hitherto-unexplored questions pertaining to the legacies of Eros and Thanatos in relation to World War II. Visitors may feel deeply threatened, outraged, or betrayed, but it

is safer by far to explore the implications of the continuing fascination with the Nazi era within the confines of a Jewish museum than outside it.

NOTES

1. Mark Cousins advocates dangerous art and safe politics. His cautionary remarks about the reverse situation teach us that our desire for safety may actually be more dangerous than we can possibly imagine; that our outcry against art we believe to be dangerous may, in fact, endanger our safety; that the museum is an ideal place for examining what makes us so afraid. See "Danger and Safety," *Art History* 17, no. 3 (September 1994): 418–23. My thanks to Kitty Scott for suggesting I read Cousins. See my "The Exhibition as Discursive Event" in *Longing and Belonging: From the Far Away Nearby* (Santa Fe, N.M.: SITE Santa Fe, 1995), 120–25, for a discussion of controversial exhibitions.

2. Carol Duncan, *Inside Public Museums: Civilizing Rituals* (London and New York: Routledge, 1995).

3. D. W. Winnicott, *Playing and Reality* (London: Tavistock, 1971).

4. See Diana Nemiroff, *Jana Sterbak: States of Being* (Ottawa: National Gallery of Canada, 1991).

5. Johanne Lamoureux, "Jana Sterbak versus Felix Holtmann: L'Expertise de Monsieur Tout-le-Monde," in Lynn Hughes and Marie-Josée Lafortune, eds., *Pensées de la Discipline: Recherches interdisciplinaires en art visuel au Canada* (Montreal: Optica, forthcoming).

6. Johanne Lamoureux, "Questioning the Public: Addressing the Response," in George Baird and Mark Lewis, eds., *Queues, Rendezvous, Riots: Questioning the Public in Art and Architecture* (Banff: Walter Phillips Gallery, 1994), 151.

7. Elizabeth Legge, "Reinventing Derivation: Roles, Stereotypes and 'Young British Art,'" *Representations* 71 (Summer 2000): 1.

8. Ibid.

9. A key area of concern for many commentators and legislators was the morality of exhibiting work from a single collection. Although the practice is common, questions were raised about the enhanced economic value a museum exhibition gave to the Saatchi works. The narrow focus of the polemic failed to acknowledge the importance of Saatchi's private museum in London as a major showcase for contemporary art or Saatchi's annual practice of giving away a substantial portion of his collection to museums in Britain, where restricted budgets preclude the acquisition of new work, especially if it is costly. In North America, visible private patronage is acceptable only when it takes more discreet forms.

10. See Richard Bolton, ed., *Culture Wars: Documents from the Recent Controversies in the Arts* (New York: New Press, 1992) for extensive documentation of the positions taken on exhibiting *The X Portfolio*.

11. Joseph Kosuth, with essay by David Freeburg, *The Play of the Unmentionable: An Installation by Joseph Kosuth at the Brooklyn Museum* (New York: New Press, 1992).

12. Arthur C. Danto, *Playing with the Edge: The Photographic Achievement of Robert Mapplethorpe* (Berkeley, Los Angeles, and London: University of California Press, 1996), 4–15.

13. Ellen C. Oppler, "Guernica—Its Creation" in Ellen C. Oppler, ed., *Picasso's Guernica* (New York and London: W. W. Norton, 1988), 134.

14. The exhibition, curated by Jennifer Fisher and Jim Drobnik, took place at the Leonard and Bina Ellen Art Gallery, Concordia University, Montreal, spring 2000. My thanks to Karen Antaki, director of the gallery, who provided me with the information about installing and monitoring the work.

15. As a way of avoiding charges of age discrimination, when *Slide* was exhibited in New York, sliders had to be a certain height.

16. These quotations are as follows:

"We will do everything that we can to remove the funding for the Brooklyn Museum until the director comes to his senses."—Rudolph Giuliani

"I would ask people to step back and think about civilization. Civilization has been about trying to find the right place to put excrement, not on the walls of museums." —Rudolph Giuliani

"Since they seem to have no compunction about putting their hands in the taxpayers' pockets for the exhibit, I'm not going to have any compunction about putting them out of business."—Rudolph Giuliani

"This elite cries 'censorship,' and falls back upon that last refuge of the modern scoundrel, the First Amendment." —Pat Buchanan

"Do you want to face the voters in your district with the charge that you are wasting their hard-earned money to promote sodomy, child pornography, and attacks on Jesus Christ?"—Pat Robertson

"No tax fund shall be used for garbage just because some self-appointed 'experts' have been foolish enough to call it 'art.'"—Jesse Helms

Distanced Mirrors:
Reflections on
the Works of Art

CHRISTINE BORLAND

L'Homme Double, 1997
PLATES 1 AND 2

Keeping One's Hands Clean: Six Commissioned Portraits of a Perpetrator

Without doubt, Hitler is the twentieth century's ultimate signifier of evil, replacing mythological figures or religious ones like the Devil. In using the image of Hitler, as Rudolf Herz does, or his attributes, as Roee Rosen does, artists self-consciously tempt the representation of taboo, show how generalized and banal certain representations have become, and question any meaning they might convey. These works admit the impossibility of interpretive closure. In her fascination with forensic issues and her fixation on the intersection of science and art, Christine Borland probes the representation of evil in the image of another infamous Nazi, Joseph Mengele. In focusing on the Nazi doctor whose "scientific experiments" with twins were actually an excuse to torture Jews, Borland also probes the ethics of modern science.

Studying the Auschwitz doctor, Borland discovered a remarkable set of contradictions between his physical beauty and the terrifying depravity of his personality. Her research revealed the equally shocking fact that some of his victims were actually captivated by his dashing features and charm. Mengele's "patients," knowing that he was a torturer and murderer, gave contradictory descriptions of him. One of the doctor's patients, Mark Berkowitz, commented that Mengele "looked so handsome that if we saw him we almost had the urge to run to the gate and greet him." He was described by others as Hollywood star material, "radiating lightness and gracefulness [in] contrast to the ugliness of the environs." One woman admitted that there were others who "would love to spend a night with him."[1] Postwar descriptions became infinitely less flattering. The conflation of seductiveness and depravity in the identity of one man coincides with Georges Bataille's belief that violence is connected with every form of eroticism.

To investigate these contradictions, Borland created—one might say, choreographed—the sculptural installation L'Homme Double. In conceptual fashion, the artist distanced herself from the very act of cre-

ation, both literally and figuratively. She set up a system for the representation (dare one call it memorialization?) of this horrific example of human evil. Borland assigned six academically trained forensic sculptors the task of making a physically accurate portrait of the man, whose identity was not revealed to them. She provided each sculptor with two indistinct photographs of Mengele, together with descriptions of him like those quoted above. The resulting busts show a remarkable range of differences. The strategy is reminiscent of Maurizio Cattelan's *Il Super Noi,* in which the artist commissioned fifty artists to draw his portrait solely from textual description. Borland's busts are displayed together in one gallery, each near the framed photographs and documents that she supplied for the sculptors. The multiplicity, or twinning, of the images and the differences among them purposely frustrate the factual base of Borland's art, thereby erasing the possibility for any sense of objectivity. As has been frequently observed in relation to Borland's work, both subject and artist disappear.

The title of Borland's work also reverberates with meaning. It refers to the psychological explanations given by lawyers for the Nazi perpetrators about a type of schizophrenic personality, one that could be good in one place, yet evil in another. (Remember Christian Boltanski's appropriated scrapbook of the Nazi soldier in domestic harmony with his family; *see page 8.)* The term "double" also refers to the actual twins on whom Mengele experimented.

But there are other levels of reference that operate in Borland's installation. The use of the "taboo" of academic art within the history of modernism is a type of aesthetic violation with which she plays, and it is precisely this type of academic art—especially the prototypically idealized bust—that was central to Nazi aesthetics. Each of the six sculptures is reminiscent of the work of ideologically and aesthetically tainted sculptors such as Arno Breker, who worked for the Nazis and helped establish the monumental and megalomaniacal style associated with the move-

ment. In the 1980s, Breker received a heavily disputed commission for portraits of the art collector Peter Ludwig and his wife. The commission extended a debate then raging in Germany about the ethics of showing art of the Nazi period in museums and exhibitions.[2] In a play of paradox, Borland distances herself from the work, from "touching" the subject, and from the ideological implications of the style she has commissioned, thus circuitously disavowing ethical connections. In staging these multiple representations of Mengele, Borland negates the notion of art as unified and holistic, a principle central to fascist aesthetics. Ultimately, the ethical implications of the situation she fabricates are also multiple. Her assigning others to depict the Nazi perpetrators in three dimensions begs the continuing and controversial questions about the appropriateness of representation in the face of the Holocaust and the confusion between the represented and the real. Even more curious is Borland's own ethical transgression in implicating other artists as she tests the limits of representation. At once coincidental and profound is the fact that not only does she use other artists in her attempts to re-create a symbol of evil, but also that their physical products actually become Borland's own artistic expression. The artists stand in for her as the sculptures stand in for Mengele. Thus, Borland raises the stakes in the rhetorical questions her work sets up. Is she free of blame because it is others who "touch" this tainted subject matter? Or is she even more guilty because she implicates others for her own personal ends? These troubling questions, central to her project, remain irresolvable. Because of the dialectic—some might say diabolic— nature of the project, they continue to persist and to frustrate. **NLK**

NOTES

1. Greg Hilty, in *Christine Borland,* exh. cat., FRAC Languedoc-Roussillon, Montpellier, France, 1997.
2. Steven Kasher, "Art of Hitler," *October* 59 (Winter 1992): 75.

ROEE ROSEN

Live and Die as Eva Braun, 1995
PLATE 3

Male Fantasies of Hitler: Confusing Gender and Identity

A "twilight zone of right and wrong [where] . . . questions are truly experienced" describes how the works of Piotr Uklański, Rudolf Herz, and Elke Krystufek operate. These are precisely the words Israeli artist Roee Rosen uses to describe his intentions for his installation and artist's book *Live and Die as Eva Braun.*[1] In ten chapters, Rosen pairs text with sixty black-and-white drawings on paper. The drawings have deckled edges mimicking mid-century vernacular photographs. Written as a virtual-reality scenario, Rosen's text asks the viewer (male or female) to become—that is, to perform, at least for the duration of his or her visit—the role of Hitler's mistress Eva Braun. We are asked to assume Braun's identity and to experience her narrative empathically at a crucial, if not culminating, moment in her life. We are to become Eva when she meets her aging lover for the last time, the moment he will, after a final sex act, kill her. The suicide pact between Hitler and his mistress is already a metanarrative that mixes fact and myth to fabricate history. In Rosen's text, Eva recalls earlier moments in their relationship. She shares intimacies that are at once naïve, titillating, and vulgar. At every turn, the narrative is accompanied by drawings that mirror its paradoxical juncture between naïveté and pornography.

Rosen requires the viewer to enter a virtual-reality world. Encountering Braun's seduction, suicide, and improbable assumption into a netherworld, the narrative is connected to disjointed images. With their scalloped edges, the drawings look as if they are from an old scrapbook. In this way they resemble Christian Boltanski's appropriation of a Nazi officer's photo album *(see page 8).* But Rosen's handmade drawings refuse to succumb to appropriation and, as such, contradict the high-tech notions of virtual reality that he wishes the viewer to enter. They fabricate a perverse fairy tale using imagery scavenged from various, often incongruous sources. These include German children's books, German

Fig. 1. Roee Rosen, *Live and Die as Eva Braun #1,* 1995. Acrylic on paper. Courtesy of the artist.

Romantic painting, and images drawn from popular culture. One pop-culture source is the well-known German farcical comic book *Adolf.* One of the first images we encounter (fig. 1) is one in which we seem to be poised at a console table or vanity looking into an empty mirror held up (or flanked) by two monkeys. We do not know if the monkeys are real or simply decorative elements of the mirror's frames. Through the mirror's emptiness and its mimetic reflection, we begin to imagine ourselves in the process of becoming Eva Braun, and we subsequently imagine the horrendous possibility of being seduced by Hitler. Although Hitler's image never appears in Rosen's project, symbols associated with him float through the drawings and confound a coherent reading. Another depiction resembles a photograph of the artist as toddler, reconfigured so that the child now sports Hitler's trademark mustache and parts his hair on the right side, as Hitler did. Rosen uses a dizzying number of symbolic and mimetic tropes, and the critic Roger Rothman has observed the disjunction of text and image.

Like Rudolf Herz in *Zugzwang,* but through radically different methods, Rosen's *Live and Die as Eva Braun* uses multiplication, fragmentation, doubling, and self-imposed confusion. Rothman demonstrates how the work's "playfulness is undercut with signs of violence, trauma, perversion, and destruction."[2] As with Krystufek's works, which force us to enter the perpetrator's space, we now become both the subject and the object of defilement. As viewers, we reincarnate the fascist impulse toward self-destruction that was theorized in the early 1930s by Georges Bataille.[3]

As we enter Rosen's world, we lose control of our judgment and sense of appropriateness. We enter a seductive, if frightening, space in which we cavort with, even approve of, evil, knowing full well its implicit terror. Hans-Jürgen Syberberg's *Hitler, A Film from Germany* created a similar sense of intimacy with the twentieth century's symbol of evil incarnate

(fig. 2). As Thomas Elsaesser has shown, watching the film we, as spectators, become exasperated and feel abused. Rosen forces us to the next level of participation, mingling innocence and sex. Rosen also shares Syberberg's deployment of screens and mirrors and engages us in what Elsaesser calls "the Medusa-face of fascination."[4] Yet Rosen is more akin to Todd Solondz, through whose films, such as *Welcome to the Doll House* (1995) and *Happiness* (1998), we begin to engage, at least in our imaginations, in "inappropriate" behavior. For example, we catch ourselves titillated, laughing at immoral situations.

Rosen's work exemplifies Sidra Ezrahi's perspective on the creation of images after Auschwitz. In opposition to those she calls "mythifiers," Ezrahi notes that for "relativizers," like Rosen and the other artists in this volume, "it is precisely in its [the Holocaust's] ineffability that it is infinitely and diversely representable." More important for Rosen is that "the urgency of representation, then, unfolds in continual tension between desire and its limits."[5] And it is precisely because of this impulse that Rosen's project was fiercely attacked when it was exhibited at the Israel Museum in 1997, even though Rosen might have possessed greater "legitimacy" than many because he is the son of a Holocaust survivor.

The project's content and consequent transgressions became international news covered by CNN, *Newsweek,* and *The New York Times.* Israel's Minister of Education asked that the exhibition be closed, and the Israeli news media focused on the controversy, claiming that the project indulged in sensationalism for its own sake and "turn[ed] the Holocaust into pornography." Yet some who saw Rosen's work tried to come face to face with the experience of psychologically entering the proverbial mind and body of Eva Braun. One critic showed how the antagonist Eva helps us come to recognize our deepest fears and desires and "get to know the worst of evil."[6] Others drew political and social par-

Fig. 2. From the film *Hitler, A Film from Germany,* 1977, directed by Hans-Jürgen Syberberg. Courtesy of Syberberg Filmproduktion, Munich.

allels to the racism that pervades Israeli society and to the situation of the Palestinians. Through our experience as Eva, we begin to ask ourselves a litany of questions: How can we, as imperfect societies and individuals, so easily cast blame on others? How can we presume to understand right and wrong, good and evil, without having succumbed to the ultimate temptation? Certainly this is not an easily defensible position with regard to the Holocaust. But is it possible to mistakenly see what Rosen has created as a Holocaust memorial or monument? According to the Israeli critic Ariella Azoulay, the exhibition throws the spectator into a maze of intricate systems, in which the viewer "becomes the subject of control, of representation, of evil, of sexuality, of passion, of rejection, of will, of resistance, and of loss." She, also, argues the faultiness of too simplistically connecting Rosen's project to the Holocaust. The subject of its narrative and the nature of its form, in fact, discourage any "sovereign interpretation" or control of the limits in representing such a chilling subject.[7] **NLK**

NOTES

1. Roee Rosen, communication with author, February 27, 1999.

2. Roger Rothman, "Speaking Through Irony: On the Recent Work of Roee Rosen," *Studio Art,* no. 88 (December 1997).

3. John Berkman, "Introduction to Bataille," *New German Critique* 16 (Winter 1979): 59.

4. Thomas Elsaesser, "Myth as the Phantasmagoria of History: H. J. Syberberg, Cinema and Representation," *New German Critique* 24/25 (Fall 1981–Winter 1982): 111–13, 144.

5. Sidra DeKoven Ezrahi, "Representing Auschwitz," *History and Memory* 7, no. 2 (Winter 1996): 144–45.

6. "Enjoying, Annoying, and Suffering with Eva," trans. Roee Rosen, *Kol Ha'ir Weekly* (Nov. 14, 1997).

7. Ariella Azoulay, "The Spectator's Place [in the Museum]," paper presented at "Representing the Holocaust: Practices, Products, Projections" conference, Lehigh University, Bethlehem, Penn., May 21–23, 2000.

MISCHA KUBALL

Hitler's Cabinet, 1990

PLATE 4

Transforming Images into Symbols

Mischa Kuball uses light as his signature medium. With it, he plays with contrasting ideas of image and symbol, the sacred and profane, power and powerlessness. In *Hitler's Cabinet* (1990) he uses the medium to probe historical archives and intellectual theories while he distorts physical structures and transforms stylistic references. Curiously, Kuball's continuing obsession with light for the exploration of intellectual theories and representational images has been associated with two opposed influences. On the one, the artist's historical outlook reflects back to earlier, utopian histories, for example, the Enlightenment of the late eighteenth century or the Bauhaus of the early twentieth. On the other, Kuball alludes to the potential of light for the display of sculptural and political might, as under the Nazis. In this case, Albert's Speer's infamous, blinding, nevertheless awesome *Dome of Light* of 1937 is a particular example, as is the use of intense light as both symbols in and strategies for Nazi architecture. Speer's overwhelming spectacle serves as the quintessence of what Walter Benjamin called "aestheticized politics." Kuball plays with the inevitable, paradoxical connections between these two strikingly opposed political and social ideologies. Rather than offer standard lessons about the social potential of one or the moral failure of the other, he shows how inextricably they are connected.

Cruciform in shape and large in scale, *Hitler's Cabinet* hugs the gallery floor. At first glance, its solid, industrial shape reminds one of the muscular and emotionally distant works of such Minimalist artists as Carl Andre and Richard Serra. Yet the humble materials Kuball uses and the meanings of the symbolic forms in which the materials are configured contrast markedly with the hardness, heft, and hermetic nature of Minimalism. Indeed, Kuball refers to his Minimalist predecessors, yet he seeks to inject purpose and content into Minimalism's ahistoricism. He uses slide projections that teach historical

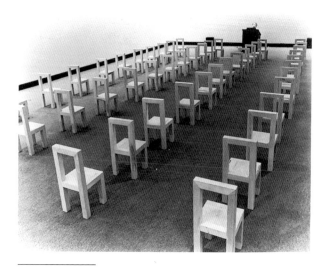

Fig. 1. Dennis Oppenheim, *Lecture #1,* 1976. Installation at Framarstudio, Naples. Two cast figures equipped with audio-synchronized jaw movements, felt suits, wood chairs, wood and Formica lectern, audio tape. 30" x 264" x 446". Courtesy of the artist. Collection of the Whitney Museum of American Art.

lessons, continuing an avant-garde tradition of installation and performance that critiques art-historical didacticism. Here one thinks of Robert Morris's renowned *21.3* of 1964, in which Morris masqueraded as the eminent German refugee art historian Erwin Panofsky mimicking a tape of *Icono-graphy and Iconology,* or of Dennis Oppenheim's installation of a puppet teaching a class (fig. 1).

Kuball's crosslike shape is made of inexpensive pressed wood, unpainted and unadorned. Each of the four ends of the cross is pierced with rectangular openings, through which 35-millimeter slides are projected onto the floor. Creating ghostlike, fan-shaped forms, these splayed images are stills from German films of the 1920s and 1930s. When lit, the stills transform the pressed-wood cross into a swastika; the durable industrial sculpture becomes an environment that performs electrically. These still photographs visually re-create Siegfried Kracauer's famous 1947 psychosocial history of German cinema *From Caligari to Hitler.*[1] According to Kracauer, the films made between the end of World War I and the election of Hitler set the stage, so to speak, for Nazism. Kracauer, a German-Jewish refugee histo-rian, saw the aspirations and fears, the psychologi-cal frailties and political struggles of the German people, encoded in a wide range of German films. For example, he claimed that movies like Paul Wegener's *Student of Prague* demonstrated the insecurities of the foundations of self and that Robert Wiene's *The Cabinet of Dr. Caligari* glorified authority connected with madness. According to Kracauer, such manifes-tations of the German psyche would make the aver-age German easily influenced by Nazi propaganda, losing the ability to make sound moral judgments. In Kracauer's observations, many productions showed German traits of chauvinism, Romanticism, national-ism, and, ultimately, preference for tyranny over chaos. Thomas Elsaesser has thoughtfully outlined the pitfalls of Kracauer's postwar theoretical posi-tion: "he fill[s] gaps, smooth[es] out the narrative

logic, invert[s] the causal chains, level[s] off intensities . . . and den[ies] ambiguities." Elsaesser shows how, according to a large corpus of feminist critiques, Kracauer's history could be easily be deconstructed as "phallocentric versions of politics and history."[2]

The slide projectors in each of the four arms of Kuball's environment continually project the range of images that frame German cinema during the period between the wars. Kuball's projections are distorted and tinted an eerie shade of blue. They fan out in megaphone shape as if to trumpet the meanings Kracauer has so forcefully assigned them. On the surface they show Kracauer's theory as a constant parade of representations. One could say that Kuball's sculpture, or teaching machine, simply performs Kracauer's lesson in the gallery—that the symbols, images, and implications Kracauer found in German film between the wars equals the swastika, the symbol of Nazism. Kuball is certainly too well read, too critically astute, and too sculpturally playful to wish his installation to present such a straightforward confirmation. The artist makes us hyperconscious that—without text—the images are an archive, no more, no less: a highly specific mode of organizing representations that Allan Sekula has dubbed a "territory of images."[3] By simply looking at the images, the viewer of this revolving archive must search for the clues through which Kracauer has orchestrated his brilliant, if now dated, transformation of culture into politics. Kuball's second-generation sculptural transformation of the hard cross into the more fleeting symbol of the swastika is a metaphor for the direct, deductive nature of Kracauer's synthetic narrative. In the deadpan flash of images and the seemingly easy transposition of one

solid symbol with impermanent other, we note the artist's implied critique of the sociologist's forced interpretation. The artificiality of these contorted slides, and the fact they are projected onto the less worthy realm of the gallery floor (instead of the privileged space of the gallery walls), makes us wary of the reliability of the meanings that have been assigned to them. Do we really see the Nazi future in these films, or does Kuball help us reenact the dark, sinister forms and symbols as they appeared to Kracauer's eyes? In fact, Kuball helps us unmask the larger issue Allan Sekula has observed about the way archives are often distorted as they are deployed: "In an archive, the possibility of meaning is 'liberated' from the actual contingencies of use. But this liberation is also a loss, an abstraction from the complexity and richness of use, the loss of context."[4]

Transgressive here is the way Kuball uses the images of film stills to transform his cruciform shape into a swastika, a symbol today forbidden by German law. Devious is the way it can be turned on and off. Kuball uses light to create this highly charged, illegal image that can be obliterated merely by pulling the plug. **NLK**

NOTES

1. Siegfried Kracauer, *From Caligari to Hitler: A Psychological History of the German Film* (Princeton, N.J.: Princeton University Press, 1947; reprint, 1974), 55.

2. Thomas Elsaesser, "Film History and Visual Pleasure: Weimar Cinema," in Patricia Mellencamp and Philip Rosen, eds., *Cinema History, Cinema Practices* (Frederick, Md.: University Publications of America, 1984), 62–64.

3. Allan Sekula, "The Currency of the Photograph," *Thinking Photography,* ed. Victor Burgin (London: Macmillan Press, 1982), passim.

4. Ibid., 116.

PIOTR UKLAŃSKI

The Nazis, 1998

PLATE 5

The Conflation of Good and Evil

Fig 1. Piotr Uklański, *The Nazis* (installation shot from Photographers' Gallery, London), 1998. Courtesy of Gavin Brown's Enterprise.

iotr Uklański's installation *The Nazis* opened at London's Photographers' Gallery in August 1998 (fig. 1). Prompted by an article in *Arena* magazine about best-dressed actors, and by his realization that a number of these actors had been shown attired in Nazi paraphernalia, Uklański tracked down photographs of movie stars dressed for roles in which they personify Nazis. His installation included 166 images displayed in a friezelike form wrapping the gallery's perimeter—a clear homage to Andy Warhol's installation of *32 Campbell's Soup Cans* paintings at the Ferus Gallery in Los Angeles in 1962.

For this project, Uklański expanded obsessively upon his interest in film and its visual strategies. The project was also motivated, in part, by the silence about the war period that ruled in his family (his grandfather had fought for the Germans).[1] Like many Generation X'ers, Uklański garnered much of his early education about the war and the Holocaust not from the recollections of his elders, but from popular films and television—media that, as Saul Friedlander has shown, play a more prominent role in Holocaust consciousness than serious historical inquiry.[2]

The Nazis is intimately related to postmodern art practice that intellectually scrutinizes and visually reframes representations from mass culture. Uklański's visual litany is exhaustive, perhaps purposefully exhausting. Included are Helmut Schneider; Dirk Bogarde; an all-too-casual Clint Eastwood; a boyish, even vulnerable Frank Sinatra; the elegant Max von Sydow; and the dashing, somewhat androgynous-looking Ralph Fiennes (fig. 2). The ambiguity of the characters' identities is enhanced by the fact that Uklański strategically rejects Walter Benjamin's imperative for the necessity of texts to clarify photographic images. In fact, the organizers of the exhibition found some viewers attempting to identify as many of the actors and roles as they could.[3]

Uklański also mines the aesthetic preoccupation of some artists to engage in anthropological or archival research to demonstrate the futility of collecting and to undermine assumed power structures.[4] Using the Duchampian prerogative to nominate any cultural property as the object of the artist's own authorship, Uklański refers to the deadpan Pop glorifications of Warhol's celebrity pictures and the archival obsession of Marcel Broodthaers's fake museums. Also part of Uklański's trajectory of influence is Gerhard Richter's series of portraits, as well Warhol's censored project for Philip Johnson's New York State Pavilion at the 1964 New York World's Fair. In his *Thirteen Most Wanted Men* (fig. 3) Warhol re-presented images of hunted criminals from broadsides offering rewards for their arrest. In selecting movie stars performing criminal roles, Uklański actually collapses these two seemingly disparate aspects of Warhol's portraiture.

In essence, Uklański offers a rogue's gallery as museum, simultaneously equating "Nazi" with "male." Flaunting how postwar society eroticized the Nazi uniform,[5] he links Nazi banality and evil with Hollywood glamour and extravagance. If we participate in his game, we are trapped in uncomfortable territory. We are torn between our desire for our favorite actors and the realization that popular representations of them commodify the evil of the Third Reich.

Showing the contentious reactions that such imagery can provoke, especially to audiences unaccustomed to contemporary art, Uklański's work attracted notice in many London newspapers. The negative responses of Lord Janner, chairman of the Holocaust Education Trust, sent the press on a feeding frenzy, as did the reaction of some members of the Jewish community, who felt that the exhibition might become a magnet for neo-Nazi worship. The headline of the *Evening Standard* proclaimed "Outrage as London gallery highlights 'glamour of Nazism.'"[6] It was even suggested that The Photogra-

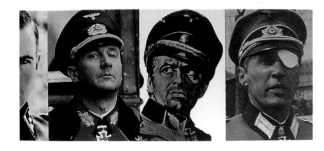

Fig. 2. Piotr Uklański, *The Nazis*, detail from the installation at Photographers' Gallery, London, 1998. C-prints, 14" x 10" each. Courtesy of Gavin Brown's Enterprise.

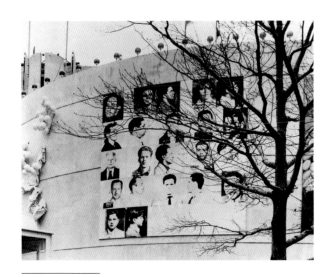

Fig. 3. Andy Warhol. *Thirteen Most Wanted Men*, 1964. Installed at the New York State Pavilion, New York World's Fair, 1964. Silkscreen on Masonite. 25 panels, each 48" x 48". © The Andy Warhol Foundation for the Visual Arts. Courtesy of the Andy Warhol Foundation, Inc./Art Resource, NY. Photograph by Eric Pollitzer.

phers' Gallery display books on the Holocaust and photographic blowups of Holocaust victims to allay the public's concerns.[7] Yet Janner felt that nothing would temper the exhibition's impact, short of a corollary presentation of photographs showing the misery that the Holocaust caused Jews and non-Jews alike. He wanted historical material to explain, validate, and even vindicate the art displayed.

Although some hip youth magazines capitalized on the glamour and sartorial aspects of the display, serious critics were able to formulate a more judicious reading of Uklański's installation. Neal Ascherson of the *Observer* commented on the artist's "sinister, intelligent talent" in making the exhibition into "a pitfall out of which no one scrambles intact."[8] The *London Times* reviewer Waldemar Januszczak, although known to be a conservative critic, took the matter most seriously, analyzing the project and exploring why it provoked such hostile reactions. Januszczak saw Uklański's Polish origin as part of the predicament. Being of Polish birth himself, he empathized with both the artist and the audience and recognized that the history of Polish anti-Semitism left wide mistrust in its wake. In addition, he blamed the film industry for its "harmless" and "picturesque" characterizations and praised Uklański's work for its scrutiny of such superficiality.[9]

NLK

NOTES

1. Alice Yaeger Kaplan discusses the problematic purveying of the history of World War II using the tale of her friend Margaret, who was told stories by her grandmothers "on the sly." See Alice Yaeger Kaplan, "Theweleit and Spiegelman: Of Men and Mice," in Barbara Kruger and Phil Mariani, eds., *Remaking History* (Seattle: Bay Press, 1989), 167–68. Information about Uklański's family is included in a number of the articles about his exhibition. The artist also spoke about his familial reaction (or lack thereof) with reference to the Holocaust and World War II during an interview with the author on January 16, 1999.

2. Saul Friedlander, *Memory, History, and the Extermination of the Jews in Europe* (Bloomington: Indiana University Press, 1993), 47.

3. Paul Wombell and Jeremy Millar, director and curator, respectively, of The Photographers' Gallery, London, in meeting with the author, January 21, 2000.

4. For other examples see the catalogue for the exhibition at P.S.1, Long Island City, New York: Ingrid Schaffner et al., eds., *Deep Storage: Collecting, Storing, and Archiving in Art* (New York and Munich: Prestel, 1998). For examples of Broodthaers's ironic collecting enterprises, see Marge Goldwater, introduction to *Marcel Broodthaers* (Minneapolis: Walker Art Center; New York: Rizzoli, 1989).

5. Susan Sontag, "Fascinating Fascism," in *Under the Sign of Saturn* (New York: Farrar, Straus & Giroux, 1980).

6. The *Evening Standard,* (29 July 1998): 21.

7. Wombell and Millar, meeting with author, January 21, 2000.

8. Neal Ascherson, "It's only David Niven dressed up. Why do we feel a chill?," the (London) *Observer,* August 23, 1998.

9. Waldemar Januszczak, *The London Times,* August 16, 1998, p. 10.

ELKE KRYSTUFEK

Economical Love (Pussy Control), 1998
PLATE 6

Economical Love (Hitler Hairdo), 1998
PLATE 6

Economical Love (Abstract Expressionism), 1998
PLATE 8

A Feminist Rejoinder to Uklański's *The Nazis*

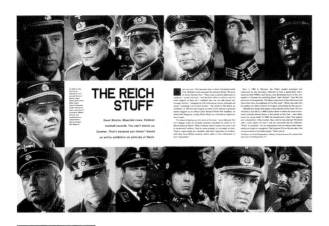

Fig. 1. Piotr Uklański's *The Nazis,* reproduced in *The Face* (London, August 1998).

J ust as journalists and critics responded to Piotr Uklański's *The Nazis,* an artist immediately responded to the installation. In her continuing series about male sexual exploitation, the Austrian artist Elke Krystufek reappropriated some of the imagery Uklański had already appropriated. She collaged elements of Uklański's celebrity Nazis onto her large-scale painted and photographic nude self-portraits. Added to one collage were three such photographs with the following quotation: "You can't shock us, Damien. That's because you haven't based an entire exhibition on pictures of Nazis." These words, from a flip review of Uklański's exhibition, had appeared in the hip English magazine *The Face* (fig. 1). ("Damien" refers to England's art star of transgression, Damien Hirst, whose dead sharks and bisected cows floating in huge glass vats of formaldehyde caused an enormous sensation in the early 1990s in London.) For Krystufek, Uklański's installation served as proof positive of a male monopoly on art-world hubris.

She simultaneously implicated the pornographic sexuality that Klaus Theweleit has shown to be central to Nazi male fantasy in his important study, *Male Fantasies.*[1] While Uklański has found the improbable but inevitable meeting between good and evil, Krystufek places the viewer in even closer complicity. In particular, she puts one in the untenable position of being a voyeur and colluding with the Nazis depicted. At the same time, she makes the viewer the object of both her gaze and that of the Nazis. She rotates the so-called male gaze by 180 degrees. As we stare at her naked body, we unwillingly, although not unwittingly, pose for her camera. Krystufek traps the viewer physically—like a stag caught in headlights. Yet her viewer is captured within the confines of the gallery space that she often overpowers with mural-size photographs and paintings. She ensnares the viewer in a moral conundrum from which there seems to be no exit. In her

take on the *droit moral* of image making, both viewer and artist are caught in a standoff, each guilty of stealing the other's likeness and dignity. In accomplishing this, Krystufek exponentially raises the stakes of Uklański's already ethically compromising, socially interrogative enterprise.

Hitler's Children takes its title from part of a text and image in Uklański's book; he himself had appropriated them from a 1940s film poster. Onto this she overlays photographs of herself in positions that are at once vulnerable and compromising. Those she has staged and then collaged are sexy, scary, and purposefully self-indulgent. She implores us to ponder the untenable question of whether she, as the child of an Austrian family, one of "Hitler's Children," has any right to portray the abuse of women by men. Simultaneously, she exposes the self-victimization she recognizes in herself and in other women of her generation.[2] This strident imagery is part of a personal crusade to unravel the "industry of images and the magazines that commercialize the [female] body."[3] Through it, Krystufek blurs the boundaries between society's abuse and misrepresentation of women and how these abuses are replayed as self-inflicted. In other words, trauma is internalized and repeated. What Mark Seltzer has observed about "wound" culture is apt for Krystufek's heavily manipulated representations. He claims that "the wound and its strange attractions have become one way . . . of locating . . . violence and . . . erotics, at the crossing point of private fantasy and collective space." In essence, Krystufek has tapped into what Seltzer has coined the "pathological public sphere."[4]

There is no underestimating the influence Theweleit's *Male Fantasies* has had for Krystufek's thought. Theweliet examines the writings of—and representations connected to—the male Freikorps, right-wing World War I veterans who became keepers of the peace (or policemen) during the postwar unrest in Germany and during the Weimar Republic.

They often became Nazis. In relating their superficially protective stereotypes of some women and violent hatred of others, Theweleit lays out potential connections between such attitudes and the eventual projection of that violence onto the bodies of Jews.

Alice Yaeger Kaplan best explains the discomfiting position that Theweleit proposes in his continuum between fascist and nonfascist and the inevitable connections of the attitudes of the men in his study to the attitudes of his German "left-wing intellectual" readers.[5] Like Theweleit, Krystufek is not propelled by the anxiety that fascism might reappear. Instead, she finds his observations compelling because of how they relate to ordinary interactions between men and women.[6] And like Theweleit, Krystufek offers the material evidence to "take precedence over interpretations."[7] Theweleit's evaluation of men's search for pleasure, that they "look for ecstasy not in embraces, but in explosions, in the rumbling of bomber squadrons or in brains being shot into flames," could well describe one of Krystufek's shocking collages. What makes her art so convincing, and often so threatening, is that she assumes the male role as the purveyor of the images, both negative and positive, but performs those male sexual fantasies using her own body. And she subjects male viewers to the distorted and perverse mimicry of male sexual fantasy inscribed on the female body. Male fantasies are mirrored on the artist's flesh and mirrored onto potential perpetrators—men who might gaze at women or fantasize violently about them. **NLK**

NOTES

1. Klaus Theweleit, *Male Fantasies,* trans. Stephen Conway in collaboration with Erica Carter and Chris Turner, foreword by Barbara Ehrenreich, 2 vols. (Minneapolis: University of Minnesota Press, 1987–89).

2. For a discussion of post-1960s feminism in Germany,

see Dagmar Herzog, "'Pleasure, Sex, and Politics Belong Together': Post-Holocaust Memory and the Sexual Revolution in West Germany," *Critical Inquiry* 24, no. 2 (Winter 1998): 397–98.

3. Elke Krystufek, "A Conversation with Henry Bounameaux," in *Economical Love* 24 (São Paulo: Bienal de São Paulo, 1998): 12.

4. Mark Seltzer, "Wounded Culture: Trauma in the Pathological Public Sphere," *October* 80 (Spring 1997): 5.

5. Alice Yaeger Kaplan, "Theweleit and Spiegelman: Of Men and Mice," in Barbara Kruger and Phil Mariani, eds., *Remaking History* (Seattle: Bay Press, 1989), 162–64.

6. Ehrenreich, foreword to Theweleit, *Male Fantasies,* xv.

7. Theweleit, *Male Fantasies,* vol. 1, 24.

ALAN SCHECHNER

Barcode to Concentration Camp Morph, 1994
PLATE 9

It's the Real Thing—Self-Portrait at Buchenwald, 1993
PLATE 10

Impersonating the Victim: Consorting with History

Past, present, and future collide in the images that Alan Schechner broadcasts on the Internet. Schechner digitally manipulates photographs of Jewish Holocaust victims to draw uneasy parallels and point out differences between the Nazi era and the present. The Holocaust and its history form the backdrop for Schechner's work, yet technology and the Internet are the overarching strategies in his world of comparisons. This heightens awareness of our relationship to the Holocaust and raises questions about memory, authenticity, individuality, corporate control, and popular culture in contemporary society.

Barcode to Concentration Camp Morph (1994) is part of Schechner's series entitled Taste of a New Generation, located on his website.[1] In this work, through progressive transitions, he digitally transforms a barcode into a photograph taken of camp victims wearing striped uniforms. Noam Milgrom-Elcott, a third-generation observer, has commented: "As numbers morph into human faces and the mark of merchandise becomes the dress of affliction, the troubling association of commodification, concentration camps, and digital imaging emerges. The larger message speaks of the barricading of human life, the transformation of beings into numbers."[2] This gradual dehumanization emerges quite literally through number sequences—both in the information bytes of digital technology and in the classification system of bodies in the death camps.

This theme of commodification permeates Schechner's website and is especially prominent in *It's the Real Thing—Self-Portrait at Buchenwald* (1993). Here the artist digitally inserts his own image into a now-famous Margaret Bourke-White photograph taken when the Jews were liberated from Buchenwald in 1945. Bourke-White's black-and-white photograph documents the horrors she witnessed—men with sunken cheeks, shaven heads, and desolate expressions, wearing ragged striped

uniforms. By introducing himself—a second-generation English-born Jew, round faced, well fed, with a full head of hair—into the picture, Schechner collapses the space between history and the present. Our familiarity with the original image transforms into terror as we are left to ponder Schechner's presence among the survivors, to connect him (and ourselves), one or more generations removed from the Holocaust, with the victims and their sufferings. Then, the terror transforms into shame as we realize our desensitization to the overexposure of Holocaust images. Our shock no longer derives from the document of a horrifying event, but rather from a manipulated artwork.

The shock allows us entry into the image, but we are immediately ejected again through Schechner's inclusion of a Diet Coke can, centrally placed and the only element of *Self-Portrait at Buchenwald* that is depicted in color. The artist does not simply hold the Diet Coke but presents it, as if the can is posing alongside him. The irony of a robust Schechner among gaunt, malnourished survivors becomes embarrassing in the presence of a symbol of our culture's self-indulgent body consciousness. We are faced with the fact that we can extravagantly afford to produce purposely nutritionless products for widespread consumption. Despite Schechner's attempt to make the Holocaust more immediate for us, we quickly become aware that his (and our) memory of it has not been fully regained.

Has memory lost its power to replication and repetition, to marketing and consumerism? The Coke can draws parallels between brainwashing tactics of the Nazis and commodification. Just as much of Europe succumbed to Nazi culture because it was the dominant paradigm, so does our contemporary culture succumb to consumerism. Given recent findings that The Coca-Cola Company collaborated with the Nazi regime in the 1930s, Schechner's image invokes how removed we have become from the devastation of the Holocaust. Even knowing about the collabora-

tion, we can easily turn our cheek to satisfy our consumer needs. In this way, *Self-Portrait at Buchenwald* delivers us directly into the psyche of the complicit Nazi, who may not have been anti-Semitic, but who didn't challenge the prevailing ideology, and was consumed by the wave of National Socialism.

Schechner discusses this image in terms of Israeli complicity, through the Israeli State's employment of traditional Holocaust imagery, which he believes has been used to frame debates about Israeli governmental policy toward Palestinians. The artist has commented that "[T]hroughout my time in Israel, I became acutely aware of how the Holocaust was used to justify some of the unsavory aspects of Israeli policy. I was told more than once how: 'Whatever we do to them (the Palestinians) can never be as bad as what they (the Germans) did to us.'"[3] In this way, not only does Schechner collapse history and the present into one image, he collapses victim and perpetrator into one person. Further, he blurs the boundaries between observer and participant.

The artist reveals his own complicity by inserting his own image into the photograph, and this becomes his medium of confession. Through the interactive nature of the Internet, where one clicks on an image to view it, and where one can pick and choose which image to view, the viewer also becomes complicit. The Internet is not a passive experience, but an active one that creates a physical dialogue between image and audience. That the viewer participates in this dialogue makes our voyeuristic attitude toward the Holocaust undeniable, and to be voyeuristic necessitates our distance from it. Again, we are confronted with our detachment.

Schechner's decision to digitally insert his image into the photograph instead of using Elke Krystufek's cut-and-paste technique creates an even more complicated image. Initially, the seamlessness of the digitally manipulated image seems to be consistent with the work's title—*It's the Real Thing*. But as we become aware of the artist's presence within the pic-

ture, we realize it's not the real thing at all. Further, as a digital image Schechner's work no longer retains the photograph's light referent from the original event (something Bourke-White's had), and is yet one more step removed from reality. This meditation on the authenticity of the works points out that our memory of the Holocaust is created and maintained through images, or as Marianne Hirsch has explained, we hold a "post-memory" of these events.[4]

Ultimately, the existence of digital images like *Self-Portrait at Buchenwald* and *Barcode to Concentration Camp Morph* becomes an analogy for an awkward and complex association with the Holocaust. On the one hand, the images are immediate and intimate. The Internet is interactive and it employs strategies of merging art and everyday life. Because these images are Internet art, we may view them anytime, anywhere. On the other hand, the images are immaterial. They exist only on our computer screens; we cannot touch or handle them, and they are not even physical referents of any event. This limbo between distance and immediacy becomes a metaphor for a new generation's discomfort with our relationship to the Holocaust. **JL**

NOTES

1. http://dottycommies.com/artists/schechner.
2. Noam Milgrom-Elcott, "A Tiger's Leap into Oblivion?: Photography in the Age of Digital Reproduction," http://www.cc.columbia.edu/cu/museo/digital.htm.
3. Alan Schechner, quoted in "How Many of My People Does It Take to Screw In a Lightbulb? On the Ownership of Experience, or, Who Can Say What to Whom, When," *Art Papers* (March–April 1997): 34.
4. Marianne Hirsch, "Family Pictures: *Maus,* Mourning and Post-Memory," *Discourse* 15, no. 2 (Winter 1992–93): 8–9.

RUDOLF HERZ

Zugzwang, 1995
PLATE 11

Impossible Bedfellows:
Adolf Hitler and Marcel Duchamp

Unlike the contentious reception that greeted Piotr Uklański's *The Nazis*, Rudolf Herz's installation *Zugzwang* (fig. 1) met little controversy. In his other occupation as a photo historian, Herz had curated a 1994 exhibition in Munich's Stadtmuseum titled *Hoffmann & Hitler*, a scholarly investigation and thoughtful interpretation of the uses of photography to create and sustain the powerful and mythical image of the Führer. The project took Herz deep into the archives of Hitler's favored and sole photographer, Heinrich Hoffmann, who glamorized Hitler along with the entire Nazi movement.

The Munich exhibition was well received by cultural critics and journalists, who saw it as an important step in understanding the mechanisms that shaped and promoted Hitler and the Third Reich. But fears that some people might misinterpret the exhibition, that others would find it painful, and that it might become a meeting place for neo-Nazis, led to the cancellation of venues in Berlin and Saarbrücken.[1] The cancellations emphasize the dialectical dilemma of silence versus openness about the Holocaust and Nazi period that relate to imagery some still consider taboo.

The cancellation of the Berlin and Saarbrücken venues fueled Herz's desire to reframe Hoffmann's imagery as *Zugzwang*. For this piece, originally installed in the Kunstverein Ruhr in Essen, the artist wallpapered the gallery space from floor to ceiling with juxtaposed images of Adolf Hitler and Marcel Duchamp. He made strategic use of the paradoxical fact that the "greatest terrorist of the twentieth century"[2] and the hero of the twentieth century's avant-garde were photographed by the same cameraman—none other than Hitler's beloved photographer and the mastermind of his public image, Heinrich Hoffmann. Hoffmann had a virtual monopoly on staging and selling images of the Führer and of the Nazi movement. He photographed Duchamp in 1912 and Hitler exactly twenty years later.

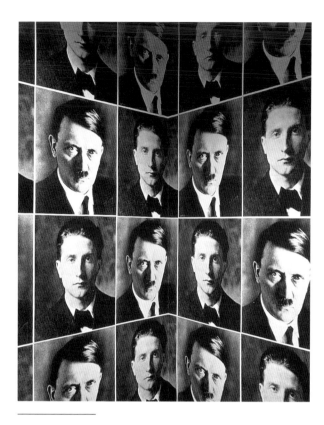

Fig. 1 Rudolf Herz, *Zugzwang* (detail), 1995. Courtesy of the artist.

Like Uklański's spare installation, Herz's is physically simple, almost painfully so. Both deploy appropriated photographs with neither identification nor legend, and both quote Warhol. Conceptually calculated, *Zugzwang* refracts both the historical and the art historical in an installation that is at once physically empty and visually saturated. Its restrained form straddles a rapid-fire trajectory of references from Dada to Pop, collage to montage, Minimalism to Conceptualism to installation art. Simultaneously, and seemingly by pure coincidence, Herz pits two ideologically divergent players on the seemingly disconnected and highly fragmented chessboard of twentieth-century history and art. The Duchampian reference to chess is as important for the work's formal aspects as it is to the installation's concept. Indeed, *Zugzwang* is organized physically as a chessboard and intellectually as a chess match. Its title is a chess term that refers to the untenable situation in which a player is limited to moves that will have a damaging effect on his or her position. As with Herz's other work, *Zugzwang* revolves around pictures of pictures, pictures of fragments, defaced pictures, and, not least, pictures as wallpaper. While the image of Hitler, with his signature mustache, instantly identifies the arch villain of the twentieth century, Duchamp's face is not as readily recognizable. It is much easier to remember Duchamp in one of his playful guises than as the man pictured here in a conservative black suit early in his career. How dare one combine the effigy of a mass murderer with that of the hero of the twentieth century's avant-garde? This question is crucial to the project, and ironic, considering that the Kunstverein in Essen occupies a historically loaded space on the ground floor of the city's now restored, former great synagogue. The upper level of the building houses a museum devoted to the city's Jewish history.

Herz permits the superficial similarities and radical differences of this implausible marriage of Hitler and Duchamp to ricochet ad infinitum into an aes-

thetic, ideological, and physical stalemate. Coinci-
dences abound, albeit superficial ones. Duchamp and
Hitler were born only two years apart—the former in
1887, the latter in 1889. Both are dressed in a simi-
larly bourgeois manner: dark suit, white shirt, and
tie. Both men were artists, Hitler a boring tradition-
alist with neither talent, nor a sense of innovation.
To call his work "academic" would be to dignify it.
Duchamp, the radical, unlocked the traps of standard
historical practice by looking outside of art for alter-
natives to its suffocating traditions. In the process,
he debunked the once holy domains of "aura" and
"originality." Zugzwang proposes yet another remark-
ably complex issue at stake in the intellectual battle
between Hitler and Duchamp, between Nazism and
Dadaism—the diabolically contrasting notions of
nihilism that pertain to each sitter's dogma.
Nihilism was the paradoxical end result of Hitler's
totalitarian holism, the havoc his terrorism wreaked
for history. Such a reading of the consequences of
his reign of horror circulated as early as the 1930s,
and was reiterated, for example, in his early postwar
biography by Alan Bullock.[3] Duchamp's self-imposed
nihilism, his play with contradictory ideas and iden-
tities, opened infinite avenues for exploration that
have proved to be virtually inexhaustible.

Because Zugzwang deploys an arsenal of aesthetic
tropes, we experience the installation as a virtual
lexicon of ideas and moods associated with
Duchamp. Aside from the use of the photograph as
readymade and the reference to chess, there is dou-
bling, mirroring, replication, multiplication, and dis-
continuity in a mise en abîme that results in a
dizzying experience for the viewer. The art historian
David Joselit has discussed Duchamp's "relay
between the 'elastic' body and a geometric system"
and his "compulsive repetition of reproduction."
Herz has "stolen" these systems conceptually and
has reapplied them physically in his appropriation of
retrograde photographs by Hoffman onto practices
liberated by Marcel Duchamp.[4] Thomas Elsaesser

observed that Syberberg dissolves Hitler as a
subject in Hitler, A Film from Germany. Herz's
Zugzwang works toward the same end. He needn't
dissolve Duchamp; the Dadaist already beat Herz
to that punch.

One element that has gone unobserved in the
considerable literature on Zugzwang is Herz's cagey
contrast of Duchampian replication with the Nazis'
very different use of multiplication. For the Nazis,
multiplication was central to the orderly and over-
whelming massing of humans and machines, to the
domination and ultimate annihilation of the value of
human life. It was an essential cog in the wheel of
Nazism's pageantry and of ultimate importance in
the consolidation of its power.[5] Of course, Duchamp,
used replication precisely to dispel notions of power,
originality, and genius.

It is also fascinating to note the remarkable dif-
ference in approach between Uklański's The Nazis
and Herz's Zugzwang. Uklański scours a remarkable
range of film sources to create an extensive archive
of movie heroes in the role of villains. Herz uses his
discovery of two images from Hoffmann's single yet
vast archive to construct an ingenious installation in
which images themselves are turned into a Dadaist
artistic strategy. Given the infinite and ambiguous
meanings that accrue for Zugzwang, Herz's work
might well have engendered controversy. But it
received mainly positive notices, was mostly
reviewed as art, and has come to be considered a
signal work of German art of the 1990s. Even the
rather aesthetically conservative director of Essen's
Jewish Historical Museum, a space housed directly
above Essen's Kunstverein, approved of the artistic
and moral ambiguities central to Zugzwang.[6]

NLK

NOTES

1. *Süddeutsche Zeitung, Frankfurter Allgemeine,* and *Die
Zeit* all were highly positive about the intentions of the

organizers and importance of the show to open a discussion and analyze the mechanisms that produced Nazism and helped it penetrate society.

2. Georg Bussman, "Kunstgeschichte als symbolierte Realgeschichte oder: Und wer ist der Andere?," in *Rudolf Herz,* exh. cat., Kunstverein Ruhr, Essen, 1995, 5.

3. Saul Friedlander, *Reflections of Nazism: An Essay on Kitsch and Death,* trans. Thomas Weyr (Bloomington and Indianapolis: Indiana University Press, 1984), 58. Georg Bussman discusses this in slightly different form. The preceding paragraphs are partly based on Bussman's and Peter Friese's articles for the Essen catalogue. See Peter Frieze, "Zugzwang," in *Rudolf Herz,* exh. cat., 13–39.

4. David Joselit, *Infinite Regress: Marcel Duchamp 1910–1941* (Cambridge: MIT Press, 1998), 53, 142.

5. Susan Sontag, "Fascinating Fascism," in *Under the Sign of Saturn* (New York: Farrar, Straus & Giroux, 1980. Friedlander, *Reflections of Nazism,* 52.

6. Peter Friese and Friederieke Wappler in conversation with author, October 20, 1999.

BOAZ ARAD

Safam, **2000**

PLATE 12

Marcel Marcel, **2000**

PLATE 13

The Villain Speaks the Victim's Language

In *Explaining Hitler* (1998), the author Ron Rosenbaum examines the obsession with Hitler's life and character in the post-Holocaust era. Rosenbaum points out that our fixation with the mastermind of "the final solution" is a search for what Hitler "had hid[den] within him." We want to understand who Hitler was, how Hitler functioned, why Hitler did what he did. We long to know if Hitler ever regretted his actions. As Rosenbaum puts it, "Was he 'convinced of his own moral rectitude'. . . or was he deeply aware of his own criminality?"[1] In his videos *Safam, Marcel Marcel,* and *Hebrew Lesson* (2000), the Israeli artist Boaz Arad explores this question with the preoccupation, obsession, and desperation about Hitler that Rosenbaum contemplates.

In *Hebrew Lesson,* Arad splices very short film clips from Hitler's propaganda speeches to produce a montage in which the Führer's strung-together German syllables are transformed into a Hebrew sentence. Arad manipulates Hitler so that he speaks in Hebrew and says: "Greetings, Jerusalem, I am deeply sorry."[2] The video is disjointed; with each cut the artist makes, we see Hitler in a different uniform, from a different angle, using a different gesture. The audio is also incongruous: the viewer does not immediately understand what Hitler is saying, or even recognize that the manipulated language is Hebrew. Arad repeats the montage seven times, making Hitler restate his apology over and over. It is only after the second or third repeat that the apology becomes comprehensible. The video's fragmentation, both audially and visually, frustrates us in much the same way as does our culture's fragmented knowledge of Hitler's life and character.

The visual and audio dissonance of *Hebrew Lesson* evokes Arad's frustration in manipulating Hitler's image and voice. The awkward transitions from clip to clip illuminate Arad's painstaking process and his meticulous attention to Hitler's speeches—listening, playing, rewinding them over and over again until

he was able to find the precise syllables with which to construct the Hebrew apology. Through this fetishistic process, Arad has become intimate with Hitler, deeply familiar with his words, his inflections, the intonations of his voice. As viewers we are privy to this intimacy, though the jarring cuts in the spliced-together segments indicate that this intimacy is driven by repulsion.

The disjunction is not only sensory. The painful irony of hearing an apology constructed from the same words that condemned so many to death is disorienting. We ask ourselves: How is it possible for this man to apologize? And how is it possible for him to do so in Hebrew? Arad does not simply propose that we fantasize such a scenario, but presents before us an example of a speaking Hitler acting out the possibility. Our collective desire to believe in film and video's ability to capture "real life," to capture "truth," stumps us here. So does our collective frustration with Hitler's suicide. We never had the chance to put Hitler on trial, to confront him with his actions, to see if he would show remorse. *Hebrew Lesson,* if only for a brief moment, allows us to explore these possibilities and then to become horrified by them. We are trapped in the confusion between reality and representation, documentary and fiction.

Through Arad's exhaustive editing process, he is able to exert power over the Führer and manipulate him, using the same propaganda films that Hitler used to exert power over the German public. The strategy is reminiscent of John Heartfield's photomontages of the 1930s *(see page 127)*, in which Heartfield manipulated propaganda photographs of Hitler to castigate the National Socialists. Both Arad and Heartfield subvert Hitler with the same materials that Hitler himself used to reach the public. And yet, the effects in each of the two artists' work are quite different. Heartfield's montages contain a comic element; they were made at a time when the world was still unaware of Hitler's plans for mass extermination. Arad's video is infused with all of the pain and anger of memory.

Arad becomes the all-powerful ventriloquist, treating the Führer as his puppet as he "teaches" him Hebrew—and remorse. The disjunction of the montage serves yet another purpose: to reveal the difficulty Hitler would have had in issuing such an apology. His words are forced: Arad may be manipulating Hitler, but Hitler resists at each syllable. This unsettling form of ventriloquism challenges any last vestiges of our faith in the "truth" of video. Arad makes it clear that we should not believe everything we see or hear, and that the apparent reality in film and video is not always as it seems. The piece forces us to wonder how history might have been different had the original audience of the original films understood such deceptions. Arad reminds us that we, as more sophisticated viewers bearing the burden of this traumatic history, must be ever vigilante to the fraudulence of contemporary visual culture.

Ultimately, *Hebrew Lesson*'s presentation of an apologetic Hitler confronts the viewer with perhaps the most difficult question of all: Is it possible to forgive Hitler? First we must digest this mea culpa, then ask what it means to us. Does post-Holocaust culture want an apology from Hitler? Then we must process our anger. How dare Hitler apologize? And how dare he be so intimate, using the Hebrew language? We are then left with the moral dilemma of how to answer this apology: Arad slyly leaves the ball in our court.

JL

NOTES

1. Ron Rosenbaum, *Explaining Hitler: The Search for the Origins of His Evil* (New York: Random House, 1998), xii.
2. "Shalom Yerushalayim, Ani mitnatzel."

MACIEJ TOPOROWICZ

Eternity #14, **1991**

PLATE NUMBER 14

**Fascinating Fascism:
Then or Now?**

The birth of the mass media at the end of the nineteenth century coincided with the privileging of the visual. During the hundred years since then, the proliferation of cheap photographic processes, the invention of film, the creation and access to television, and more recently, the image-laden Web have led to society's bombardment with photography. Pictures, so easily generated by these media, weave in and out of daily life in such a dizzying manner that images from journalism, advertising, entertainment, and art can become conflated and confused.[1] As part of a long-time tradition, advertisers have manipulated images from high art to market their wares. During the last several decades, however, certain artists who use photos toward conceptual ends appropriate images from popular culture and transform them into art. Much of this art questions the way images function and asks what they are meant to represent, interrogating societal attitudes about a litany of issues, from gender and sexuality to politics and power.

Maciej Toporowicz tackles these issues head-on in his mock advertisements and videos. Through his "advertisements," he plays with the way popular commercial posters are designed to seduce buyers, demonstrating how some advertisers prey on imagery from fascism in general and the Nazi period in particular to sell contemporary design. Toporowicz replaces photographs of contemporary fashion and cosmetic products with images of depravation, prostitution, and, more specifically, photographs of Nazi architecture and sculpture, such as the megalomaniacal buildings by Third Reich architect Albert Speer and falsely heroic, idealized Aryan sculptures by Arno Breker. All these images make up Toporowicz's appropriated repertoire. He then overlays typographic logos from contemporary fashion and cosmetics products onto these seemingly seductive images, which prompts us to understand them as threatening. Toporowicz delivers the viewer to the

threshold of evil, and forces a comparison of historic imagery with contemporary ones. In doing so, he hopes to illustrate how chillingly close we can come to ignoring the aesthetic and ideological origins of our luxury products, and how often their promotion is modeled on Aryan, Nazi, or fascist ideals.

Like much work involving artistic appropriation, Toporowicz's video *Obsession* (1991) uses scavenged images. Here, clips from the Nazi-era propaganda films of Leni Reifenstahl are combined with the controversial postwar Nazi imagery in such films as Luchino Visconti's *The Damned* (1969), Pier Paulo Pasolini's *Salo* (1975), and Liliana Cavani's *The Night Porter* (1973). Toporowicz cuts back and forth among these highly loaded representations, interjecting stills and video clips from Calvin Klein's advertising campaigns. Given the way Toporowicz manipulates the material, he makes us see how one of the world's most popular designers (and numerous others as well) has based his advertising campaign on German fascist ideology and art.[2] This video is neither easy to watch nor easy to ignore. The artist has us enter, self-consciously, the clutches of fascism and Nazism. The imagery comes from different epochs—Germany in the 1930s, Europe in the 1970s, and the United States in the 1990s—and thus has radically different intentions and meanings, forcing us to a self-examination about the continuing seduction of Nazi imagery. If we remain compelled to watch this video, whom do we blame for the imagery that fascinates us? Why do we continue to look? What makes us voyeurs? Certainly, images from the 1930s in Germany are implicitly reprehensible, especially given their intent. However, purely in terms of representation, we have difficulty separating the origins of the images and weighing them on a scale of transgression.

Susan Sontag has demonstrated the dangers of what she regards fascism's fascination. She calls attention to how fascism's aesthetics of physical perfection—what she deems "an ideal rather than

ideals"—is coupled with the diametrically opposed notions of control and submission, ecstasy and pain.[3] The films Toporowicz uses are, in the main, part of the late 1960s' and 1970s' revival of interest in the Nazi period and its erotic, sometimes sadomasochistic associations. Laura Frost has taken Sontag's study a step further, showing that eroticized fictions of fascism are a significant, stock-in-trade tradition of modernist practice that goes back to the turn of the century.[4] As such, she asks the complicated question of what it means when an author or artist eroticizes and rebukes fascism simultaneously. This is precisely the tautology that *Obsession* constructs. Toporowicz uses various fascist images, complicit and not, in a tense cultural critique. Yet he seduces us with tainted imagery, and forces us into the complicated position of separating our feelings of attraction for evil and terror from repulsion at its moral connotations.

Like Piotr Uklański and Rudolf Herz, who also manipulate already existing material, Toporowicz keeps a distance from the subject. His cool manner of cutting and editing his video and the provocative, spine-tingling sound track he uses makes us all the more conflicted and ambivalent. Viewers often look to artists to resolve moral issues at hand; this was certainly the case with art about identity that pervaded the art world during the late 1980s and much of the 1990s. In these cases, messages were explicit about right and wrong; battle lines clearly drawn. Here, however, the artist shifts the onus of moral decision making back on to viewers. Beyond making us aware of dangerous seductions at play everywhere in the contemporary world, Toporowicz forces us to confront some very elemental instincts. Following philosopher and social critic Georges Bataille's observations, Toporowicz demonstrates the fundamental violence connected to eroticism. The artist thus forces us to participate in the basic, contrary, and even dangerous tensions that underlie human nature, through which, in Bataille's words, we are

"driven away by terror, [yet] drawn to it by an awed fascination."[5] The viewer is made to feel the treacherousness of the duality and must wrestle with himself or herself toward a resolution. **NLK**

NOTES

1. For additional discussions of these phenomena, see Jonathan Crary, *Techniques of the Observer: On Vision and Modernity in the Nineteenth Century* (Cambridge, Mass., and London: MIT Press, 1990), 1–24. For the issue of the birth of the mass media during the Dreyfus Affair in France, see Norman L. Kleeblatt, "The Dreyfus Affair: A Visual Record," in Norman L. Kleeblatt, ed., *The Dreyfus Affair: Art, Truth, and Justice* (Berkeley and Los Angeles: University of California Press, 1987), chapter 1.

2. Vasif Kortun, "Maciej Toporowicz: *Obsession,*" exh. brochure, Bard College Center for Curatorial Studies, N.Y., 1995.

3. Susan Sontag, "Fascinating Fascism," in *Under the Sign of Saturn* (New York: Farrar, Straus & Giroux, 1980).

4. Laura Frost, *Sex Drives: Fantasies of Fascism in Twentieth-Century Literature* (Ithaca: Cornell University Press, forthcoming, fall 2001).

5. Georges Bataille, *Eroticism,* trans. Mary Dalwood (London: J. Calder, 1962), 68.

ALAIN SÉCHAS

Enfants Gâtés (Spoiled Children), 1997

PLATES 15 AND 16

Mirrors of Innocence and Violence

A group of five identical sculptures sits on individual white pedestals. Each sculpture uses one of Alain Séchas's signature Disney-like animals to animate the space and confront the viewer. In this case, his seemingly harmless small-scale pets are made threatening by the addition of Nazi symbols. Séchas has grafted a Hitler mustache onto each feline face. Swastika-emblazoned rattle in hand, each kitten sits perched in a playpen onto which additional swastikas are centered in each of the enclosure's sides. Attached to opposite walls on either end of the five-part enfilade, two mirrors multiply the images of these mini-sculptures ad infinitum. The homespun, kitsch, pop-culture animals appear benign; through the addition of simple symbols associated with evil, they resonate fear. The pure white animal is both imprisoned and protected in its pen. Its small size makes it appear additionally helpless and vulnerable. Yet, the gesture of its implied salute emits and heightens its danger. Given the conflicting sense of scale and the disarmingly simple accumulation of symbols, it is not easy for the viewer to distill his or her disparate reactions to the ensemble.

This work forms part of Séchas's assimilation of three-dimensional cartoon-like characters into confrontations with provocative topics. In his depictions of such themes as suicide, rape, torture, and decapitation we experience violence combined with vulnerability. Séchas inscribes transgressive experiences on composite cartoon creatures with whom we have comfortable and long-established ties. Do we feel them more deeply because of our familiarity with the types he has chosen? Do their simplicity of means and disarming expression remove us further from—or bring us closer to—their implicit danger? Devoid of irony, the suggested humor of the creatures delivers us to a paradoxical space.[1] Guy Walter has aptly observed the frustrating circularity of Séchas's sculptures and shows how the sculptor connects the most abstract with the most representa-

tional sensibilities. In particular, Walter demonstrates how the work keeps us from entering it, how it forces us to return to the surface.[2] Although we are warned not to overlay an American reading of the collision between high art and popular culture on his work,[3] Séchas pits the viewer in a space of inextricable frustration between subjectivity and objectivity, between style and surface, meaning and superficiality. The contrasting intersection of these sensations—and between the innocence and violence at the heart of his project—are precisely those that fix the outer limits of contemporary popular culture.

While artistic sources such as Georg Grosz are mentioned in discussions of Séchas's drawings, there is little speculation concerning artistic roots for his sculptures. Nevertheless, it is clear that his three-dimensional work plays off stylistic contradictions. The peculiarity of having forbears as disparate as Nikki de St. Phalle and Michaelangelo Pistoletto is part of Séchas's premeditated effect, and connects to his sculptures' play between innocence and instability. De St. Phalle serves as perceptual model while Pistoletto functions in a predominately conceptual way. The former links Séchas back to Matisse, to the luxe and joyousness that is inherent in one strain of modernism. De St. Phalle's childlike sculptures and specific environments for children make us eternally playful and juvenile in our wish to engage her exuberant figures and undulating forms. Pistoletto, virtually of the same generation as de St. Phalle—but with a totally different sensibility—forges links with other stylistic and strategic expressions of modernism, namely Surrealism, Dadaism, and photomontage. In his trajectory from the perceptual to the conceptual, the physical to the pictorial, and the represented to the real, Pistoletto is a perfect model for Séchas. The mirrored surfaces Pistoletto uses, like those real mirrors Séchas incorporates into *Spoiled Children,* insinuate the viewer into the center of the exhibition space. Reflected representations,

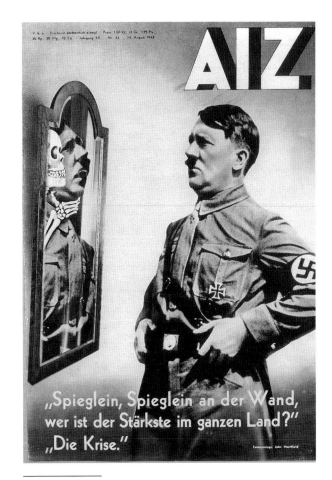

Fig. 1. John Heartfield, *Mirror, mirror on the wall, who's the strongest of them all? The crisis.* Published in *Arbeiter-Illusstrierte Zeitung* 12, no. 33, 1933. © 2001 Artists Rights Society (ARS), New York/VG Bild-Kunst, Bohn. Courtesy of Kent Gallery, New York.

both literally and figuratively, are central to *Spoiled Children*. Not only do the feline creatures serve as the artist's alter-ego, but Séchas explains his sculptures as "mirrors of our desires and fears" in which we are stuck "halfway between being a spectator and being a witness to violence."[4]

The symbols and imagery of Séchas's *Spoiled Children* bear startling similarities to the German artist John Heartfield's *Mirror, mirror on the wall, who's the strongest of them all? The crisis* (1933; fig. 1). In Heartfield's photomontage we see the recently elected Adolf Hitler peering at himself in a traditional, framed mirror. The Nazi dictator's assumed position is one of self-admiration, yet, in Heartfield's hopeful reflection, we see Hitler's form contorted as it becomes strangled by a skeleton. Séchas takes the two-dimensional disjunctions of Heartfield's (and Pistoletto's) games of reflection and refraction and makes sculpture which is a composite of innocence and evil, vulnerability and violence. In a continued play of doubling and multiplicity, the work continues its representations and reflections ad infinitum in two real mirrors.

Certainly, Séchas was also toying farcically with the essay by French post-structural psychoanalyst Jacques Lacan. Lacan's famous piece on the "mirror phase" which deals with a child's identity and ego formation as he/she recognizes him/herself in the mirror for the first time, was invoked frequently in the art criticism of the 1980s and 1990s.[5] The essay was one of the cornerstones in the oft-discussed issues around the nexus of personal identity and marginality, so crucial to much art making during the last decade. Séchas subverts the usefulness of Lacan's essay as he frustrates any kind of fixed identity for the sculpture. The dizzying multiplicity and mirroring refuse any of the synthetic identities that

Lacan's theory was used to underwrite. The mirrors contradict theoretically and stylistically. The creation of this ad-infinitum refraction of the five sculptures is clearly a pastiche reference to Nazi architectural models in which one architectural element is repeated excessively to create a sense of deep spatial recession. For the Nazis, such solid lapidary spaces were meant to overwhelm and to disempower the viewer. However, Séchas's recession is neither solid nor real. Rather it mocks those fascist spaces by its fugitive manaical reflection.

Without a doubt, Séchas's *Spoiled Children*, like much of his other work, is a study in contradiction. Issues of childhood and violence, style and surface, real and reflected, craft and artlessness combine to destabilize our very act of looking and our sense of engagement. When we look, these dualities, and many others, keep ricocheting in our mind's eye. The work has been said to create a figure of a "pre-Nazi" in whom fascism is more "innate than acquired."[6] This question about our personal, moral distance from history, from society and from evil itself seems remarkably similar to the question the Israeli writer David Grossman poses about the Nazi inside each one of us.[7] **NLK**

NOTES

1. Patrick Javault, "Things Seen," trans. J. Tyler Tuttle, in *Alain Séchas,* exh. cat., Hôtel des Arts, Paris, 1992, 70.

2. Guy Walter, "One Thing and the Opposite," trans. Joan Olivar, in *Alain Séchas,* exh. cat., 1992, 83.

3. Javault, "Things Seen," 70.

4. Ibid., 98, 99.

5. Jacques Lacan, "The Mirror Stage as Formative of the Function of I as Revealed in Psychoanalytic Theory," 1949.

6. Javault, "Things Seen," 97.

7. David Grossman, *See Under: LOVE,* trans. Betsy Rosenberg (London: Jonathan Cape, 1989).

ZBIGNIEW LIBERA

LEGO Concentration Camp Set, 1996

PLATES 17, 18, AND 19

Toying with Terror

Forcing this collusion of innocence and aggression, naïveté and devastation, Zbigniew Libera refashioned the internationally beloved toy, the LEGO building block set, into a concentration camp. Annually, the LEGO Corporation offers grants to artists to incorporate the popular line of toys into their work. Libera had been making art about childhood and the process of learning. In doing so, he used standard playthings in order to demonstrate how children's toys perpetuate ideals of beauty and perfection, as well as the sometimes malignant fantasies of society. Given these interests, Libera seemed the perfect candidate for a LEGO grant.

LEGO Concentration Camp Set is a group of seven boxes in an edition of three. On each box are pictured various three-dimensional miniatures that the artist has built. He photographed the self-constructed models and then refashioned the images into what seems to be standard, juvenile-friendly packaging. The miniatures represent nothing less than the most horrific and morally debased architectural complexes ever built. Among the structures he has made and photographed are models of barracks and crematoria. Aggregate objects, including body parts and clothing, appear on the side of one box. Such representations are derived from Libera's multiple and blurred associations. He fuses—and confuses—images from history and art history, mixing Holocaust images of death camps and human remains with references to masterpieces of postwar art, such as Arman's accumulations.

The French cultural theorist Michel Foucault's interpretations of architecture are crucial to Libera's thinking. Foucault observes that buildings are highly loaded spaces invariably manipulated to wield authority. In *Discipline and Punish,* he shows that Western society has formed a nuanced architectural vocabulary based on the structure of the prison that is manipulated symbolically and categorically to exert control. For Libera, like Foucault, benign insti-

Fig. 1. Zbigniew Libera, *Ken's Aunt*, 1995. Courtesy of the artist.

tutions such as the school, the cloister, the military barracks, or the factory are modeled on disciplinary institutions and buildings. Reaching further, Libera grasps the ultimate paradigm of disciplinary models and one overlooked by Foucault: the concentration camp.[2] Libera also perceives that the camps, with their towers and crematoria, have become, paradoxically, twentieth-century icons.[3]

LEGO Concentration Camp Set grew out of the artist's interest in war toys, educational programs, and self-improvement devices. Libera sees how such seemingly harmless items may pose serious psychological and philosophical questions about gender, sexuality, and childhood. This is the logical outgrowth of his earlier works that engage with Foucault's notion of moral orthopedics to question societal conventions of beauty and propriety. For example, through the disarming vulnerability of *The Doll You Love to Undress* (1998) Libera forces us to encounter our own voyeuristic streak. Our uncomfortable reaction to *Ken's Aunt* (1995; fig. 1), a doll-sized version of a middle-aged, overweight matron—an anti-Barbie—exposes the ageism that pervades contemporary society.

LEGO Concentration Camp Set led Libera to legal battles with the manufacturers and, ultimately, censorship of the work in a major international exhibition. After unsuccessful attempts to have the artist withdraw the piece from exhibitions in Germany, the United States, and Brazil, the LEGO Company initiated a lawsuit when it was exhibited in Copenhagen, near the company's headquarters. In the media coverage commentary that ensued, connections were inevitably made between censoring Libera's work and the official and highly circumscribed protocols for Nazi art, as well as Hitler's campaign to rid Germany of degenerate art.[4] Because European law permits artists to use products and logos in their work, LEGO's attempt to restrict Libera's use of its product ultimately failed. Further repercussions for *LEGO Concentration Camp Set* took place the next year, when

the artist was invited to represent Poland at the Venice Biennale. When Libera prepared to show the LEGO set as part of his installation, the Polish curator demanded it be removed, claiming, according to the artist, that this explosive material might offend certain circles.[5] Libera, who had been jailed in Communist Poland for subversive artistic activities and for championing free expression, withdrew his entire submission.

What created this negative reaction to Libera's work? The responses greatly exceeded the infinitely more subdued criticism that had surrounded the art of David Levinthal and Art Spiegelman, for example. Like Uklański, Libera's status as a non-Jewish Pole was at issue. In contrast to Libera's guilt by association, Levinthal admitted that because he was Jewish, he was given great latitude for his Mein Kampf series of seductive photographs of Nazi toys. Not so for Levinthal's recent work focusing on African-American stereotypes. When Levinthal, like Libera and Uklański, crossed the boundaries into representations outside his own Jewish identity, society was quick to condemn him.[6]

Issues of desire and consumption are conspicuously at play in Libera's toys and sharply magnified in *LEGO Concentration Camp Set*. These toys' three-dimensionality forces us to imagine intimate physical contact with them in ways that Levinthal's and Spiegelman's works do not. Libera's sculpture possesses an anti-monumentality that creates the illusion that the works are hyper-real. In fact, we regress to our own childhoods and become vulnerable in the toys' presence. When we regain our adult intelligence and recognize what the boxes represent, we become repelled. To encounter *LEGO Concentration Camp Set,* to select it, or to desire to play with it, suspends us at the contradictory intersection of a world of make-believe with one of horror.

NLK

NOTES

1. Zbigniew Libera, "Analysis of the Historical Representations of Auschwitz in Contemporary Art in LEGO 1996," in *The Memory of Auschwitz in Contemporary Art,* unpaginated.

2. Roxana Marcoici, "The Antinomies of Censorship: The Case of Zbigniew Libera," *Index* 3-4.98, no. 23 : 58–59.

3. Libera, "Analysis," 204.

4. Marcoici, "Antinomies," 59.

5. Ibid., 60.

6. David Levinthal in conversation with author, January 1999.

TOM SACHS

***Giftgas Giftset*, 1998**
PLATE 20

***Prada Deathcamp*, 1998**
PLATE 21

Fashioning Terror

U sing the moniker *Cultural Prosthetics,* Tom Sachs constructs potentially harmful objects from the elegant wrappings of luxury goods. Detritus from Prada, Hermes, Tiffany, Fendi, and Chanel provide the artist with raw materials from which he fashions functional, and often frightening, sculptures. These take the form of guns, guillotines, electric chairs, and hand grenades. The seduction of these fragile works lies in their homespun charm as hand-crafted objects, with all the disarming finesse this implies, and in their conflation of fragility and danger. Form follows function, but his models function feebly. For example, Sachs's patchwork constructions reveal seams of leaking glue. Such details add an artisanal note as they simultaneously revere and ridicule modern design's penchant for expressed joins. Sachs adapts discarded materials in a way that is reminiscent of the innocence of nineteenth-century self-taught crafts. At the same time its coy, modernist stylistic references underscore the negative uses of technology.

Sachs turns the strategies of Marcel Duchamp around by 180 degrees. In the early twentieth century, Duchamp lifted humble objects from their real life functions, isolated them, signed them, and displayed them in galleries as art objects. In contrast, Sachs takes the emptied and discarded boxes emblazoned with the logos of luxury brands and reworks them as independently functioning objects. He then exhibits them in the inert space of the "white cube," where art, the ultimate luxury object, is assumed to be devoid of utility. Paradoxically, the fashion logos emblazoned on high-end wrapping materials, devoid of any utilitarian function, merely purvey and present status. As with much challenging twentieth-century art, Sachs's objects raise questions about their validity as art. While some have called Duchamp an artistic terrorist, Sachs turns the residue of his self-observed (and self-obsessed) fashion terrorism into potentially harmful, usable weapons capable of real terror.

The artist investigates the way consumer culture works against personal identity, especially marketing and advertising. For Sachs, these objects reflect the most controlled corporate identity since National Socialism.[1] *Giftgas Giftset* (1998) and *Prada Deathcamp* (1998), are especially troubling. Because of their associations with the Holocaust, viewers expect to encounter them at historic museums and sites, where they can be interpreted cautiously. But Sachs, Jewish and born and raised in Connecticut, dares to observe Holocaust museums and their visitors from the position of a critique of consumption. He finds that the lessons that these museums intend to teach are often poorly assimilated, particularly by young people. His cynicism toward the museums' promotion of their goals is like his cynicism in the face of high-style consumerism.[2] With these two works, the unabashed conflation of supposed "good" and outright "evil" tests our sense of propriety and our ability to separate aesthetics from history, morality from lifestyle. The seduction of the luxury label pitted against the horror of mass extermination is almost too much to bear. Yet, Sachs asks us to suspend notions of high and low culture. He asks that we ponder a continuum between high and low, then and now, and then asks whether we can recognize our desires in this less threatening environment, mirrored through the lens of the political conformity and ideological consumption of Nazi Germany.

Sachs's work is inherently barbaric, particularly these two sculptures. It is as if he intends to bring to life the "aesthetic barbarity" of culture noted by Theodor Adorno and Max Horkeimer.[3] Writing in the middle of World War II, the two Frankfurt School philosophers defined culture across a vast commercial spectrum, creating a continuum from automobiles to films, from bombs to bungalows. Their observation about the fabrication and manipulation of the consumer's needs is one to which Sachs would readily subscribe.[4] Yet his ambiguous objects that exist between the functional and the dysfunctional set up a disturbing retort to the secure, ideologically "correct" focus of Adorno and Horkheimer. In an otherwise glamorous article about the artist and his lifestyle, Thomas Hüetlin sets up important contradictory readings of Sachs's works. For example, he sees the tension, mentioned above between the appeal for status and the real threat of his works. He also asks irreconcilable questions about whether the works glamorize or critique power and whether the artist is fascinated by the label-logo culture or mocking it. Indeed, he sees the novelty of the artist's approach in the purposefully ambiguous message in which the sculptures "criticize and reinforce the fetish" simultaneously.[5] **NLK**

NOTES

1. Thomas Hüetlin, "Angst und Schrecken und Chanel," *Spiegel Reporter* (January 2000): 120.
2. Tom Sachs in conversation with author, January 3, 2000.
3. Theodor Adorno and Max Horkeimer, "The Culture Industry: Enlightenment as Mass Deception," in *The Dialectic of Enlightenment* (New York: Continuum, 1993), 7.
4. Ibid., 1.
5. Hüetlin, 120.

MAT COLLISHAW

Burnt Almonds (Gustav and Helga), 2000

PLATE 22

Staging Depravity

The windowless walls are made of discolored, disintegrating brick, and the room is in a state of elegant distress. It is furnished with a brass bed, a leather reading chair, a gold candelabra, and a mahogany nightstand—even a deer's head, mounted on the wall. The lighting is dramatic, the colors are lush, the textures seem palpable; yet there is the sense that luxury is crumbling. Pearls have fallen next to empty champagne bottles, the bed is un-made, and a half-dressed woman lies across it. Are the man and woman on the bed simply exhausted or in a drug-induced stupor?

As the viewer is made privy to this intimate scene, initial embarrassment gives way to curious seduction. We are invited into the uneasy situation of becoming a voyeur, yet we can't look away. Titil-lation turns into horror as we realize that this scene is the restaging of a Nazi couple dying in the diabol-ical finale of the Third Reich—a suicidal bacchana-lia. Similar to Delacroix's *Death of Sardanapalus*, executed almost two centuries earlier, the viewer becomes bystander to the shocking, yet alluring, unraveling of an empire in which the dreamlike qual-ity of the scenario only marginally serves to distance us from the morally questionable events taking place. This is the world that British artist Mat Coll-ishaw creates in his photographic series Burnt Almonds (2000).

The tactility of the scenarios is heightened by baroque staging—dramatic lighting, exaggerated color, high gloss, and dynamic vectors. Authenticity is achieved through tabletop (or setup) photogra-phy, which is characterized by the inclusion of minute detail. The tactility and the authenticity combine to make Collishaw's scenes incredibly entic-ing, so that we gaze (willfully) at scenes of deprav-ity. The moment the Nazi presence is detected, however, the viewer becomes uncomfortably aware that he or she is staring pleasurably into this staged world of evil. It is unsettling because we have

entered the foreign and unthinkable world of the Nazis. Is it even more so because we dare to continue staring?

The narrative implied in these images is similar to that of Roee Rosen's *Live and Die as Eva Braun,* in which the audience is invited to experience intimacy with Hitler in his own bunker. However, while Rosen creates a narrative with words, illustrating scenes with flat, monochrome, and abstracted images, Collishaw's photographic constructions are highly explicit and graphically captivating. Rosen's title itself notifies the viewer that engaging his artwork can be dangerous, and he creates a safety valve from its contamination by calling the experience a "Virtual Scenario." Collishaw, however, allows the viewer to stumble unknowingly into the scene, and makes the experience horrifying through its hyperreality.

Collishaw overlays numerous photographic transparencies and exhibits them in a lightbox to create a three-dimensional effect in which the viewer sees the spectacle from multiple angles, thus becoming part of the scene. This effect evokes photography, cinema, painting, and propaganda. The associations are crucial to the Burnt Almonds series. They emphasize the close connections between the lightbox works and the image-world that pervades popular culture, suggesting that Nazi imagery—and the debauchery and eroticism associated with it—is frequently appealing, just as contemporary advertisements are. By using the tabletop style, which borrows much from stage photography, Collishaw refers to the way Nazi imagery has been appropriated by the entertainment industry. This makes us painfully aware of the illusion of representation so prevalent in popular culture. As Collishaw has explained, "the image makes the real thing invisible . . . [by] making it [the real thing] picturesque, you can get away from the initial problem . . . it's a way of shortcutting social problems."

The conflation of Nazism and sexuality was examined by Susan Sontag in her essay "Fascinating Fascism," in which she points out society's attraction to and desire for absolute order and control, as embodied by fascist principle.[1] What is also usually implicit in the link between fascism and sexuality is the attraction to the cult of masculinity, a central credo of Nazi culture. Works such as Robert Morris's Castelli poster (1974) *(see page 60)* and films such as Cavani's *The Night Porter* (1974) demonstrate these phenomena through the fusion of Nazism and sexuality, the extreme domination and control of sadomasochistic behavior, and, in Morris's case, male exclusivity. Collishaw, however, refuses the Nazi focus on masculinity, order, or control. By presenting the cyanide-drugged Nazis during their last moments, Collishaw creates scenes that lack order and purposely go against the grain of fascist dogma. These disheveled rooms are littered with imperfect, untidy, often effeminate (and certainly ineffectual) male bodies that bear the marks of a physical perfection lost not too long before.

Ultimately, Collishaw's images equate the allure of depravity with the pleasure of looking at the downfall of an empire. Just as we must question our complicity in images representing depravity, especially Nazi depravity, we must also question the moral implications of witnessing the decay and death of human beings, be they evil or not. **JL**

NOTES

1. Susan Sontag, "Fascinating Fascism," in *Under the Sign of Saturn* (New York: Farrar, Straus & Giroux, 1980).

ARTIST BIOGRAPHIES

BOAZ ARAD

Born in Afula, Israel, 1956
Lives in Tel Aviv, Israel

EDUCATION

B.A. Avny Institute of Fine Art, 1982

SELECTED GROUP EXHIBITIONS

2000 Eyn Harod Museum, Eyn Harod, Israel, *The Disaster of Love*
 Herzliya Museum of Art, Herzliya, Israel, *The Angel of History* (video catalogue)
 Peer Gallery, Tel Aviv, *Erections in Israeli Art*
1997 Camera Obscura School of Art Gallery, Tel Aviv, *White Cube*
 Ashdot Yaakov Museum of Art, Ashdot Yaakov, Israel, *Irony and Love of the Motherland*
1994 Tivon Gallery, Tivon, Israel, *Israeli Contemporary Art*
1989 Shara Levy Gallery, Tel Aviv
1988 Mapu Gallery, Tel Aviv
1985 Shluch Gallery, Tel Aviv

SELECTED BIBLIOGRAPHY

2000 Melzer, Gilad. "Holocaust with a Moustache." *Seven Days* (September).

CHRISTINE BORLAND

Born in Darvel, Ayrshire, Scotland, 1965
Lives in Glasgow, Scotland

EDUCATION

B.A. Glasgow School of Art, 1987
M.A. University of Ulster, Belfast, 1988
Kunstwerke, Berlin Studio Residency, 1996
Fellow in Fine Art, Glasgow School of Art, Glasgow, 1998–2001

SELECTED ONE-PERSON EXHIBITIONS

2000 Sean Kelly Gallery, New York, *Spirit Collection*
 Galeria Tony Tapies, Barcelona, *Treasury of Human Inheritance*
 Galerie cent 8, Paris, *Christine Borland*
1999 Dundee Contemporary Arts, Dundee, Scotland, *What makes for the fullness and perfection of life, for beauty and happiness, is good. What makes for death, disease, imperfection, suffering is bad.* (catalogue)
 Galerie Eigen + Art, Berlin, *Christine Borland*
1998 De Appel Foundation, Amsterdam; Fundação Serralves, Lisbon; Museum für Gegenwartskunst, Zürich, *Christine Borland* (catalogue)
 Galerie cent 8, Paris, *Christine Borland*
 Århus Kunstmuseum, Århus, Denmark, *L'Homme double*
1997 Lisson Gallery, London, *Christine Borland*

Skulpturen Projekte III, Münster, Germany, *Christine Borland* (catalogue)

FRAC Languedoc-Roussillon, Montpellier, France, *Christine Borland* (catalogue)

1996 Sean Kelly Gallery, New York, *Second Class Male, Second Class Female*

Kunstwerke, Berlin, *From Life, Berlin* (catalogue)

Galerie Eigen + Art, Leipzig, Germany, *Christine Borland*

Gallery Enkehuset, Stockholm, *To Dust We Will Return* (part of *Sawn-Off*) (catalogue)

1995 The British Council Gallery, Prague, *Inside Gallery*

1994 Tramway Glasgow, *From Life, Glasgow* (catalogue)

SELECTED GROUP EXHIBITIONS

2000 Hayward Gallery, London, *Know Thyself* (catalogue)

Orkney, Scotland, site-specific millennium projects, *The Constant Moment* (catalogue)

Royal Armouries, Leeds, England, *Warning Shots* (catalogue)

Biennale d'Art Contemporain, Lyon, France, *Partage d'Exotismes* (catalogue)

Lisson Gallery, London, *A Shot in the Head*

Exit Art, New York, *Paradise Now*

1999 CCA, Glasgow, *High Red Center*

Henry Moore Institute, Leeds, England, *Sampled: The Use of Fabric in Sculpture*

Chac Mool Contemporary Fine Art, West Hollywood, Calif. (in collaboration with Lisson Gallery, London), *Rewind the Future*

1998 The Andy Warhol Museum, Pittsburgh, *In Your Face*

Tate Gallery Liverpool, Liverpool, England, *artranspennine98* (catalogue)

Museet for Samtidskunst, Oslo, *Nettverk-Glasgow* (catalogue)

Yerba Buena Center for the Arts, San Francisco, *To Be Real*

Luxembourg, *Manifesta 2, European Biennial of Contemporary Art* (catalogue)

City Gallery, Prague; Kunsthalle Krems, Krems, Austria, *Close Echoes*

The Modern Institute, Glasgow, *Artists' Editions*

Kunstraum Innsbruck, Innsbruck, Austria, *New Art from Britain* (catalogue)

1997 Tate Gallery, London, *The Turner Prize Exhibition*

Museum für Gegenwartskunst, Zürich, *Flexible*

Museum of Contemporary Art, Sydney, Australia, *Contemporary British Art*

Apex Art C.P., New York, *Letter and Event* (catalogue)

Kópagovur Art Museum, Iceland, *absence/presence* (catalogue)

École Nationale Supérieure des Beaux-Arts, Paris, *Connections Implicites* (catalogue)

Museum of Contemporary Art, Sydney; Art Gallery of South Australia, Adelaide; City Gallery Wellington, Wellington, New Zealand, *Pictura Britannica: Art from Britain* (catalogue)

1996 Hayward Gallery, London, *Material Culture: The Object in British Art of the 1980s and '90s* (catalogue)

Galerie Eigen + Art, Berlin, *Christine Borland, Roddy Buchanan, Jacqueline Donachie, Douglas Gordon*

Specta Gallery, Copenhagen, *Are You Talking to Me*

Kunstsammlungen Weimar, Weimar, Germany, *Nach Weimar* (catalogue)

Transmission Gallery, Glasgow, *21 Days of Darkness*

Fundação Serralves, Oporto, Portugal, *More Time/Less History* (catalogue)

Musée d'Art Moderne de la Ville de Paris, *Live/Life* (catalogue)

1995 Independent Art Space, London, *Eigen + Art at I.A.S.*

Mackintosh Museum, Glasgow School of Art, Glasgow, *External Links*

The Photographers' Gallery, London, *Pulp Fact*

1994 De Appel Foundation, Amsterdam, *The Spine* (catalogue)

Schloss Mosigkau, Mosigkau, Germany, site-specific works for castle and grounds, *East of Eden* (catalogue)

Marc Jancou Gallery, London, *Little House on the Prairie* (catalogue)

Rijksmuseum Kröller-Müller, Otterlo, Netherlands, *Heart of Darkness*

1993 Chisenhale Gallery, London, *Christine Borland & Craig Richardson* (catalogue)

Venice Biennale, Italy, *Aperto* (catalogue)

Lisson Gallery, London, *Wonderful Life*

1992 Irish Museum of Modern Art, Dublin, *Guilt by Association* (catalogue)

578 Broadway, New York, *In and Out/Back and Forth* (catalogue)

SELECTED BIBLIOGRAPHY

2000 Clot, Manel. "Christine Borland," *Lapiz* (163).

Heartney, Eleanor. "Christine Borland at Sean Kelley," *Art in America* (September).

Pol, Marta. "Fusio complexa entre ciencia I art: Christine Borland," *Avvi* (May).

Riding, Alan. "The Human Body in its Aesthetic Glory and Scientific Gore," *The New York Times* (November).

1999 Brown, Allan. "Through a Jellyfish, Darkly," *The Sunday Times Ecosse* (October).

Cumming, Laura. "More Skeletons in the Closet," *The Sunday Observer* (December).

Mahoney, Elisabeth. "More than Just a Pretty Jellyfish," *The Guardian* (November).

1998 Ter Borg, Lucette. "Naïeve Griezelarij van Alice in Wonderland," *Der Volkskrant* (December).

1997 Barrett, David. "Christine Borland," *Frieze* (July).

Feldman, Melissa E. "Christine Borland at Lisson," *Art in America* (November).

Kemp, Martin. "Hidden Dimensions," *Tate Magazine* (Winter 1997).

Searle, Adrian. "Bring on the Naked Dwarf," *The Guardian* (May).

1996 Feldman, Melissa E. "21 Days of Darkness," *Art Monthly* (April).

Hunt, Ian. "Serious Play," *Frieze* (January/February).

Ippolito, Jon. "Where has All the Uncertainty Gone?," *Flash Art* (Summer 1996).

1995 Higgins, Ria. "Gun Shots," *The Face* (May).

O'Reilly, John. "Dark Deeds from the Darkroom," *The Guardian* (May).

1994 Kastner, Keff. "A New Powerhouse," *Artnews* (September).

Cottingham, Laura. "Wonderful Life, Lisson Gallery," *Frieze* (12).

MAT COLLISHAW

Born in Nottingham, England, 1966
Lives in London

EDUCATION

B.F.A. Goldsmith's College, University of London, 1989

SELECTED ONE-PERSON EXHIBITIONS

2001 Modern Art, London, *New Works*

Shoreditch Town Hall, London, *Ultra Violet Baby* (four-day film screening)

Lux Gallery, London, *Pandaemonium*

Bonakdar Jancou Gallery, New York

Galerie Raucci/Santamaria, Naples

2000 Museum of Contemporary Art, Warsaw

1999 Galeria d'art Moderna di Bologna, Italy

Galerie Analix, Geneva, *Analix Forever*

1998 Bonakdar Jancou Gallery, New York

Bloom Gallery, London

1997 Lisson Gallery, London, *Duty Free Spirits*

Ridinghouse Editions, London, *Ideal Boys* (catalogue)

Galerie Raucci/Santamaria, Naples

Tanya Bonakdar Gallery, New York

Camden Arts Centre, London

1996 Tanya Bonakdar Gallery, New York,
 Control Freaks

 Galerie Analix, Geneva

1995 Karsten Schubert Ltd., London (in collaboration
 with Thomas Dane)

 Camden Arts Centre, London

1994 No. 20 Glasshouse Street, London, *The Eclipse
 of London* (one-day installation)

SELECTED GROUP EXHIBITIONS

2000 Institute of Contemporary Art, Boston, *From a
 Distance: Approaching Landscape*

 Museum of Contemporary Art, La Jolla, Calif.,
 *Small Worlds: The Diorama in Contemporary
 Art*

 Serpentine Gallery, London, *Greenhouse Effect*

 Landesmuseum, Lindz, Austria, *1000+1 Nacht*

1999 Printemps de Cahors, France, *EXTRAetORDINAIRE*

 Museu de Arte Moderne de São Paulo,
 Chiva[s]ynergies/art: Moving Image

1998 Kunsthalle Krems, Austria, *Public Body &
 Artificial Space*

 Hayward Gallery, London, *Secret Victorians,
 Contemporary Artists and a 19th-Century
 Vision* (catalogue)

 P.S.1, New York, *The Edge of Awareness*

 Japanese Museum Tour, *Exhibition of Contem-
 porary British Art*

1997 Museum of Contemporary Art, Sydney, *Pictura
 Britannica*

 Staatliche Kunsthalle, Baden Baden, Germany,
 Urban Legends

 Royal Academy of Arts, London, *Sensation:
 Young British Artists from the Saatchi
 Collection*

 Kunstmuseum Wolfsburg, Wolfsburg, Germany,
 Full House: Young British Art

 Gasworks, United Kingdom, *Private Face–Urban*

*Space: A New Generation of Artists from
Britain*

1996 Galeria Raucci/Santamaria, Naples, *More Than
 Real*

 De Appel Foundation, Amsterdam, *Hybrids*

 Natural History Museum, Rotterdam, *Manifesta*
 (catalogue)

 Manchester City Art Gallery, Manchester, *The
 Inner Eye*

 Musée d'Art Moderne, Paris, *Live/Life*
 (catalogue)

 Museum van Loon, Amsterdam, *Exchanging
 Interiors*

1995 Istanbul, *Istanbul Biennial* (catalogue)

 Hayward Gallery, London, *The British Art Show 4*

 Ice Box, Athens, *Other Men's Flowers*

 Walker Art Center, Minneapolis, *Brilliant! New
 Art From London* (catalogue)

 Stedelijk Museum, Amsterdam, *Wild Walls*

 San Marino, Italy, *Moderne e Contemporanea*

1994 Musée d'Art Moderne de la Ville de Paris, Paris,
 L'Hiver de l'amour

 Tanya Bonakdar Gallery, New York, *Nature Morte*

 Institute of Contemporary Art, London,
 Institute for Cultural Anxiety

1993 Stedhalle, Zurich, *Changing I Dense Cities*

 Venice, *Venice Biennale*

 Cohen Gallery, New York, *Displace*

1992 Serpentine Gallery, London, *Exhibit A*

 Galerie Analix, Geneva, *Twenty Fragile Pieces*

 Galerie Metropol, Vienna, *Under Thirty*

1991 Stedhalle, Zurich, *Stillstand Switches*

1990 Building One, London, *Modern Medicine*

1989 Touring exhibition, Italy, *Ghost Photography:
 The Illusion of the Visible*

1988 Surrey Docks, London, *Freeze*

SELECTED BIBLIOGRAPHY

2000 Lewinson, David. "Small World—MCA San
 Diego." *Artweek* (March).

1999 *Vision. 50 Years of British Creativity*. London:

Thames & Hudson. Introduction by Michael
Raeburn.

1998 Smith, Roberta. "Mat Collishaw." *The New York
Times,* October 9.

Thompson, Elsbeth. "Singularly Beautiful."
Vogue (May).

Gleadell, Collin. "The Shape of Things to
Come." *ArtMonthly* (May).

"Made in London." *The Royal Academy Magazine*
(Spring).

"Making a Spectacle of Oneself." *Make* (March).

Hall, James. "Mat Collishaw." *Artforum* (January).

Barret, David. "Animation, LEA Gallery." *Frieze*
(September/October).

1997 Cork, Richard. "If you go down to the woods
today . . ." *The Times* (London), December 2.

Cotton, Michelle. "Duty Free Spirits." *Roar*
(December).

Feaver, William. "Omo it's that woman again."
The Observer, December 7.

Morrisey, Simon. "Interrogating Beauty."
Contemporary Visual Arts 16.

1996 Kimmelman, Michael. "Reviews." *The New York
Times,* December 20.

Levin, Kim. "Voice Choices." *The Village Voice,*
December 24.

Morgan, Stuart. "Forbidden Images." *Frieze*
(January/February).

Feaver, William. "Shaving Grace." *The Observer,*
January 14.

Maloney, Martin. "Mat Collishaw." *Artforum*
(April).

1995 Morgan, Stuart. "Stuart Morgan Visits the
Institute of Cultural Anxiety." *Frieze*
(March/April).

Searle, Adrian. "Life, the universe, and every-
thing." *The Independent,* April 18.

Barrett, David. "Minky Manky." *ArtMonthly* (May).

MacRitchie, Lynn. "Begging for Scraps." *The
Guardian,* December 12.

RUDOLF HERZ
Born in Sonthofen, Germany, 1954
Lives in Munich

EDUCATION
B.A. Akademie der Bildenden Künste, 1981
M.A. Ludwig-Maximilians-University, 1989
Ph.D. Carl von Ossietzky-University, 1994

SELECTED ONE-PERSON EXHIBITIONS
1999 Kunstverein Konstanz, Konstanz, Germany,
Rat Race

Kunstbunker Tumulka, Munich, *Flesh for
Your Fantasy*

1997 Neue Gesellschaft für Bildende Kunst, Berlin,
Transit I

Neues Museum Weserberg, Bremen, *Transit II*

Halle K, Hamburg, *Transit III*

1996 Badischer Kunstverein, Karlsruhe, Germany,
Rotfront

1995 Kunstverein Ruhr, Essen, *Zugzwang*

Villa Massimo, Rome, *Späte Triumphe des
erschöpften Widerspruchs*

1992 Kunstraum, Wuppertal, Germany,
Autodemontage II

1988 Städtische Galerie im Lenbachhaus, Munich,
Schauplatz, Kunstforum

SELECTED GROUP EXHIBITIONS
2000 Kunsthalle Düsseldorf, Düsseldorf, *Metaformen:
Dekonstruktivistiche Positionen in Architektur
und Kunst*

Haus der Kunst, Munich, *Die scheinbaren
Dinge*

1999 Banhof, Hamburg; Nationalgalerie, Berlin,
*Das XX. Jahrhundert: Ein Jahrhundert Kunst
in Deutschland*

1998 Galerie im Marstall, Berlin, *Ausstellung zum
Denkmal für die ermordeten Juden Europas*

1997 Martin-Gropius-Bau, Berlin, *Deutschlandbilder*

1996 ICC/MUKA, Antwerp, *Summer of Photography*

1995 Kunstmuseum Wiesbaden, Wiesbaden; Neues
 Museum Weserburg, Bremen, *RAM*

1994 Villa Massimo, Rome, *RomEuropa*

1983 Kunstverein Bonn, Bonn, *Ansatzpunkte
 kritischer Kunst heute*

SELECTED WRITINGS BY THE ARTIST

1995 Coauthor with Loiperdinger, Martin, and Ulrich
 Pohlmann. *Führerbilder. Hitler, Mussolini,
 Roosevelt, Stalin in Fotografie und Film.*
 Munich: Piper.

1994 *Hoffmann & Hitler. Fotografie als Medium des
 Hitler-Mythos.* Munich: Stadtmuseum
 München.

1989 Coauthor with Halfbrodt, Dirk. *München
 1918/19. Fotografie und Revolution.* Munich:
 Stadtmuseum München.

1985 Coauthor with Bruns, Brigitte. *Atelier Elvira.
 Ästheten, Emanzen, Aristokraten.* Munich:
 Stadtmuseum München.

SELECTED BIBLIOGRAPHY

2001 Reichelt, Matthias, ed. *Zwei Entwürfe zum
 Holocaust-Denkmal von Rudolf Herz und
 Reinhard Matz.* Berlin: Edition Tiamat.

1997 Halfbrodt, Dirk, and Peter Friese, eds. *Herz.*
 Nuremberg: Verlag für moderne Kunst.

1995 Bussmann, Georg, and Peter Friese. *Rudolf Herz.
 Zugzwang.* Essen: Kunstverein Ruhr.

1992 Lager, Lenins. *Rudolf Herz. Entwurf für eine
 Skulptur in Dresden.* Berlin: Karin Kramer
 Verlag.

1991 Werckmeister, O. K. *Rudolf Herz. Schauplatz.*
 Munich: Städtische Galerie im Lenbachhaus.

AWARDS

1998 Project Scholarship, Kunstfonds, Bonn

1997 Prizewinner, competition for the Memorial for
 Assassinated European Jews

1994–1995
 Scholarship of the German Academy, Villa
 Massimo, Rome

1992 Baldreit Scholarship, City of Baden-Baden

1991 Art Award of Bavaria

1990 Award, City of Munich

1987 Scholarship for Contemporary Photography,
 Alfried Krupp von Bohlen and Halbach
 Foundation, Essen

ELKE KRYSTUFEK

Born in Vienna, 1970
Lives in Vienna

SELECTED ONE-PERSON EXHIBITIONS

2000 Portikus, Frankfurt, *Nobody Has to Know*
 Galerie Georg Kargl, Vienna, *Elke Krystufek*
 Gallery Side 2, Tokyo
 Centre National de L'Estampe et de L'Art
 Imprimée, Chatou, France, *Hollywoodland*

1999 Bahnwärterhaus, Galerie der Stadt Esslingen,
 Germany, *Sleepingbetterland*
 Centre genevois de gravure contemporaine,
 Geneva; Kunstwerke Berlin, Berlin, *In the
 Arms of Luck* (catalogue)
 Galerie Georg Kargl, Vienna, *Like Nothing You've
 Ever Seen*
 Contemporary Art Center, Vilnius, Lithuania,
 I Am Dreaming My Dreams with You
 (catalogue)

1998 São Paulo Biennal, São Paulo, *I Am Your Mirror*
 (catalogue)
 Galleria il Capricorno, Venice
 Galerie Drantmann, Brussels
 303 Gallery, New York
 Emily Tsingou, London

1997 Secession, Vienna
 Galleri Nicolai Wallner, Copenhagen

1994 Musée d'Art Moderne de la Ville de Paris,
 Migrateurs

1992 Galerie Metropol, Vienna (with Franz Graf)

SELECTED GROUP EXHIBITIONS

2000 Musée d'art contemporain, Bordeaux, France

Presumed Innocent: Childhood and Contemporary Art

Galerie im Taxispalais, Innsbruck, Austria, *Die verietzte Diva: Hysterie, Körper, Technik in der Kunst des 20. Jahrhunderts*

1999 Migros Museum, Zürich, *Peace*

P.S.1, Contemporary Art Center, Long Island City, N.Y., *Generation Z*

Museum Bochum, Bochum, Germany, *FunktionsSystemMensch*

Galerie im Traklhaus, Salzburg, *Zeichenen— Österreichische Zeichnungen der Neunziger Jahre*

Austrian Cultural Institute, London, *Wild Life*

1998 São Paulo, *São Paulo Biennial*

Casino Luxembourg, *Luxembourg Manifesta 2— European Biennal of Contemporary Art*

Secession, Vienna, *Das Jahrhundert der künstlerischen Freiheit*

De Appel Foundation, Amsterdam, *Life Is a Bitch*

1997 Charlottenborg Exhibition Hall, Copenhagen, *Display*

EA-General Foundation, Vienna, *Post-Production*

1996 Magasin Grenoble, France, *Autoreverse 2*

1995 Centre Pompidou, Paris, *Feminin/Masculin*

Centre Pompidou, Paris, *X/Y*

1994 Kunsthalle, Vienna; De Appel Foundation, Amsterdam, *Jetztzeit*

1993 Venice Biennale, Italy, *Aperto*

SELECTED BIBLIOGRAPHY

1999 Granjean, Emmanuel. "Elke Krystufek se met a nu au Centre de gravure" *Tribune de Geneve* (September 24).

Lebovici, Elizabeth. "Elke Krystufek se met a nu," *Liberation* (June).

Huck, Brigitte. "Celebrity Skin: Elke Krystufek," *Noema* (May/June).

1998 "disdentico—maschile femminile e altro," *Camera Austria* (61).

1997 Metzger, Rainer. "Kunst kommt von Kaufen," *Der Standard* (August).

Hofleitner, Johanna. "Der Körper—nackt bekleidet, verkleidet," *Die Presse* (March).

Krawagna, Christian. "Elke Krystufek, Secessions" *Artforum* (April).

1996 Krawagna, Christian. "Ich möchte funktionieren, nicht perfekt aber doch," *Text zer Kunst* (June).

Dany, Hans-Christian. "Poor Little Rich Girl," *Vogue* (November).

Bubias, Marius. "Wenn Frauen masturbieren, sind Männer dann überflüssig?," *Zitty* (24).

1994 Janus, Elizabeth. "Private Functions," *Frieze* (December).

Volkart, Yvonne. "Medusa and Co.," *Flash Art* (May/June).

Interview with Peter Nesweda, "Der weibliche Körper und der männliche Blick," *Kunsforum* (October/November).

1993 Renton, Andrew. "Venice Biennial," *Flash Art* (October).

MISCHA KUBALL

Born in Düsseldorf, 1959

Lives in Düsseldorf

EDUCATION

B. A. Düsseldorf University, Düsseldorf, 1984

SELECTED ONE-PERSON EXHIBITIONS

2000 Kunstverein Ruhr, Essen, *Sling of Memory*

Vedanta Gallery, Chicago, *Chicago Sling*

1999 Tokyo National Museum, Tokyo, *Power of Codes*

Konrad Fischer Galerie, Düsseldorf, *Fischer's Loop*

Wood Street Galleries, Pittsburgh, *Light Traps*

1998 Kabinett für aktuelle Kunst, Bremerhaven, Germany, *Project Rooms*

São Paulo Biennial, São Paulo, *Private Light/Public Light*

Kölnische Kunstverein, Cologne, *Project Rooms*

1997 Museum Boymans-van Beuningen, Rotterdam, *In Alphabetical Order*

1996	Museum moderner Kunst Stiftung Ludwig, Vienna, *Moderne, Rundum/Vienna Version*
1995	Diözesanmuseum, Cologne, *Worldrorschach-Rorschachworld*
1994	Sprengel Museum, Hannover, Germany, *No-Place*
1993	De Appel Foundation, Amsterdam, *Double Standard*
1992	Konrad Fischer, Düsseldorf, *Projektionsraum 1:1:1* Bauhaus, Dessau, Germany, *Bauhaus-Block*
1991	Haus Wittgenstein, Vienna, *Welt/Fall*
1990	Kunsthalle, Cologne, *Kabinett/Cabinet* Mannesmann Hochhaus, Düsseldorf, *Megazeichen*
1987	Städtische Galerie im Museum Folkwang, Essen Tibor de Nagy Gallery, New York

ARTIST'S BOOKS

Todesfuge/Paul Celan (Death Fugue/Paul Celan). Poestenkill, New York: Kaldewey Press, 1984.

refraction house. Pulheim, Germany: Kulturamt der Stadt Pulheim, 1985.

Sand aus den Urnen/Paul Celan (Sand from the Urns/Paul Celan). Poestenkill, New York: Kaldewey Press, 1997.

BOOKS/DOCUMENTATIONS

Bartetzko, Dieter. *Mischa Kuball: Die Rede* (The Speech) (in German and English). Düsseldorf: Heinen Verlag, 1990.

Crockett, Tobey. *Mischa Kuball: World/Fall* (in German and English). Bensheim, Germany: Bollmann-Verlag, 1992.

Flemming, Klaus. *Mischa Kuball: Kabinett* (Cabinet) (in German and English). Düsseldorf: Heinen Verlag, 1990.

Flusser, Vilém. *Mischa Kuball: Welt/Fall* (World/Fall) (in German and English). Mönchengladbach, Germany: Juni-Verlag, 1991.

Giloy-Hirtz, Petra, Manfred Schneckenburger, et al. *München im Kunstlicht*. Munich, 2000.

Goodrow, Gerard A., ed. *Mischa Kuball: Project Rooms* (in German and English). Cologne: Verlag der Buchhandlung Walther König, 1997.

Hanstein, Mariana, and Kurt Danach, eds. *Mischa Kuball: Projektion/Reflektion* (Projection/Reflection) (in German and English). Cologne: Kunst-Station Sankt Peter, 1995.

Kauffmann, Bernd, and Ulrich Krempel. *Sprach Platz Sprache* (in German and English). Cantz Series. With audio compact disc produced by Harald Grosskopf. Ostfildern, Germany: Hatje Cantz, 1999.

Krempel, Ulrich. *Mischa Kuball: Megazeichen* (Megasigns)(in German and English). Düsseldorf: Heinen Verlag, 1990.

Krempel, Ulrich, et al. *Mischa Kuball—Urban Context. Projekt Bunker Lüneburg* (Lüneburg Bunker Project) (exh. cat.; in German and English). Lüneburg, Germany: Dähnhardt-Schulenburg, 2000.

Schöbe, Lutz, ed. *Mischa Kuball: Bauhaus-Block* (in German and English). Ostfildern, Germany: Edition Cantz, 1992.

Smolik, Noemi. *Mischa Kuball: Double Standard* (in Dutch and English). Amsterdam: De Appel Foundation, 1993.

Stempel, Karin. *Mischa Kuball: B(l)aupause*. Mülheim an der Ruhr, Germany: Städtisches Museum, 1991.

Stempel, Karin, Tracey Bashkoff, and José Artur Giannotti. *Private Light/Public Light. Deutscher Beitrag zur 24. Biennale São Paulo 1998.* (German contribution to the 24th São Paulo 1998 Biennial) (in German, English, and Portuguese). Stuttgart: Cantz Druckerei, 1998.

Stilper, Petra, ed. "Mischa Kuball: *Rotierenderlicht-traumhorizont*," in *Project Rooms* (in German and English), ed. Gerard A. Goodrow. Cologne: Verlag der Buchhandlung Walther König, 1997.

Thoenges, Hans-Georg. *Mischa Kuball: Greenlight* (exh. cat.). Montevideo, Uruguay: Goethe Institut, 1999.

Wappler, Friederike, Peter Friese, and Norman L. Kleeblatt. *Mischa Kuball: Schleudertrauma* (Whiplash). (exh. cat.; in German and English). Essen, Germany: Kunstverein Ruhr, 2000.

Wieg, Cornelia, Dieter Daniels, Ulrike Kremeier, and Katja Schneider. *Mischa Kuball: Public Stage Project,*

Staatliche Galerie Moritzburg Halle (exh. cat.;
in German and English). Cologne: Salon
Verlag, 2001.

Zweite, Armin, and Gerhard Dornseifer. *Mischa Kuball:
refraction house*. Pulheim, Germany: Kulturamt der
Stadt Pulheim, 1994.

AWARDS

1997 Stiftung Kunst und Kultur NRW, Düsseldorf
 Ministerium für Familie, Stadtentwicklung und
 Kultur NRW, Düsseldorf
1996 Kunstfonds Bonn
1995 Travel Grant from Art & Culture Foundation,
 Düsseldorf
1993 ArtAward of NRW
 Award of Experimental Photography from the
 Krupp Bohlen and Halbach Foundation, Essen
1991 Scholarship for Contemporary Photography of
 Alfried Krupp von Bohlen and Halbach
 Foundation, Essen
 Ars Viva Award of Cultural Association BDI,
 Cologne
1990 Ars Viva Award, Kuturkreis in BDI, Cologne

ZBIGNIEW LIBERA
Born in Pabianice, Poland, 1959
Lives in Warsaw

EDUCATION
B.A. Kopernik University, Torun, Poland

SELECTED ONE-PERSON EXHIBITIONS

2000 American-European Art Associates, New York,
 A Different Type of Prison
1998 Guy McIntyre Gallery, New York, *Correct Me If I
 Am Wrong*
1997 Center for Contemporary Art, Ujazdowski Castle,
 Warsaw, *Correcting Devices*
1993 Na Mazowieckiej Gallery, Warsaw, *Works with Air
 and Electricity*

1992 Laboratorium Gallery, Center for Contemporary
 Art, Warsaw
1982 Strych Gallery, Lodz, Poland, *Photocollages and
 Drawings*

SELECTED GROUP EXHIBITIONS

2000 Nikolai Fine Art, New York, *The Toy Show*
 Galerie Nationale du Jeu de Paume, Paris,
 L'Autre moitié de l'Europe
1999 Center for Contemporary Art, Warsaw, *Post
 Conceptual Reflections*
 Lombard-Freid Fine Arts, New York,
 Persuasion
 Museum moderner Kunst Stiftung Ludwig,
 Vienna, *Aspects/Positions*
 NGBK, Berlin, *Blue for Girls, Pink for Boys*
 Ludwig Museum, Budapest, *Rondo*
 Moderna Museet, Stockholm, *After the Wall*
 Nash Gallery, University of Minnesota,
 Minneapolis, *Absence/Presence*
1998 Edsvik Konst, Stockholm, *Medialization*
 Center for Contemporary Art, Warsaw, *At the
 Time of Writing*
1996 Museum of Contemporary Art, Chicago, *Beyond
 Belief*
 Saõ Paulo Biennial, Saõ Paulo, *Universalis*
 Technische Sammlungen der Stadt Dresden,
 Germany, *The Thing Between*
1995 Kunstlerhaus Bethanien, Berlin, *New I's for New
 Years*
1994 Kunsthalle Elsterpark, Leipzig, *Minima Media*
 Bundeskunsthalle, Bonn, *Europa, Europa*
1993 Forty-fifth Venice Biennale, Italy, *Emergency:
 Aperto '93*
1992 State Gallery of Art, Sopot, Poland, *Mystical
 Perseverence and the Rose*
1991 Kunstverein Bonn, Bonn, *Kunst Europa*
1990 Arnheim, Netherlands, *AVE Festival*
 Kunstpalast Düsseldorf, Düsseldorf, *Bakunin in
 Dresden*
1989 John Hansard Gallery, Southampton, N.Y.,
 Supplements: Contemporary Polish Drawing

1987 Foto-Galerie Gauss, Stockholm, *Erotic and Satire*
 Atelier Dziekanka, Warsaw, *Rattling Machines*
 and Fuming Chimneys

SELECTED BIBLIOGRAPHY

2000 Jones, Ronald. "After the Wall: Art and Culture
 in Post-Communist Europe, Moderna Museet,
 Stockholm." *Artforum* (March).

1998 Marcoci, Roxana. "The Antinomes of
 Censorship: The Case of Zbigniew Libera."
 Index 23 (March–April).
 Libera, Zbigniew. "Analysis of the Historical
 Representation of Auschwitz in Contempo-
 rary Art in LEGO 1996." *The Memory of
 Auschwitz in Contemporary Art,* ed. Yannis
 Thanassekos and Daniel Weyssow. Brussels:
 Fondation Auschwitz.

1997 Murphy, Dean E. "Artist Constructs a Volatile
 Story." *The Los Angeles Times* (May 20).

ROEE ROSEN

Born in Rehovot, Israel, 1963
Lives in Tel Aviv, Israel

EDUCATION

B.A. Tel Aviv University, 1984
B.F.A. School of Visual Arts. New York, 1989
M.F.A. Hunter College, New York, 1991

SELECTED ONE-PERSON EXHIBITIONS

2000 Kibbutz Be'eri Gallery, Kibbutz Be'eri,
 Lucy: Iconographic Sources
 Rosenfeld Gallery, Tel Aviv, *Two Books: A
 Different Face* and *Lucy*

1997 Israel Museum, Jerusalem, *Live and Die as Eva
 Braun* (catalogue)

1996 Artists' Studios, Tel Aviv, *Professionals*
 (catalogue)

1994 Museum of Israeli Art, Ramat Gan, Israel,
 Martyr Paintings (catalogue)

1992 Bugrashov Gallery, Tel Aviv, *The Blind Merchant*

1988 School of Visual Arts Gallery, New York
1986 Sharet Gallery, Givataim, Israel

SELECTED GROUP EXHIBITIONS

2001 Beit Ha'am Gallery, Tel Aviv, *The Thirty Third
 Year, Artists Against the Strong Arm*
 Palazzo Della Papesse, Siena, *The Gift*
 (catalogue)

2000 Herzliya Museum of Art, Herzliya, Israel,
 The Angel of History (video catalogue)
 Palazzo Delle Papesse, Siena, *Republics of Art:
 Israel* (catalogue)
 Ha'Midrasha Gallery, Tel Aviv, *"Arieh Aroch,"
 Erections in Israeli Art*

1999 Ha'Midrasha Gallery, Tel Aviv, *Regarding Rafie*

1998 Israel Museum, Jerusalem, *Good Kids, Bad Kids,
 "Childliness" in Israeli Art* (catalogue)
 Ami Steinitz Contemporary Art, Tel Aviv,
 Forbidden
 The Pyramid, Haifa, *Recommended Retail Price*

1997 Beit-Ha'Am, Tel Aviv, *Imprisoned Without a Trial*
 Museum of Israeli Art, Ramat Gan, Israel,
 Ha'Midrasha (catalogue)
 Ami Steinitz Contemporary Art, Tel Aviv, *I/zkor*

1995 The Artists' House, Jerusalem, *Shades of
 Sexuality* (catalogue)

1994 Museum of Israeli Art, Ramat Gan, Israel,
 Anxiety (catalogue)
 319 Grand, New York, *Petty Schemes & Grand
 Designs*

1991 Hunter College Art Gallery, New York, *Happy
 Paintings*

1990 Old Norfolk Street Synagogue, New York,
 Markings
 Hunter Gallery, New York, *Re-Configuring Bodies*
 (catalogue)

1987 New York University, New York, *Annual Small
 Work Exhibition*

1985 Jerusalem Theater, *Sir-Lahatz* (catalogue)

SELECTED WRITINGS BY THE ARTIST

2000 *A Different Face* (in Hebrew). Tel Aviv: Hed-Artzi/ Ma'Ariv.

Lucy (in Hebrew). Tel Aviv: Shadorian Press. (Artist's edition, in English, published 1991–1992).

1998 "The Visibility and Invisibility of Trauma: On Traces of the Holocaust in the Work of Moshe Gershuni and in Israeli Art." *Jerusalem Review* 2: 98–118.

1997 *Live and Die as Eva Braun, an Illustrated Proposal for a Virtual Reality Scenario, Not to Be Realized* (in Hebrew and English). Jerusalem: Israel Museum.

"Quality Time: On Maggie Cardelús's 'Taglio, L'Origine du Monde (II),'" in *Maggie Cardelús, Matrix*. Almagro, Spain: Galería Fúcares.

1996 "Beyond Idomania," in *Ido Bar-El: Construction Works* (exh. cat.). Herzliya, Israel: Herzliya Museum of Art.

"Less and More Than Two," in *Ariela Shavid: Beauty Is a Promise of Happiness* (exh. cat.). Jerusalem: Israel Museum.

1992 *Art, Money, Identity, Fragments from Contemporary American Art*. Tel Aviv: Tel Aviv Museum Press.

1989 *The Blind Merchant*. Artist's edition.

SELECTED BIBLIOGRAPHY

2001 Azoulay, Ariella. *Death's Show Case: The Power of the Image in Contemporary Democracy* (trans. by Ruvik Damielli). Cambridge, Mass.: MIT Press.

2000 Somaini, Antonio. "Roee Rosen," in *Art and Artists from Israel and Palestine* (Siena: Palazzo Delle Papesse), 116, 162–63.

Gilerman, Daba. "I Didn't Know Her Well," *Ha'aretz International Edition* (September 27th).

1998 Manor, Dalia. "From Rejection to Recognition, Israeli Art and the Holocaust." *Israel Affairs* 4, nos. 3 and 4. (Spring/Summer).

Shapira, Sarit. "The Supressed Syndrome: Holocaust Imagery as a Taboo in Israeli Art." *Israel Museum Journal* 16 (Summer).

Ronnen, Meir. "Eva Braun Artwork Causes Outcry." *ARTnews* 92 (January).

1997 Rothman, Roger. "Mourning and Mania, Roee Rosen's *Live and Die as Eva Braun,*" in *Roee Rosen: Live and Die as Eva Braun* (exh. cat.). Jerusalem: Israel Museum.

Green, David B. "Shock Treatment." *The Jerusalem Report* 8, December 11.

"Nuzzling with the No. 1 Nazi." *Newsweek*, December 8.

Günther, Inge. "Anschließend in die Holle." *Berliner Zeitung*, November 26.

Derfner, Larry. "The Holocaust According to Eva Braun." *The Jerusalem Post,* November 14.

AWARDS

1997 Israeli Ministry of Education and Culture Prize for the Encouragement of Artists in the Fields of Plastic Arts and Design

TOM SACHS

Born in New York, 1966
Lives in New York

EDUCATION

B.A. Bennington College, Bennington, Vermont, 1989

Architectural Association, London, 1987

SELECTED ONE-PERSON EXHIBITIONS

2000 Galeria Enzo Sperone, Basel, Switzerland, *Art/31/Basel*

Baldwin Gallery, Aspen, Colo., *Defender*

Tomiyo Koyama Gallery, Tokyo, *Test Module Five (Urinal)*

1999 Mary Boone Gallery, New York, *Haute Bricolage*

Galerie Thaddaeus Ropac, Salzburg, *W.w.J.B.D. and Other Smash Hits*

Galerie Thaddaeus Ropac, Paris, *Creativity Is the Enemy* (catalogue)

SITE Santa Fe, New Mexico, *SONY Outsider*

Mario Diacono Gallery, Boston, *Tom Sachs*

Mont Blanc Store, Hamburg, *Stairmaster*

Mont Blanc Store, New York, *Burn Baby Burn*

1998 Thomas Healy Gallery, New York, *Creativity Is the Enemy*

1997 John Berggruen Gallery, San Francisco, *Cultural Prosthetics*

Galeria Gian Enzo Sperone, Rome, *Tom Sachs*

1996 Mario Diacono Gallery, Boston, *Tom Sachs*

1995 Morris-Healy Gallery, New York, *Cultural Prosthetics*

1993 Allied Cultural Prosthetics, New York, *Watch Me Work*

SELECTED GROUP EXHIBITIONS

2000 Sperone Westwater, New York, *American Bricolage*

Ubu Gallery, New York, *Destruction/Creation*

Wetterling Gallery, Stockholm, *Seven New York Artists*

1999 Alleged Gallery, New York, *Coup d'État*

Wunderkammer, London, *Readymade Project*

Center Galleries, Detroit, *Dysfunctional Sculpture*

Paine Webber Art Gallery, New York, *Comfort Zone: Furniture by Artists*

Kettle's Yard, Cambridge, England; Cornerhouse, Manchester, England; Camden Arts Center, London, *Thinking Aloud*

New Museum, New York, *New Museum Gala* (catalogue)

New Jersey Center for Visual Arts, Summit, N.J., *Food for Thought*

Bank of America Plaza, Charlotte, N.C., *Material Perception* (catalogue)

1998 Gallery F15, Moss, Norway, *New York* (catalogue)

1997 Weatherspoon Art Gallery, University of North Carolina at Greensboro, *Thirty-third Annual Exhibition of Art on Paper*

Ubu Gallery, New York, *The Subverted Object*

San Francisco Museum of Modern Art, San Francisco, *Icons: Modern Design and the Haunting Quality of Everyday Objects*

1996 Thread Waxing Space, New York, *Shred Sled Symposium*

1995 Paul Morris Gallery, New York, *Inaugural Exhibition*

1994 Barney's, New York, *Red Windows*

Public performance, New York, *Kill All Artists*

Alleged Gallery, New York, *Pathetic Masterworks*

SELECTED BIBLIOGRAPHY

2000 O'Brien, Glenn and James Meyer, "Best of 2000," *Artforum* (December).

Sheets, Hilarie M. "Contemporary Realism," *Artnews* (March).

Hass, Nancy, "Stirring Up the Art World Again," *The New York Times* (March).

Hüetlin, Thomas and Dirk Westphal. "Angst und Schrecken und Chanel," *Spiegel Reporter* (January).

1999 Valdez, Sarah. "Tom Sachs at Mary Boone," *Art in America* (December).

Smith, Roberta. "Removing the Bullets and Trying to Judge a Show," *The New York Times* (October).

Moxham, Tony. "Life is 2029," *Interview* (October).

Szabo, Julia. "The Merchandising of Tom Sachs," *Elle Décor* (October).

Staff. "Goings on About Town," *The New Yorker* (September).

Staff. "Tom Sachs and Mary Boone," *Gallery Guide* (September).

Karcher, Eva. "Glamour-Partisan," *German Vogue* (July).

Attias, Laurie. "Tom Sachs," *Artnews* (May).

Talley, Andre Leon. "Brand of Horror," *Vogue* (April).

1998 Williams, Yseult. "Une Oeuvre d'art sur un plateau." *French Elle* (September).

"Tom Foolery." *Black Book* (September).

Talbot, Stephanie. "Rave." *Blue Print*
(September).

Lemons, Steven. "Are You Looking at Me?"
SOMA (May).

Keeps, David A. "Shot Through the Art."
Details (May).

Cash, Stephanie. "Tom Sachs at Morris-Healy."
Art in America (May).

Morris, Bob. "Loco for Logos," *The New York
Times Magazine* (November).

1997 Slowey, Anne. "The Joy of Sachs." *W* (December).

Verrico, Lisa. "Feeling Flush." *The (London)
Sunday Times,* June 7.

Jackson, Jennifer, and Andrea Linnet. "Fashion
f.y.i." *Harper's Bazaar* (March).

1996 Dambrot, Shana Nys. "Tom Sachs: Fashion
Terrorist." *Hot Lava* (September).

Gibson, Jeff. "Tom Sachs." *Art and Text* (August).

Chaikivsky, Andrew. "You Can't Hunt with a
Brancusi." *Esquire* (April).

Hucko, Leslie. "Tom Sachs." *World Art* (February).

Tanabe, Ryota. "Trash Art." *Brutus* (February).

AWARDS

1987 Furniture Prize, Architectural Association,
London

ALAN SCHECHNER

Born in London, 1962
Lives in Savannah, Georgia

EDUCATION

B.F.A. Dartington College of Art, Devon, England, 1991
M.F.A. Electronic Art, Coventry University, England,
1993

FILM FESTIVALS
AND INTERACTIVE PERFORMANCES

1999 Trustees Theater, Interactive Dance Technology
Performance, Savannah, *E-Motion*

Festival De Video Y Artes Electrónicas, Centro

de Capacitación Cinematografica, Mexico,
Vide@rt

Nexus Art Gallery, Atlanta, *Body as Commodity*

1996 Institute for Contemporary Art, London, *Wired
and Wonderful*

1994 Hong Kong, *Hong Kong Film Festival*

1993 Museum of the Moving Image, London, *London
Film Festival*

ICA, London, *British Animation Week*

1992 Villa Le Serre & FERT, Turin, Italy, *Capricci Art
Exhibition*

Goethe Institute, Glasgow, *New Visions,
International Film and Video Festival*

Clermont-Ferrand, France, *VideoFormes*

1991 Café des Images, Paris, *Recontres Video
Art Plastique*

SELECTED WRITINGS BY THE ARTIST

1996 "Anyway, It's My Image." *Art Monthly* 199
(September).

SELECTED BIBLIOGRAPHY

2000 Milgrom-Elcott, Noam. "A Tiger's Leap into
Oblivion: Photography in the Age of Digital
Reproduction." *Museo* 3 (Spring).

1997 Harris, Jonathan. "Art Education and Cyber-ide-
ology: Beyond Individualism and Technolog-
ical Determinism." *Art Journal* 56 (Fall).

Reardon, Valerie. "Whose Image Is It Anyway?"
Art Monthly 195 (April).

"How Many People Does It Take to Screw in a
Lightbulb? On the Ownership of Experience,
or Who Can Say What to Whom, When." *Art
Papers* 21 (March/April).

1996 Frascina, Francis, and Jonathan Harris. "Power
and Responsibility." *Art Monthly* 197 (June).

Frascina, Francis, and Jonathan Harris. "Social
Control and Permissibility." *Art Monthly* 194
(March).

AWARDS

1999 Third Prize, Arts on the River, Savannah

1995 Wyndham Deeds Travel Scholarship, AIA, London
Runner-up in the Special Jury Award for
Experimental Video, Second Annual Jewish
Video Competition, Art Museum, University
of California at Berkeley

1994 New Production Award, West Midlands Arts,
England

1993 Intermediate Award, South West Arts, Exeter,
England
Jane Sutton Memorial Award, Stoneleigh,
England

1992 First Time Award, South West Arts, Exeter,
England

ALAIN SÉCHAS

Born in Colombes, France, 1955
Lives in Paris

SELECTED ONE-PERSON EXHIBITIONS

1999 Le Safran, Amiens, France, *Projet pour Amiens*

1998 Centre d'art contemporain, Le Parvis 3, Pau,
France; Le Parvis, Ibos, France, *Une
exposition à cheval* (catalogue)

1997 Fondation Cartier, Paris

1996 São Paulo Biennial (catalog)

1995 Galerie Ghislaine Hussenot, Paris
FRAC Auvergne, Mauriac, France; Le
Puy-en-Velay, France, *La Pieuvre*
Centre d'Art, Thiers, France, *Le Creux de
L'Enfer*

1993 Galerie Albert Baronian, Brussels

1992 Hôtel des Arts, Paris

1991 Galerie Ghislaine Hussenot, Paris

1990 Halle d'Art Contemporain, Rennes, France

1988 Galerie Ghislaine Hussenot, Paris
Galerie Albert Baronian, Bruxelles

1987 Galerie Wittenbrink, Münich

1985 Galerie Crousel-Houssenot, Paris

SELECTED GROUP EXHIBITIONS

1998 Guggenheim Museum SoHo, New York, *Premises*
(catalogue)
Galerie für zeitgenössische Kunst, Leipzig,
Weather Everything

1997 Magasin, Centre national d'art contemporain de
Grenoble, France, *Dramatically Different*

1996 Musée de Cognac, Cognac, France, *Variations
op. 96*

1995 Galerie Jousse-Seguin, Paris, *Toys*
Venise, Montlucon, *Histoire de l'infamie*

1991 Biennale d'art contemporain, Lyons, France,
L'Amour de l'art

1990 Venice Biennale, Italy, *Aperto*

1989 Institute for Contemporary Art, P.S.1 Museum,
Long Island City, N.Y.; Teatro Lope de Vega,
Seville, Spain; Confort Moderne, Poitiers,
France, *Theater Garden Bestiarium*

SELECTED BIBLIOGRAPHY

1999 Lebovici, Elisabeth. "L'art félin de Séchas."
Libération no. 4943. (January).

1998 Javault, Patrick. *Alain Séchas*. Paris: Hazan

1997 Rian, Jeff. *Frieze* (August).
Gauville, Hervé. "Séchas et ses chats au rayon
art." *Libération,* January 7.

1996 Francblin, Catherine. "If It's Beautiful, It's
Beautiful for Everybody," *Art Press*
(April).

1992 Bellido, Ramon Tio, et al. *Alain Séchas*. Paris:
Hôtel des Arts.

1988 Javault, Patrick. *Alain Séchas*. Nevers, France:
APAC.

MACIEJ TOPOROWICZ

Born in Bialystock, Poland, 1958
Lives in New York

EDUCATION

M.F.A. Academy of Fine Arts, Cracow, 1982

SELECTED ONE-PERSON EXHIBITIONS

2000 Pori Art Museum, Finland, *Obsession*
 Lombard-Freid Fine Arts, New York, *Stairs 2 Heaven*

1997 Lombard-Freid Fine Arts, New York, *A Season in Hell*

1996 Lombard-Freid Fine Arts, New York, *Lure*
 Galeria Camargo Vilaca, São Paulo, *Obsession*

1994 Center for Curatorial Studies, Bard College, Annandale-on-Hudson, N.Y., *Obsession*

SELECTED GROUP EXHIBITIONS

2000 Fuller Museum of Art, Brockton, Mass., *Confronting the Figure*
 Musée de l'Elysee, Lausanne, *Obsession*
 Dulcinea, Istanbul, *Confession of a Voyeur*

1999 Center for Curatorial Studies, Bard College, Annandale-on-Hudson, N.Y., *Your I*
 Katherine Nash Gallery, Minneapolis, *Absence/Presence*
 Lombard-Freid Fine Arts, New York, *Propaganda*

1998 Edsvik Konst Kultur, Stockholm, *Medialization*
 International Center for Photography, Moscow, *Photobiennale '98*
 Paco Das Artes, São Paulo, *Canibal City*

1996 Center for Curatorial Studies, Bard College, Annandale-on-Hudson, N.Y., *Untitled*
 Stefan Stux Gallery, New York, *Sex/Industry*
 Lombard-Freid Fine Arts, New York, *The Experimenters*
 Franklin Furnace, New York, *Voyeur's Delight*

1995 Goethe Institute, Cracow, *Giordano Bruno*
 Mitzpe Ramon, *Construction in Process V*

1994 Bronx Museum of the Arts, Bronx, New York, *Beyond the Borders*

1993 The Artists' Museum, Lodz, Poland, *Construction in Process IV*
 Kohler Arts Center, Sheboygan, Wisconsin, *Hair*

1990 Institute for Contemporary Art, P.S.1 Museum, Long Island City, N.Y., *Sites of Intolerance*

SELECTED BIBLIOGRAPHY

2000 Valdez, Sarah. "Maciej Toporowicz at Lombard-Freid." *Art in America* (September).
 Morgan, Robert. "Stairs 2 Heaven." *Review* (March).

1998 Morgan, Robert. "Maciej Toporowicz." *Art Press* (February).

1997 "Maciej's 'Obsession.'" *Creative Review* (Spring).

1996 "Obsession." *Archive* (Fall).
 Corn, Alfred. "Maciej Toporowicz at Lombard-Freid." *Art in America* (October).
 Smith, Roberta. "Lombard-Freid." *The New York Times,* May 17.

1994 Loos, Ted. "Making Scents of Fascism." *Art & Antiques* (November).
 Vogel, Carol. "Inside Art." *The New York Times,* May 27.

AWARDS

1991–1992
 National Studio Program Award, Institute for Contemporary Art, P.S.1 Museum, Long Island City, N.Y.

PIOTR UKLAŃSKI

Born in Warsaw, 1968
Lives in New York

SELECTED ONE-PERSON EXHIBITIONS

2000 Fotogaleriet, Oslo, Norway, *A Norwegian Photograph*
 Kunstwerke, Berlin, *The Nazis*
 Museum of Modern Art, New York, *Project*

1999 Foksal Gallery, Warsaw, *A Mosaic at DH Smyk*

1998 The Photographers' Gallery, London, *The Nazis*
 Gavin Brown's enterprise, New York, *More Joy of Photography*
 Sabine Knust Galerie & Edition, Munich, *Some of More Joy of Photography*

1997 Galerie Voges & Desein, Frankfurt, *Joy of Photography*

1996 Gavin Brown's enterprise, New York, *Dance Floor*

1995 Galeria Grodzka, Lublin, Poland, *Life as it Should Be*

1994 Jan Kuzinski's shop, Premysl, Poland, *High Density Color, High Definition Lips*

1993 Bureau of Art Exhibitions, Sandomierz, Poland, *Pojedynek w pojedynke*

SELECTED GROUP EXHIBITIONS

2000 Museum of Contemporary Art, Chicago, *Age of Influence: Reflections in the Mirror of American Culture*

Walker Art Center, Minneapolis, *Let's Entertain*

Institute for Contemporary Art, P.S.1, Long Island City, N.Y., *Greater New York*

1999 Migros Museum, Zürich, *Peace*

1998 Museum Ludwig, Cologne, *I Love NY* (catalogue)

Neues Museum Weserburg, Bremen, *Minimal-Maximal* (catalogue)

Luxembourg, *Manifesta 2* (catalogue)

1997 ICA, London, a dance floor in *Assuming Positions* (catalogue)

CCA, Glasgow, a dance floor in *Waves In, Particles Out*

1996 P.S.1 Museum at the Clocktower, New York, *Departure Lounge*

Galerie Voges & Deisen, Frankfurt, *Quick Time*

Ice Factory, Hannover, Germany, *Weil Morgen*

Galerie Voges & Deisen, Frankfurt, *Skizze*

BEAM Gallery, Tokyo, *Nippon International Performance Festival*

1995 Real Art Ways, Hartford, Conn., *Raw Spaces*

Cubitt Gallery, London, *Just Do It*

SELECTED BIBLIOGRAPHY

2000 Neumann, Hans-Joachim. "Die Schrillen, die Bizarren, die Abseitigen." *Zitty,* March 22.

Ruthe, Ingeborg. "Jeder auf eigene Faust." *Berliner Zeitung* 63, March 15.

"Schlechte Kerle." *Süddeutsche Zeitung,* March 14.

Heller, Steven. "Snazi Nazis." *The New York Times Book Review,* March 12.

Schröder, Christian. "Das Böse hat viele Gesichter." *Der Tagesspiegel,* March 8.

Becker, Claudia. "Stahlblaue Augen." *Berliner Morgenpost,* March 7.

Leinemann, Susanne. "Der filmische Albtraum vom Nazi." *Die Welt,* March 3.

1999 Rimanelli, David. "If You Lived There. . . ." *Interior Design* (August).

Januszczak, Waldemar. "Dress to Kill." *The Sunday Times* (London), August 16.

Sanchez, Antonio. "Minimal Maximal." *Arte Y Parte* (April–May).

Pjede, Manuela. "Mode, Künstler, Visionen." *Max* (March).

Stange, Raimar. "Eine Frage der Lust." *Kunst-Bulletin* (January–February).

Jocks, Heinz-Norbert. "Rauschmittel für den Geist: Interview with Piotr Uklański" *Kunst-forum* (January–February).

1998 Gross, Ulrike, and Markus Müller. *Make It Funky.* Cologne: Oktagon Verlag.

Higgie, Jennifer. "Piotr Uklański." Review. *Frieze* (December).

Stoeber, Michael. "Minimal Maximal." *Artist: Kunstmagazine* (November).

"Expedition in der New York Kunstszene." *Der Weltkunst* (November).

Gordon-Nesbitt, Rebecca. "The Truth Is Out Where?" *Make* 81 (September–November).

Kent, Sarah. "Piotr Uklański." Review. *Time Out London,* September 2–9.

Wittneven, Katrin. "Eurovisionen, Die Manifesta 2 in Luxemburg." *Neue Bildende Kunst* (August–September).

"Nazi Movie Shots Are Defended as Art." *Amateur Photographer,* August 29.

Blom, Phillip. "Ikonen des Bösen." *Berliner Zeitung,* August 28.

Hopkinson, Amanda. "Good Eye, Steady Nerve,

Generous Heart." *The (London) Independent on Sunday,* August 23.

"Spiel mit dem Nazi-Chic." *Der Spiegel* 32. February.

Ascherson, Neal. "It's only David Niven dressed up. Why do we feel a chill?" *The (London) Observer,* August 23.

Jones, Jonathan. "Faces of Evil." *The (London) Guardian,* August 18.

Edwards-Jones, Imogen. "Arty Animal." *The (London) Times,* August 15–21.

Corner, Lena. "Sinatra. Eastwood. Fiennes. Why do we love a man in uniform?" *The Big Issue,* August 3–9.

Stringer, Robin. "Outrage as London Gallery Highlights 'Glamour of Nazism.'" *The (London) Evening Standard,* July 28.

Epstein, Rob. "Janner's fears of Nazis exhibition." *London Jewish News,* July 17.

Lunghi, Enrico. "Encore une occasion pour approcher l'art d'aujourd'hui." *Kulturissimo,* July 3.

Shave, Stuart. "Nice Nazi Nasty Nazi." *I-D* (July).

Lyle, Peter. "The Reich Stuff." *The Face* (June).

Stoeber, Michael. "Minimal-Maximal." *Artist Kunstmagazin* 37 (April).

Schmerler, Sarah. "Super Freaks." Review. *Time Out London* 129 (March).

Johnson, Ken. "Super Freaks." Review. *The New York Times,* March 6.

Taylor, John Russell. "Around the Galleries." *The (London) Times,* March 3.

Burrows, David. "Waves In Particles Out." *Art Monthly* 123 (February).

1997 "Happening Hop." *The Scotsman,* November 29.

Mahoney, Elizabeth. "Waves In Particles Out." *The Scotsman,* November 5.

Gibb, Eddie. "Exploring the Art of Hedonism." *The (London) Guardian,* October 27.

Dibdin, Thom. "Jive Talkin' . . . Sound Art." *The Scotsman,* October 23.

Slyce, John. Review, ICA. *Art* (August).

Madden, Jenny. "Yes, But Is It Art?" *I-D* (August).

Kent, Sarah. "Assuming Positions." *Time Out London,* July 23.

Feaver, William. "Frankly, This Place Is Going Down the Pan." *The (London) Observer,* July 20.

Morris, Mark. "Hype." *The Face* (July).

Decter, Joshua. Review. *Artforum* (April).

1996 Mir, Aleksandra. "Ouverture: Piotr Uklański." *Flash Art* (October).

1995 Coomer, Martin. "Just Do It." *Time Out London,* November 8–15.

Peters, Christine. "Mehr oder weniger listige Störungen des Alltags." *Frankfurter Rundschau,* February 16.

CONTRIBUTORS

ERNST VAN ALPHEN is a professor of comparative literature at the University of Leiden. His publications include *Francis Bacon and the Loss of the Self* (1993) and *Caught By History: Holocaust Effects in Contemporary Art, Literature, and Theory* (1997). His most recent book is *Armando: Shaping Memory* (2000).

SIDRA DEKOVEN EZRAHI teaches comparative Jewish literature at the Hebrew University of Jerusalem. Since her first book, *By Words Alone: The Holocaust in Literature,* she has been part of the ongoing theoretical discussion of the avenues and "limits" of representation. She has written widely on the culture of memory in Israel and how it reflects renegotiations with the past in light of present struggles. Her latest publication, *Booking Passage,* is a study of exile and homecoming in the modern Jewish imagination.

REESA GREENBERG is a museum consultant and adjunct professor of art history at Concordia University, Montreal. She is co-editor of *Thinking About Exhibitions* (1996) and a founding director of *Project Mosaica,* a recently formed Canadian virtual Jewish Museum. Her most recent book is *Museums, Private Collections, and Display: Post Holocaust Perspectives* (forthcoming).

NORMAN L. KLEEBLATT is Susan and Elihu Rose Curator of Fine Arts at The Jewish Museum in New York City. Among the exhibitions he has curated are *The Dreyfus Affair: Art, Truth, and Justice* (1987–88); *Too Jewish? Challenging Traditional Identities* (1994); *John Singer Sargent: Portraits of the Wertheimer Family* (1999); and *An Expressionist in Paris: The Paintings of*

Chaim Soutine (1998), which was co-curated by Kenneth E. Silver. His work explores the intersection of art and history, identity and culture.

LISA SALTZMAN is an assistant professor of modern and contemporary art in the Department of Art History at Bryn Mawr College. She is the author of *Anselm Kiefer and Art after Auschwitz* (1999). She is working on a new collection of essays, entitled *Mnemonic Devices,* dealing with issues of memory in contemporary art.

ELLEN HANDLER SPITZ teaches in the Department of Art and Art History at Stanford University. She has held fellowships at the Getty Center, the Bunting Institute, the Center for Advanced Study in Behavioral Sciences at Stanford, and the Camargo Foundation. She is the author of *Art and Psyche* (1985), *Image and Insight* (1991), *Museums of the Mind* (1994), and *Inside Picture Books* (1999). In her writing she explores the realms of aesthetics and psychology in the visual, literary, and performing arts.

JAMES E. YOUNG is Professor of English and Judaic Studies at the University of Massachusetts at Amherst, where he is Chair of the Department of Judaic and Near Eastern Studies. He is author of *Writing and ReWriting the Holocaust* (1998), *The Texture of Memory* (1993) and *At Memory's Edge* (2000). In 1997, Mr. Young served as the only foreigner appointed by the Berlin Senate to a five-member committee to select a design for Germany's national "Memorial for the Murdered Jews of Europe," now under construction in Berlin.

BIBLIOGRAPHY

BOOKS

Adorno, Theodor W. *Aesthetic Theory*. Translated by C. Lenhardt. New York: Routledge and Kegan Paul, 1984.

———. *Prisms*. Translated by Samuel and Shierry Weber. London: Nevills Spearman, 1967; Cambridge: MIT Press, 1981.

Alphen, Ernst van. *Caught by History: Holocaust Effects in Contemporary Art, Literature, and Theory*. Stanford, Calif.: Stanford University Press, 1997.

Amishai-Maisels, Ziva. *Depiction and Interpretation: The Influence of the Holocaust on the Visual Arts*. Oxford: Pergamon Press, 1993.

Arendt, Hannah. *Eichmann in Jerusalem: A Report on the Banality of Evil*. New York: Viking, 1963.

Baigell, Matthew. *Jewish American Artists and the Holocaust*. New Brunswick, N.J.: Rutgers University Press, 1997.

Bartov, Omer. *Murder in Our Midst: The Holocaust, Industrial Killing, and Representation*. New York and Oxford: Oxford University Press, 1996.

Bauer, Yehuda. *The Jewish Emergence from Powerlessness*. Buffalo: University of Toronto Press, 1978.

Blatter, Janet, and Sybil Milton. *Art of the Holocaust*. London: Pan Books Ltd., 1982.

Camon, Ferdinando. *Conversations with Primo Levi*. Translated by John Shepley. Marlboro, Vt.: Marlboro Press, 1989.

Cole, Tim. *Selling the Holocaust: From Auschwitz to Schindler: How History Is Bought, Packaged and Sold*. New York and London: Routledge, 1999.

Delbo, Charlotte. *Auschwitz and After*. New Haven: Yale University Press, 1995.

Ezrahi, Sidra DeKoven. *By Words Alone: The Holocaust in Literature*. Chicago: University of Chicago Press, 1980.

Foster, Hal. *Recodings: Art, Spectacle, Cultural Politics*. Seattle: Bay Press, 1985.

Friedlander, Saul. *Memory, History, and the Extermination of the Jews in Europe*. Bloomington: Indiana University Press, 1993.

———. *Reflections of Nazism: An Essay on Kitsch and Death*. Translated by Thomas Weyr. Bloomington and Indianapolis: Indiana University Press, 1984.

———. *When Memory Comes*. Translated by Helen R. Lane. New York: Farrar, Straus & Giroux, 1979.

———, ed. *Probing the Limits of Representation: Nazism and the "Final Solution."* Cambridge: Harvard University Press, 1992.

Gockel, Cornelia. *Zeige deine Wunde: Faschismusrezeption in der deutschen Gegenwartskunst*. Munich: Verlag Silke Schreiber, 1998.

Goldhagen, Daniel Jonah. *Hitler's Willing Executioners: Ordinary Germans and the Holocaust*. New York: Knopf, 1996.

Greenberg, Clement. *Art and Culture: Critical Essays*. Boston: Beacon Press, 1961.

Gutman, Israel, ed. *The Encyclopedia of the Holocaust*. 4 vols. New York: Macmillan, 1990.

Hartman, Geoffrey H. *The Longest Shadow: In the Aftermath of the Holocaust*. Bloomington: Indiana University Press, 1996.

———, ed. *Holocaust Remembrance: The Shapes of Memory*. Oxford, England, and Cambridge, Mass.: Blackwell Publishers, 1994.

Hass, Aaron. *In the Shadow of the Holocaust: The Second Generation*. New York: Cambridge University Press, 1990.

Hayes, Peter, ed. *Lessons and Legacies: The Meaning of*

the *Holocaust in a Changing World*. Evanston, Ill.: Northwestern University Press, 1991.

Hirsch, Marianne. *Family Frames: Photography, Narrative and Postmemory*. Cambridge: Harvard University Press, 1997.

Huyssen, Andreas. *Twilight Memories: Marking Time in a Culture of Amnesia*. New York and London: Routledge, 1995.

Kaes, Anton. *From Hitler to "Heimat": The Return of History as Film*. Cambridge: Harvard University Press, 1989.

König, Kaspar. *Von Hier Aus*. Cologne: DuMont Buchverlag, 1984.

Köppen, Manuel, ed. *Kunst und Literatur nach Auschwitz*. Berlin: Erich Schmidt Verlag, 1993.

Kracauer, Siegfried. *From Caligari to Hitler: A Psychological History of the German Film*. Princeton, N.J.: Princeton University Press, 1947; reprint, 1974.

LaCapra, Dominick. *History and Memory after Auschwitz*. Ithaca, N.Y., and London: Cornell University Press, 1998.

———. *Representing the Holocaust: History, Theory, Trauma*. Ithaca, N.Y.: Cornell University Press, 1994.

Lang, Berel. *Act and Idea in the Nazi Genocide*. Chicago: University of Chicago Press, 1990.

———, ed. *Writing and the Holocaust*. New York: Holmes & Meier, 1988.

Langer, Lawrence L. *The Holocaust in the Literary Imagination*. New Haven: Yale University Press, 1975.

———, ed. *Art from the Ashes: A Holocaust Anthology*. New York and Oxford: Oxford University Press, 1995.

Lanzmann, Claude. *Shoah: An Oral History of the Holocaust*. New York: Pantheon Books, 1985.

Levi, Primo. *The Drowned and the Saved*. Translated by Raymond Rosenthal. New York: Summit Books, 1988.

———. *If This Is a Man* (1947) (also published as *Survival in Auschwitz*) and *The Truce* (1963) (also published as *The Reawakening*). Translated by Stuart Wolf, with an introduction by Paul Bailey and an afterword by the author. London: Abacus, 1987.

Linenthal, Edward T. *Preserving Memory: The Struggle to Create America's Holocaust Museum*. New York: Viking, 1995.

Liss, Andrea. *Trespassing Through Shadows: Memory, Photography, and the Holocaust*. Minneapolis: University of Minnesota Press, 1998.

Lukacs, John. *The Hitler of History*. New York: Knopf, 1998.

Maier, Charles S. *The Unmasterable Past: History, Holocaust, and German National Identity*. Cambridge: Harvard University Press, 1988.

Marrus, Michael R. *The Holocaust in History*. Hanover, N.H., and London: University Press of New England, 1987.

Michaels, Anne. *Fugitive Pieces*. New York: Vintage Books, 1996.

Miller, Judith. *One, by One, by One: The Landmark Exploration of the Holocaust and the Uses of Memory*. New York: Simon & Schuster, 1990.

Milton, Sybil. *In Fitting Memory: The Art and Politics of Holocaust Memorials*. Photographs by Ira Nowinski. Detroit: Wayne State University Press, in cooperation with the Judah L. Magnes Museum, Berkeley, Calif., 1991.

Mizejewski, Linda. *Divine Decadence: Fascism, Female Spectacle, and the Makings of Sally Bowles*. Princeton, N.J.: Princeton University Press, 1992.

Novick, Peter. *The Holocaust in American Life*. Boston: Houghton Mifflin, 1999.

Nyiszli, Miklos. *Auschwitz: An Eyewitness Account of Mengele's Infamous Death Camp*. Translated by Tibere Kremer and Richard Seaver, with a foreword by Bruno Bettelheim. New York: Seaver Books, 1960.

Rosenbaum, Ron. *Explaining Hitler: The Search for the Origins of His Evil*. New York: Random House, 1998.

Rosenfeld, Alvin H. *Imagining Hitler*. Bloomington: Indiana University Press, 1985.

Rosenfield, Alvin H., and Irving Greenberg, eds. *Confronting the Holocaust: The Impact of Elie Wiesel*. Bloomington and London: Indiana University Press, 1978.

Salomon, Charlotte. *Leben oder Theater?: Ein autobiographisches Singspiel in 769 Bildern.* Cologne: Kiepenheuer & Witsch, 1981.

Saltzman, Lisa. *Anselm Kiefer and Art after Auschwitz.* Cambridge and New York: Cambridge University Press, 1999.

Santner, Eric L. *Stranded Objects: Mourning, Memory and Film in Postwar Germany.* Ithaca, N.Y.: Cornell University Press, 1990.

Schiff, Gert. *Images of Horror and Fantasy.* Edited by Margaret L. Kaplan. New York: Abrams, 1978.

Schlink, Bernhard. *The Reader.* Translated by Carol Brown Janeway. New York: Pantheon Books, 1997.

Segev, Tom. *The Seventh Million: The Israelis and the Holocaust.* Translated by Haim Watzman. New York: Hill & Wang, 1993.

Sontag, Susan. *On Photography.* New York: Farrar, Straus & Giroux, 1977.

———. *Under the Sign of Saturn.* New York: Farrar, Straus & Giroux, 1980.

Spiegelman, Art. *Maus I: A Survivor's Tale: My Father Bleeds History.* New York: Pantheon Books, 1986.

———. *Maus II: A Survivor's Tale: And Here My Troubles Began.* New York: Pantheon Books, 1991.

Spitz, Ellen Handler. *Museums of the Mind: Magritte's Labyrinth and Other Essays in the Arts.* New Haven: Yale University Press, 1995.

Steiner, George. *The Portage to San Cristóbal of A. H.* Chicago: University of Chicago Press, 1979.

Theweleit, Klaus. *Male Fantasies.* 2 vols. Translated by Stephen Conway in collaboration with Erica Carter and Chris Turner, with a foreword by Barbara Ehrenreich. Minneapolis: University of Minnesota Press, 1987–89.

Thompson, Vivian Alpert. *A Mission in Art: Recent Holocaust Works in America.* Macon, Georgia: Mercer University Press, 1988.

Todorov, Tzvetan. *Facing the Extreme: Moral Life in the Concentration Camp* (1992). Translated by Arthur Denner and Abigail Pollak. New York: Metropolitan Books, Henry Holt & Co., 1996.

Tournier, Michel. *The Ogre.* Translated by Barbara Bray. Baltimore: Johns Hopkins University Press, 1997.

Trevor-Roper, Hugh. *The Last Days of Hitler* (1947). London: Macmillan, 1987.

Turner, Henry Ashby, Jr. *Hitler's Thirty Days to Power: January 1933.* Reading, Mass.: Addison-Wesley, 1996.

Vidal-Naquet, Pierre. *Assassins of Memory: Essays on the Denial of the Holocaust.* Translated and with a foreword by Jeffrey Mehlman. New York: Columbia University Press, 1992.

Wiesel, Elie. *From the Kingdom of Memory: Reminiscences.* New York: Simon & Schuster, 1990.

———. *Night.* Translated by Stella Rodway. New York: Hill & Wang, 1960.

Young, James E. *At Memory's Edge: After-Images of the Holocaust in Contemporary Art and Architecture.* New Haven: Yale University Press, 2000.

———. *The Texture of Memory: Holocaust Memorials and Meaning.* New Haven and London: Yale University Press, 1993.

———. *Writing and Rewriting the Holocaust: Narrative and the Consequences of Interpretation.* Bloomington: Indiana University Press, 1990.

EXHIBITION CATALOGUES

After Auschwitz: Responses to the Holocaust in Contemporary Art. Edited by Monica Böhm-Duchen. Northern Centre for Contemporary Art, Sunderland, England. London: Lund Humphries, 1995.

The Art of Memory: Holocaust Memorials in History. Edited by James E. Young. The Jewish Museum, New York, 1994. New York: Prestel, 1994.

Burnt Whole: Contemporary Artists Reflect Upon the Holocaust. Washington Project for the Arts, Washington, D.C., 1994.

Contemporary Artists View the Holocaust. Edited by Jill Snyder. Freedman Gallery, Reading, Penn., 1994.

Dark Light: David Levinthal Photographs, 1984–1994.

Edited by David Chandler. The Photographers' Gallery, London, 1994.

The Living Witness, Art in the Concentration Camps. Museum of American Jewish History, Philadelphia, 1978.

The Road to Maus. Jane Kalir. Galerie St. Etienne, New York, 1992–93.

Seeing Through "Paradise": Artists and the Terezin Concentration Camp. Massachusetts College of Art, Boston, 1991.

Witness and Legacy: Contemporary Art about the Holocaust. Edited by Stephen C. Feinstein. Minnesota Museum of American Art, St. Paul. St. Paul: Lerner Publications, 1995.

ARTICLES

Adorno, Theodor. "What Does Coming to the Past Mean?" In *Bitburg in Moral and Political Perspective,* edited by Geoffrey Hartman, 114–29. Bloomington and Indianapolis: Indiana University Press, 1986.

Azoulay, Ariella. "The Spectator's Place [in the Museum]." Paper presented at the conference "Representing the Holocaust: Practices, Products, Projections," Lehigh University, Bethlehem, Penn., May 2000.

Bartov, Omer. "Kitsch and Sadism in Ka-Tzetnik's Other Planet: Israeli Youth Imagine the Holocaust." *Jewish Social Studies* 3 (Winter 1997): 42–76.

Benjamin, Walter. "The Work of Art in the Age of Mechanical Reproduction" (1936). Translated by Harry Zohn. In *Illuminations,* 217–52. New York: Schocken Books, 1969.

Bier, Jean-Paul. "The Holocaust and West Germany: Strategies of Oblivion, 1947–1979." Translated by Michael Allinder. *New German Critique* 19 (Winter 1980): 9–29.

Cory, Mark. "Comedic Distance in Holocaust Literature." *Journal of American Culture* 18, no. 1 (Spring 1995): 35.

Cousins, Mark. "Danger and Safety." *Art History* 17, no. 3 (September 1994): 418–23.

Elsaesser, Thomas. "Myth as the Phantasmagoria of History: H. J. Syberberg, Cinema and Representation." *New German Critique* 24/25 (Fall 1981–Winter 1982): 108–54.

Ezrahi, Sidra DeKoven. "Revisioning the Past: The Changing Legacy of the Holocaust in Hebrew Literature." *Salmagundi,* no. 68/69 (Fall 1985–Winter 1986).

———. "The Holocaust and the Shifting Boundaries of Art and History." *History and Memory* 1, no. 2 (1989): 77–98.

Feinstein, Stephen C. "Mediums of Memory: Artistic Responses of the Second Generation." In *Breaking Crystal: Writing and Memory after Auschwitz,* edited by Ephraim Sicher, 201–75. Urbana: University of Illinois Press, 1998.

Geuens, Jean-Pierre. "Pornography and the Holocaust: The Last Transgression." *Film Criticism* 20 (Fall–Winter 1996): 114–30.

Gilman, Sander. "Is Life Beautiful? Can the Shoah Be Funny? Some Thoughts on Recent and Older Films." *Critical Inquiry* 26 (Winter 2000): 300–8.

Goertz, Karein K. "Writing from the Secret Annex: The Case of Anne Frank." *Michigan Quarterly Review* 39, no. 3 (Summer 2000): 655.

Goldenberg, Myrna. "Different Horrors, Same Hell: Women Remembering the Holocaust." In *Thinking the Unthinkable: Meanings of the Holocaust,* edited by Roger S. Gottlieb, 150–66. New York: Paulist Press, 1990.

Greenberg, Reesa. "The Exhibition as Discursive Event." In *Longing and Belonging: From the Far Away Nearby,* 120–25. Santa Fe, N.M.: SITE Santa Fe, 1995.

Hansen, Miriam Bratu. "Schindler's List Is Not Shoah: The Second Commandment, Popular Modernism, and Public Memory." *Critical Inquiry* 22 (Winter 1996): 292–312.

Hartman, Geoffrey H. "Holocaust, Testimony, Art and

Trauma." In *The Longest Shadow: In the Aftermath of the Holocaust,* 151–72. Bloomington: Indiana University Press, 1996.

Herzog, Dagmar. "'Pleasure, Sex, and Politics Belong Together': Post-Holocaust Memory and the Sexual Revolution in West Germany." *Critical Inquiry* 24, no. 2 (Winter 1998): 393–444.

Hilberg, Raul. "The Nature of the Process." In *Survivors, Victims and Perpetrators: Essays on the Nazi Holocaust,* edited by Joel E. Dimsdale, M.D. Washington, D.C.: Taylor & Francis, 1980.

Hirsch, Marianne. "Family Pictures: *Maus,* Mourning, and Post-Memory." *Discourse* 15, no. 2 (Winter 1992–93): 8–9.

Hirsch, Marianne, and Leo Spitzer. "Gendered Translations: Claude Lanzmann's *Shoah.*" In *Gendering War Talk,* edited by Miriam Cook and Angela Wollacott, 4–19. Princeton, N.J.: Princeton University Press, 1994.

Johnson, Ken. "Art and Memory." *Art in America* (November 1998).

Kacandes, Irene. "You Who Live Safe in Your Warm Houses: Your Role in the Production of Holocaust Testimony." In *Insiders and Outsiders: Jewish and Gentile Culture in Germany and Austria,* edited by Dagmar Lorenz and Gabriela Weinberger, 189–213. Detroit: Wayne State University Press, 1994.

Kasher, Steven. "Art of Hitler." *October* 59 (Winter 1992): 48–85.

Langer, Lawrence. "The Americanization of the Holocaust on Stage and Screen." In *From Hester Street to Hollywood,* edited by Sarah Blacher Cohen. Bloomington: Indiana University Press, 1983.

———. "Pre-empting the Holocaust." *The Atlantic Monthly* (November 1998): 105–15.

Miller, Nancy. "Cartoons of the Self: Portrait of the Artist as a Young Murderer: Art Spiegelman's *Maus.*" *M/e/a/n/i/n/g* (Fall 1992): 43–54.

Milton, Sybil. "Images of the Holocaust." *Holocaust & Genocide Studies* 1, nos. 1 and 2 (1986): 27–61.

Pres, Terrence des. "Holocaust Laughter." In *Writing and the Holocaust,* edited by Berel Lang, 216–33. New York: Holmes & Meier, 1988.

Rogoff, Irit. "The Aesthetics of Post-History: A German Perspective." In *Vision and Textuality,* edited by Stephen Melville and Bill Readings, 115–46. Durham, N.C.: Duke University Press, 1995.

Rosen, Jonathan. "The Trivialization of Tragedy." *Culturefront* (Winter 1997): 80–85.

Santner, Eric L. "The Trouble with Hitler: Postwar German Aesthetics and the Legacy of Fascism." *New German Critique* 57 (Fall 1992): 5–24.

Schoenfeld, Gabriel. "Death Camps as Kitsch." *The New York Times,* March 18, 1999: sec. A, p. 25.

Seidman, Naomi. "Elie Wiesel and the Scandal of Jewish Rage." *Jewish Social Studies* 3, no. 1 (Fall 1996): 1–19.

Shapira, Sarit. "The Suppressed Syndrome: Holocaust Imagery as a Taboo in Israeli Art." *The Israel Museum Journal* 16 (Summer 1998): 35–45.

Spitz, Ellen Handler. "Tattoos and Teddy Bears." *Studies in Gender and Sexuality* 1, no. 2 (2000): 207–22.

Suleiman, Susan. "Problems of Memory in Recent Holocaust Memoirs: Wilkomirski/Wiesel." *Poetics Today* 21, no. 3 (Fall 2000).

Weinstein, Andrew. "Art after Auschwitz." *Boulevard* 9 (1994): 187–96.

Yaeger Kaplan, Alice. "Theweleit and Spiegelman: Of Men and Mice." In *Remaking History,* edited by Barbara Kruger and Phil Mariani. Seattle: Bay Press, 1989.

Zeitlin, Froma. "The Vicarious Witness: Belated Memory and Authorial Presence in Recent Holocaust Literature." *History and Memory* 10, no. 2 (Fall 1998): 5–42.

Zielenski, Sigfried. "History as Entertainment and Provocation: The TV Series *Holocaust* in West Germany." Translated by Gloria Custance. *New German Critique* 19 (Winter 1980): 81–96.

CREDITS

TEXT CREDITS

While every effort has been made to contact all copyright owners, the editor apologizes to anyone who has been unable to trace. Due acknowledgment will be made in any future editions.

Clement Greenberg, "Avant-Garde and Kitsch" (1939), in *Art and Culture: Critical Essays* (Boston: Beacon Press, 1961). Reprinted by permission of the estate of Clement Greenberg.

Excerpt from *See Under: LOVE* by David Grossman, translated by Betsy Rosenberg. Translation copyright © 1989 by Betsy Rosenberg. Reprinted by permission of Farrar, Straus & Giroux, LLC.

Dan Pagis, "An Opening to Satan" and "Testimony," from *Variable Directions: The Selected Poetry of Dan Pagis,* translated by Stephen Mitchell (San Francisco: North Point Press, 1989). Reprinted by permission of Stephen Mitchell.

Excerpt from "In Plato's Cave" in *On Photography* by Susan Sontag. Copyright © 1977 by Susan Sontag. Reprinted by permission of Farrar, Straus & Giroux, LLC.

Excerpt from "Fascinating Fascism" in *Under the Sign of Saturn* by Susan Sontag. Copyright © 1980 by Susan Sontag. Reprinted by permission of Farrar, Straus & Giroux, LLC.

Excerpt from "Theatre Impressions" in *View with a Grain of Sand,* copyright © 1993 by Wislawa Szymborska, English translation by Stanislaw Baranczak and Clare Cavanagh, copyright © 1995 by Harcourt, Inc., reprinted with permission of the publisher.

FIGURE AND PLATE CREDITS

For figures that accompany the catalogue essays, credits are included within the captions. Following are credits for the color plates.

Plate 1: Courtesy of the artist. In the collection of The Migros Museum, Zurich.

Plate 2: Courtesy of the artist. Photograph by Andrew Whittuck.

Plate 3: Courtesy of the artist.

Plate 4: Courtesy of Vedanta Gallery, Chicago/Konrad Fischer Gallery, Düsseldorf. Photograph by Norbert Faehling.

Plate 5: Courtesy of Gavin Brown's Enterprise, New York. Photograph by Adam Reich.

Plates 6, 7, and 8: Courtesy of Georg Kargl Gallery, Vienna.

Plates 9 and 10: Courtesy of the artist.

Plate 11: Courtesy of the artist. Photograph by Hans Döring.

Plates 12 and 13: Courtesy of the artist.

Plate 14: Courtesy of the artist.

Plates 15 and 16: Courtesy of Galerie Jennifer Flay and Galerie Emmanuel Perrotin, Paris.

Plates 17, 18, and 19: Courtesy of The Jewish Museum, New York. Photographs by David Heald.

Plates 20 and 21: Courtesy of Galerie Thaddeus Ropac, Paris.

Plate 22: Courtesy of Bonakdar Jancou Gallery, New York.